IMAGES
of America

DEEP RIVER
AND IVORYTON

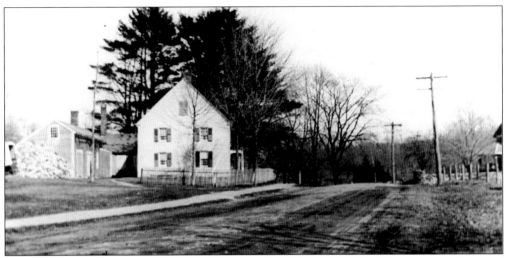

THE BULL HOUSE. Although the current two-story dwelling dates from *c.* 1770, part of this building dates back to *c.* 1720. The Bull family was among the first to settle in Ivoryton and owned a good part of what is today the center of Ivoryton. When the Bulls opened their Centre Brooke Tavern in 1749, they became the operators of the first local inn. The original sign for this tavern is on display at the Connecticut Historical Society in Hartford. Some members of the family were farmers, and others were involved in the maritime industry that became important locally during the late 18th century. They left a legacy of variously styled homes along Main Street in Ivoryton and Centerbrook. (Photograph courtesy of Ivoryton Library Association.)

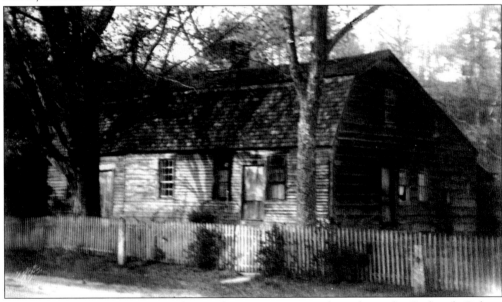

THE BENJAMIN LORD HOUSE. The Lords were prominent throughout the Saybrook Colony from the time of the original settlement. The family was related to Lt. William Pratt, a founder of Potapoug Quarter. This cape was built *c.* 1770, ostensibly by Elijah Lord, on the old main road through Deep River, once known as Country Road, near the corner of Main and Union Streets. When the house was later demolished by Judge E.G. Burke, a 1735 silver coin was discovered in the foundation. (Photograph courtesy of Deep River Historical Society.)

IMAGES
of America

DEEP RIVER
AND IVORYTON

Don Malcarne, Edith DeForest, and Robbi Storms

ARCADIA

Copyright © 2002 by Don Malcarne, Edith DeForest, and Robbi Storms
ISBN 0-7385-1096-3

First printed in 2002.
Reprinted in 2003.

Published by Arcadia Publishing,
an imprint of Tempus Publishing, Inc.
2A Cumberland Street
Charleston, SC 29401

Printed in Great Britain.

Library of Congress Catalog Card Number: 2002108541

For all general information contact Arcadia Publishing at:
Telephone 843-853-2070
Fax 843-853-0044
E-Mail sales@arcadiapublishing.com

For customer service and orders:
Toll-Free 1-888-313-2665

Visit us on the internet at http://www.arcadiapublishing.com

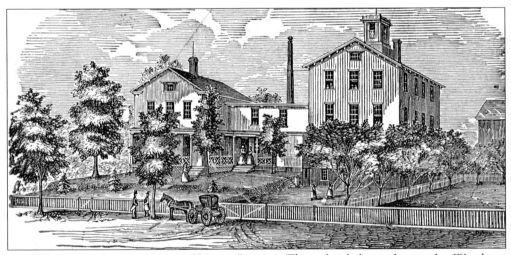

THE WINTHROP INSTITUTE FOR YOUNG LADIES. This school, located near the Winthrop Baptist Church, was founded and operated by Baptist minister William Denison. It had a limited enrollment of thirty pupils, of which six males per year would be "received and accommodated." An 1860 advertisement described the school as located "four miles west of the steamboat landing in Deep River," with the yearly tuition of $128, which included board, room, rent, fuel, lights, English, Latin, painting in watercolors, drawing ($10 more), music on the pianoforte or melodeon, singing (two hours per day of practice, instruments extra), and washing (37¢ per dozen). The school closed in 1864, and the largest building was sold to the Comstock, Cheney & Company and moved to Ivoryton. There, it became a boardinghouse for men who worked at the factory in West Centerbrook, as Ivoryton was then known. The boardinghouse was subsequently named the Ivory Hotel, the Ivoryton Hotel, the Ivoryton Inn, and Tavern at the Inn. (Photograph courtesy of Deep River Historical Society.)

CONTENTS

ACKNOWLEDGMENTS

If it were not for the efforts of many people preserving these artifacts and photographs, this book would not be possible. We wish to those whose efforts have maintained this history and assisted us in writing the book. Many thanks go to Essex Historical Society, Essex Lions Club, Essex Savings Bank, Daniel A. Nesbett, Connecticut River Museum, Bill Nelson, Hermes Foundation, Elizabeth Alvord, Rosalie Zonder, Bea Fox McLean, Helen Zabielski MacWhinney, May Sterling Rutty, Betty Austin, and Shirley and Vanessa Malcarne. Special thanks go to the Deep River Historical Society, which provided many of the photographs. The list of veterans from the three villages of Essex is taken directly from the new memorial in Centerbrook. The list World War II, Korea, and Vietnam veterans from Deep River reflects the listing on the Columbia memorial. Many thanks go to Edmund Negrelli for the list of Deep River World War I veterans.

—Don Malcarne and Robbi Storms

This book is dedicated to Bill Nickse for his heartfelt commitment to the lower Connecticut River Valley and the preservation of its culture. Bill Nickse grew up in Ivoryton and ultimately lived in Deep River. His family was very active economically and socially for many years in Ivoryton, and he married Jeanne Gualazzi of Ivoryton, who continues to serve as town clerk in Deep River. An accomplished carpenter, Bill Nickse rebuilt the only existing section of an ivory bleach house for the Deep River Historical Society. It is located on the grounds of the Stone House property and is testament to his belief in the importance of expanding our knowledge of the ivory trade. We all salute you, Bill. (Photograph by Kelly Quinlan, courtesy of Shoreline Newspaper.)

INTRODUCTION

The Saybrook Colony, which included areas that are today the villages of Ivoryton and Deep River, was characterized by a great deal of subdivision during its first 225 years. Originally, it was over 10 miles long, north to south, and extended from the Clinton-Westbrook line to East Lyme. In 1648, it was divided into the Eastern Quarter (Lyme), Oyster River Quarter (Westbrook and sections of Ivoryton and Winthrop), and Potapoug Quarter (Essex, Deep River, Chester), and the original Saybrook Point section. Over the subsequent years, Westbrook, Chester, Essex, Lyme, and Old Saybrook became separate entities and Deep River maintained the official name of Saybrook. In 1859, a final division was made, with Essex getting a part of West Centerbrook from Westbrook, which would become part of Ivoryton, and Deep River (Saybrook) receiving that area known as Winthrop. In typical New England fashion, the main towns consisted of smaller, nucleated villages. Essex now consisted of Essex Village, Centerbrook, and West Centerbrook (later Ivoryton), and Saybrook was made up of Deep River Village and Winthrop. In 1947, Deep River was officially named.

Although these two villages were founded as part of the overall Saybrook Colony in 1635, an actual settlement did not occur until c. 1720, when homes were built in these two places. Ivoryton consisted of fewer than a dozen homes in 1800, and Deep River had no more than 24 at that time. The population in 1800 was concentrated in the Potapoug Point area (Essex Village), with lesser numbers in Chester, Westbrook, and Saybrook Point. Deep River and Ivoryton can truly be referred to as children of the Industrial Revolution, for it was not until after 1830 that either began to bloom. This is in contrast to other sections of the Saybrook Colony, which saw major preindustrial activity, such as shipbuilding, much earlier.

Although the last to evolve, these two villages became the dominant social and economic forces in the lower Connecticut River Valley until after World War II. For historical reasons, such as Deacon Phineas Pratt's invention of a machine to cut combs, the ivory industry was located in Deep River and Ivoryton, and it ultimately became the largest employer in the area. In fact, it has been said that 90 percent of the ivory exported from Zanzibar to the United States (the most significant port off the East African coast in the ivory trade) was processed in these two places. Most pianos made in the United States had keyboards, actions, and sounding boards made in one of these two villages.

The Deep River area had Pratt, Read & Company as a major factor but not the only player in town. A viable shipbuilding business existed for a good part of the 19th century and a thriving retail base grew throughout this period. Other non-ivory-related factories were established, such as the Niland Glass Company, Jennings Auger Bit Company, and the A.J. Smith Company, which manufactured wire goods. Deep River was conveniently located on the Connecticut River and the Middlesex Turnpike, which was established in 1801 and ran through the heart of the village.

Ivoryton, in contrast, was a town that grew almost exclusively because of the ivory industry. The Comstock, Cheney & Company was not part of the town. It was the town. There was no Middlesex Turnpike running through and no competing industries. The town was essentially the vision and creation of one man: Samuel M. Comstock. An article in the September 20, 1899 issue of the *New Era* stated, "if one would know the real history of Ivoryton, he should look up and study the business history of the Comstock, Cheney & Company, for that firm is the Ivoryton of today."

Deep River and Ivoryton have changed greatly since World War II. The factories that dominated their cultures are now only a memory. As time passes, artifacts that remind us of the heyday of the Industrial Revolution locally are slowly being destroyed, forgotten, or absorbed into the electronic revolution. These two villages are more and more becoming residential places, as they offer to the more urban members of our nation an escape to what can be conceived as rural paradises.

The histories of these villages, preserved in photographs, paintings, pamphlets, books, documents, scrapbooks, artifacts, and other resources, are catalogued and stored in the archival troves of the Deep River Historical Society, the Essex Historical Society, the Comstock Cheney Archives Room in the Ivoryton Library, and the Museum of American History at the Smithsonian Institute in Washington, D.C.

—Don Malcarne

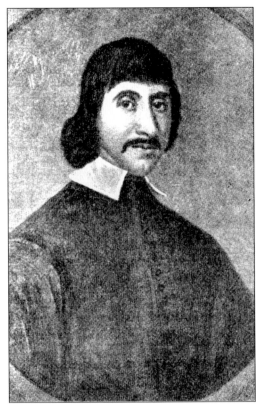

JOHN WINTHROP JR., 1606–1676. John Winthrop Jr. was the son of the governor of the Massachusetts Colony and was appointed by Lord Say, Lord Brook, and other notable persons to establish a colony at the Connecticut River. He was made governor of the Connecticut Colony for one year and established a settlement at Saybrook Point in late 1635. Thereby was born the Saybrook Colony, which encompassed the present towns of Old Saybrook, Old Lyme, Lyme, Essex, Centerbrook, Ivoryton, Deep River, Chester, Winthrop, and Westbrook. Englishmen who had planned to settle this colony, because of the political situation in England, never came because of favorable changes there. The Winthrop section of Deep River and John Winthrop Junior High School—the regional middle school for Essex, Chester, and Deep River—are both named for John Winthrop Jr. Consideration was made to change the school's name during building renovations, but the public insisted the name remain.

One

WE GATHER TOGETHER

The Puritan Church was dominant in the lower Connecticut River Valley from the inception of the Saybrook Colony in 1635 until well into the 19th century. The influence of this Congregational Church ebbed as shipbuilding and shipping exposed many local residents to a world they had never known. This is shown by an 1819 survey, which indicated that leading shipbuilding areas, Essex (Potapoug) and Middletown, were by far the most diverse religiously. By that time, Potapoug, which included Deep River, had firmly established Congregational, Methodist, Baptist, and Episcopalian Societies, but the strict Congregationalists were conspicuous in their absence.

The original Congregational (Puritan) Society in the area was in today's Saybrook Point. People from as far away as Chester were required to attend church there, and due to a lack of population, this situation existed until 1722. At that time, the General Court of Connecticut allowed the formation of the Second Ecclesiastical Society in Potapoug. This church was located in Center Saybrook (as Centerbrook was then known), the most important, and most populous section of that division of Saybrook. The first minister was the Reverend Abraham Nott, who held this position until his death in 1756. He was followed by the Reverends Stephen Holmes, Benjamin Dunning, Richard Ely, and Aaron Hovey, in that order. The Westbrook Congregational Church was the Third Society, and in 1740, the Fourth Society was formed in Chester, effectively creating that town.

About the same time as the Chester Church was starting, a Baptist group arose in Winthrop, one of the first in the Connecticut Colony. Some of these dissenters were arrested and persecuted by civil authorities in 1744. They were jailed for weeks in New London, the county seat. By 1773, these people had erected a church building, which served until 1867, when a former Methodist church structure was moved to Winthrop from Deep River. This is still in use.

By the third decade of the 19th century, Deep River Village was expanding at a fairly rapid rate. As a consequence, a Baptist church was established there in 1829, and shortly thereafter, in 1833, a new Congregational Society was formed. This was an offshoot of the mother church in Centerbrook, paralleling the subdivision of the Congregational churches in the rest of Saybrook Colony. In 1818, the Puritan (Congregational) Church had been ruled against as the official state church. By the middle of the 19th century, the Baptist churches in Deep River and Essex had the greatest number of parishioners.

The number of immigrants moving to the lower valley had a direct effect on the local religious scene. Swedish Congregational and Swedish Lutheran churches were established in Deep River in the 1890s, and the new St. Joseph's Catholic Church was built in Chester, accommodating Catholics from Deep River as well. In the same decade, Our Lady of Sorrows in Essex moved into the former Episcopal church on Prospect Street to serve the growing number of Catholic parishioners in Essex, Centerbrook, and Ivoryton. The Catholic churches still exist as such, but the Swedish Societies have combined in Centerbrook.

As with social and economic growth, what happened in Ivoryton religiously was quite different from that which happened in Deep River. The Comstock family took the lead in establishing the Ivoryton Congregational Church in 1888 as a mission of the Centerbrook Congregational Church. Ten years later, it was made a church on its own, clear of direct ties to the mother church. In 1897, the Swedish Congregational Society was established on West Main Street with a gift of $500 from Comstock, Cheney & Company, and by 1905, St. John's Episcopal Church in Essex, with a $150 donation from the company, had set up a mission in

Ivoryton, known today as All Saints Church. All these churches were formed with encouragement and donations from the company, which operated under a business theory known as welfare capitalism, a paternalistic practice emphasizing benefits for employees outside the workplace to develop company loyalty. This was not always the situation in Deep River with the Pratt, Read & Company.

There is no question that industrial growth in Deep River and Ivoryton led to a diversity of religions. This was in direct contrast to the agricultural towns, where spiritual change was relatively slow. The mere presence of the great ivory factories meant that spiritual diversity would be an order of the day.

—Don Malcarne

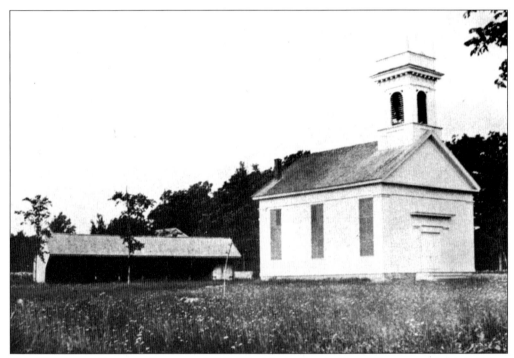

THE WINTHROP BAPTIST CHURCH, 1900. The Methodists in Deep River erected this building in 1858, but membership was not strong after 12 years, and they were forced to disband. The building was sold to the Baptist Church of Winthrop and moved there in 1868, from North Main Street, across from what is now Kirtland Commons. It was known as the Meeting House of the First Baptist Church of Saybrook. The Reverend Fenner B. Dickinson (1840–1886) was rector from 1872 to 1874. The son of Obadiah and Henrietta Shipman Dickinson, he grew up on Kirtland Street, where his father built a house in 1842. He obtained ownership of the Dickinson homestead "at the landing," in 1885. His father, Obadiah Dickinson, was a quarryman and a portrait painter, and his brother, the Reverend Thomas Newton Dickinson, a Baptist minister, founded the Dickinson Witch Hazel Company. (Photograph courtesy of Deep River Historical Society.)

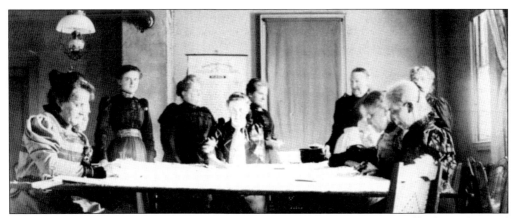

THE LADIES AID SOCIETY, DEEP RIVER BAPTIST CHURCH CHAPEL. Usually the Ladies Aid Society met for quilting bees. The ladies would gather one afternoon each month at a private home to sew and have supper. The minister would stop by to say grace. The sewing society pictured here was held in the church parlor. From left to right are Julia L'Hommedieu, the wife of town clerk, Frederick L'Hommedieu; Mary Lincoln Moore (hidden); Clarissa Glover Rogers; Ella Moore Edmonds; Mrs. Rowland Post, the wife of sea captain David Rowland Post; Mrs. George Arnold; Mrs. George Gardner; Mrs. J. Hamilton Moore; Mrs. Charles Dickinson (standing in corner); Olive Snow; Jane Harrison; and Julia Ann Stevens Moore. The original Deep River Baptist Church was built in 1832. The church itself was formed in 1830 at the house of George Read, with 27 original members. Meetings were initially held in a nearby local schoolhouse. This structure was enlarged in 1845 and renovated in 1864. Another addition was completed in 1881. This late 1800s photograph reflects the prestigious position of the Baptist Church in Deep River at that time. In 1900, membership in this church rose to over 200. (Photograph courtesy of Deep River Historical Society.)

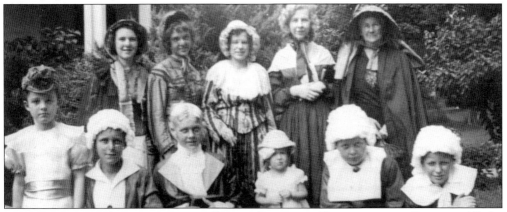

THE DEEP RIVER CONGREGATIONAL FLOAT, SAYBROOK TERCENTENARY PARADE. All the towns within the original colony supported this 1935 celebration of 300 years of the Saybrook Colony. Deep River was still officially known as Saybrook in 1935 and, as a result, all the original land records for the entire area are held in the vault of the Deep River town clerk. From left to right are the following: (front row) unidentified, Brad Johnson, Sumner Ziegra (currently a trustee of the Deep River Historical Society and the director of the Fountain Hill Cemetery Association), Nancy Prann, Albert Ziegra, and Harvey Brooks; (back row) ? Leibert, Lucille Johnson, Nellie Prann (the wife of Wallace, a local printer and publisher, and the mother of Nancy Prann who is also pictured), Cora Nelson, and Mrs. Herb Mather. (Photograph courtesy of Deep River Historical Society.)

THE DEEP RIVER CONGREGATIONAL CHURCH AND CHAPEL. This Congregational Church was formed in late 1833 at the same time the church building was completed. Most of the 49 constituent members had previously worshiped at the Centerbrook Congregational Church. John Platt supplied the land for this church in 1833, and the initial resident pastor was Darius Mead. The second pastor for the church was Zabdiel Ely from Lyme, and the third was Frederick Chapman. By 1900, this organization had 175 members, slightly fewer than its Baptist counterpart. In 1909, the adjacent chapel was sold to the Grange and moved across lots to Lafayette Street. In 1923, the Masons Trinity Lodge purchased it from the Grange. (Photograph courtesy of Deep River Historical Society.)

THE SWEDISH CONGREGATIONAL CHURCH, UNION STREET. The Swedish Congregational church building was completed in 1892. Most of the members from 1890 to 1935 were from Deep River and Ivoryton. From left to right are the following: (first row) Frieda Olsen, Dorothy Ray, Agnes Olsen, Evelyn Olsen, and Constance Ray; (second row) Mrs. Gustav Ostling, Mrs. Carl Anderson, Carl Anderson, Mrs. Ole Olsen, Ole Olsen, Emil Lund, Frank Lund, and John Parsons; (third row) Theodore Lund, Pastor Edwards, Mrs. Edwards, a woman from Haddam Neck, Mrs. Lundgren, Christine Lundgren, Charles Pierson, Gladys Pierson, Mildred Anderson Muggleston, Agnes Olsen, Esther Lund, and Harry Olsen; (fourth row) an unidentified person from Haddam Neck, Ted Johnson, Alfred Johnson, Bruce Bowen, Dorothy Anderson Bowen, Lillian Raynor's niece, Lawrence Lundgren, Lillian Raynor, Fredricka Eleanor Pierson, Helen Parr, and Mrs. Theodore Lund. (Photograph courtesy of Deep River Historical Society.)

THE IVORYTON CONGREGATIONAL
CHURCH. In this view looking east on
Main Street in Ivoryton, the Ivoryton
Congregational Church is on the left,
originally the Comstock Memorial
Chapel. The Comstock Chapel was
essentially under the direction of Harriet
Comstock, daughter of Samuel M.
Comstock. It was formed in 1888 as a
mission of the mother church in
Centerbrook. Its founding was due to the
enormous growth of the Comstock,
Cheney & Company. The company
allowed parishioners building the church
to take as much stone from the former
Comstock & Dickinson property as
needed. Comstock & Griswold had been
the first company on the site that
became Comstock & Dickinson and,
later, the Brackett Shop of Comstock,
Cheney & Company. Comstock &
Dickinson manufactured ivory products
but only lasted for part of the 1850s.
There are three Congregational churches
in the town of Essex. (Photograph
courtesy of Tom Schroeder.)

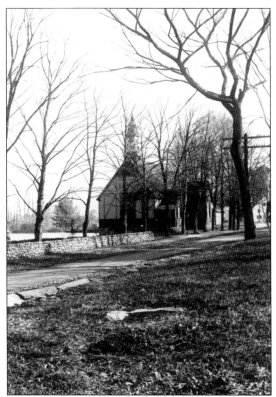

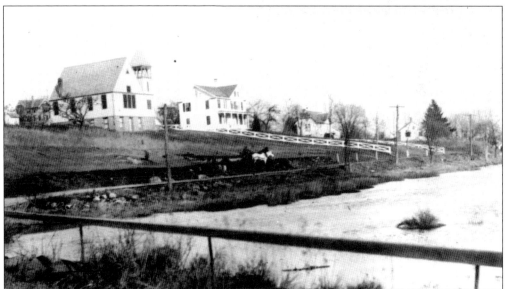

THE SWEDISH MISSION IN IVORYTON. This church resulted from the growing number of
Swedish settlers in Ivoryton. It was constructed in 1897 and originally shared a pastor with the
Swedish Mission in Deep River. Before this church was built, services were held in private
homes. The local Swedish denominations combined into a single church, which still stands
along the Falls River in Centerbrook. The above structure is now a private home. (Photograph
courtesy of Ivoryton Library Association.)

ALL SAINTS EPISCOPAL CHURCH AND ITS REFLECTION IN IVORYTON LAKE ACROSS THE ROAD. This church was established in 1905 as a mission of St. John's Episcopal Church in Essex Village. It has been an important cog in the spiritual life of Ivoryton ever since. The diversification of churches in Ivoryton at the beginning of the 20th century was evidence of the expanding ivory factory workforce. A Catholic church was never founded in Ivoryton or Deep River, but Essex and Chester, adjacent villages, both set up Catholic churches. St. John's Episcopal Church was the first non-Congregational group to be established in Essex when it was founded in 1790 on the site of the current Essex Steam Train. (Photograph courtesy of Ivoryton Library Association.)

14

Two

THE LANDING

The influence of the Great River (as the Connecticut River was once known) moved Deep River from a place that had been agriculturally and spiritually oriented to one that would be dominated by economics. At the end of the Revolutionary War, ships were needed to carry on trading, both on a national and an international scale. The towns of the lower Connecticut River Valley were suited to build these wooden sailing vessels, and Deep River became well known in shipbuilding. Only 20 houses existed in Deep River prior to 1825, but that changed quickly as the town grew along the waterfront.

The first ship built here was a 40-ton sloop named *Hannah*, completed in 1793 by Nathan and Job Southworth. This was followed, in 1794, with the 119-ton brig *Rowena*, built by the same family, and so it went for almost 70 years, as more than 60 vessels of all types slid "down the ways." Shipbuilding was a truly Yankee exercise and symbolized this group's emergence from the old puritanical way of living. In this early entrepreneurial exercise, the family and family ties were vital. The daughter of Nathan Southworth, Eunice, married sea captain Calvin Williams from Potapoug Point (Essex). He was the son of shipbuilder Samuel Williams, whose various business operations were located at the mouth of the Falls River. The marriage of Calvin Williams and Eunice Southworth bound together two families active in the construction of ships. Williams moved to Deep River, then part of Potapoug, built one of the most significant houses in the lower valley on the waterfront, and essentially, started a "villagette," which exists to this day. This cluster of houses, formed in a roughly triangular manner, exists from Phelps Lane to the riverfront on both Kirtland and River Streets. Sea captains, shipbuilders, and others involved in maritime pursuits built and settled here. The captains included John Saunders, Joseph and Justus Arnold, and Stillman Tiley, to name a few.

Williams's home, built in 1826, was the stone structure on Kirtland Street that dominated this area. Upon his death in August 1833, his inventory listed one of his possessions as being a marine railway. This was very early for a railway that facilitated the launching and repair of ships, but it did indicate the prominence of this area in the building of ships. Calvin Williams also owned more than 100 acres of land between Kirtland Street and Saw Mill Cove to the north. In the 1850s, Stillman Tiley built the Wahginnicutt House, an inn overlooking the river on Kirtland Rocks, and John Lane had a store on a waterfront pier. Under the direction of Thomas and Eli Denison, the Denison family operated perhaps the most famous of the local shipyards. Eli Denison lived in a home on Phelps Lane that overlooked his building yard which ran to the waterfront. However, change is always constant, and with the end of the Civil War, the era of the commercial wooden sailing ship was over. One of Denison's final ships was the 181-ton schooner *William Vail*, built in 1866, which has become an official symbol of Deep River. About the time of this vessel's construction, plans for another mode of transportation were well under way.

Steamships had plied the Connecticut River since 1823, with Deep River being a regular stop. These ships generally ran from Hartford to New York City and continued in operation, with varying degrees of commercial success, until 1931. In 1870, construction of the Connecticut Valley Railroad began. The railroad ran through the waterfront, displacing Lane's Store and the Denison Shipyard, among other places, and literally eliminated shipbuilding. The Industrial Revolution had reached the Deep River waterfront, and things would never be the same. Eli Denison was soon forced into bankruptcy, and a wire goods factory, operated by Joseph A. Smith, was built on part of his shipyard. Waterpower was no longer required to power

** Samuel Williams built 25 River Rd Essex his son Ezra purchased it in 1806*

a shop, as steam engines had come into vogue, thereby allowing for the placement of factories virtually anywhere. In the case of Smith, the prominence of the railroad must have been foremost in his thinking. John Lane was able to build a new store behind the Wahginnicutt House, but the area had been irreversibly altered. The hotel later became the home and office of Dr. William Tate. Ironically, the Connecticut Valley Railroad was never that successful, and it soon became part of the New York, New Haven & Hartford line.

Eli Denison built three steam-powered vessels in his yard. The tugboat *Amos Clark* was built in 1852, the 73-ton *Henry B. Beach*, a steam propeller ship, was constructed in 1853, and the 247-ton *Scorpio*, a side-paddle wheeler, was launched in 1865. These attempts at modernization were of little avail. Another symbol of the impending cultural change was Obadiah Dickinson's move to this area in 1842, when he built a new dwelling on Kirtland Street immediately west of John Lane's home. Dickinson was the premier portrait painter in Middlesex County, thereby making him, for all practical purposes, the only non-nautical personality there. His paintings are historically significant locally and remain valuable.

The artifacts of Deep River's seafaring past, as represented by homes, fortunately remain. They were saved by an economic movement from the banks of the river to the center of town, due to the rise of the most significant industry in the history of the lower Connecticut River Valley, the manufacture of ivory goods and piano-related items. The riverfront was virtually forgotten and has not been smitten by economic growth since the glory years. Mount Saint John School was built on a hill behind the home of Calvin Williams in 1906 on what was once his land. The railroad was revived as a tourist attraction, pleasure craft marinas were built, and the waterfront came alive once more. A section of the waterfront was rebuilt for public use and parking, with a gazebo and tourist riverboats. Tourism has replaced the old Yankee preindustrial era of shipbuilding.

—Don Malcarne

THE DEEP RIVER WATERFRONT. This 1906 postcard shows the Deep River waterfront in a rather depleted condition. After the failure of the shipbuilding industry, the economic interest of Deep River focused on the manufacture of ivory products and piano parts. With the growing importance of a nation-wide railway system, fewer ships handled merchandise and the waterfront became less significant. In fact, the Deep River railway freight station was located right on this waterfront in direct competition. Note, in the upper background, the ongoing construction of Mount Saint John School, located on land once owned by the Calvin Williams family.

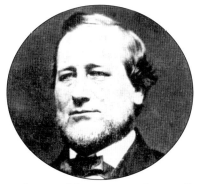 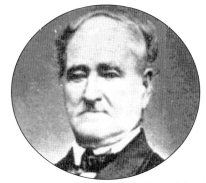

CAPTS. SAMUEL MATHER AND JOSEPH ROWLAND POST. The large Egyptian-style marble obelisk in Fountain Hill Cemetery features an engraving of the clipper ship *Nightingale* and verifies the position of Samuel Mather (left) as an important mariner and a leading citizen of the town. Joseph Post (right) was also one of the leading sea captains in the Connecticut River valley. He was one of the founders of Hills Academy, a private school in Essex, in 1832. He lived in one of the most prestigious houses in that town. His home was located on West Avenue, across from the current town hall. Post subsequently moved to Deep River and was instrumental in establishing the Deep River Savings Bank.(Photographs courtesy of Deep River Historical Society.)

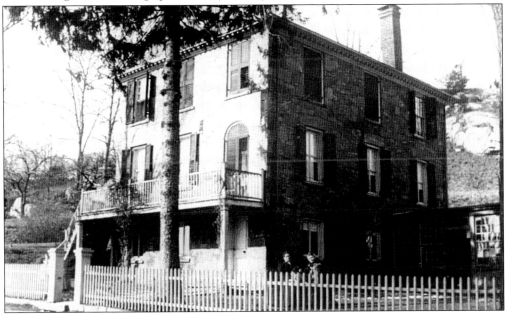

CAPT. CALVIN WILLIAMS'S HOMESTEAD. Capt. Calvin Williams built the stone house, constructed in the Federal-Greek style in 1826, and it was the epitome of style and luxury in this period. Williams died in 1833, at the age of 47, leaving a 120-acre estate. His widow, Eunice Williams, was part owner of the sloop *Deep River*, built in 1839. Williams was the son of shipbuilder Samuel Williams and the grandson of Capt. Benjamin Williams, the smithy who forged the iron for the *Oliver Cromwell*, the first warship built for the Colony of Connecticut. The mason for the Williams house was probably Capt. Ambrose Post, the same man who built a similar homestead in Essex Borough and the Champlin-Hayden Vault in the Grove Hill Cemetery in Essex. The cemetery, like the Williams homestead, is a great artifact of the Connecticut River Valley because it is symbolic of the fall of a shipbuilding culture. (Photograph courtesy of Deep River Historical Society.)

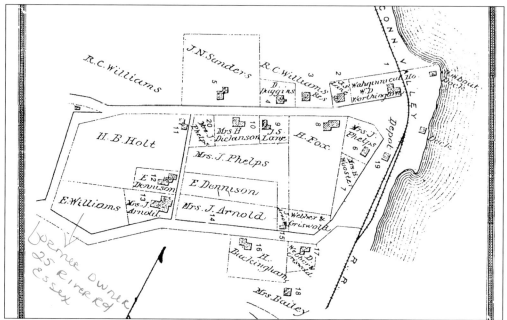

A MAP OF THE LANDING AT DEEP RIVER VILLAGE. This 1874 Beers & Company map indicates the prominence of the Connecticut Valley Railroad, which dominated the waterfront. What is today Kirtland Street runs east to west near the top of this drawing, and River Street can be seen at the bottom. They both meet at the waterfront. The lot marked No.12 was the home of Eli Denison. His shipyard ran from his home to the waterfront. The general failure of shipbuilding led to bankruptcy for Denison and the division and development of his property for the railroad. The location of the Wahginnicutt House Hotel, on Kirtland Rocks, is indicated in the northeast part of this map. This section of Deep River was dominated for years by sea captains and mariners. The Connecticut Valley Railroad installed tracks in 1870, signifying the downfall of the wooden shipbuilding industry. Fortunately, most of the great buildings remain today as a reminder that wooden sailing vessels were constructed here. (Photograph courtesy of Deep River Historical Society.)

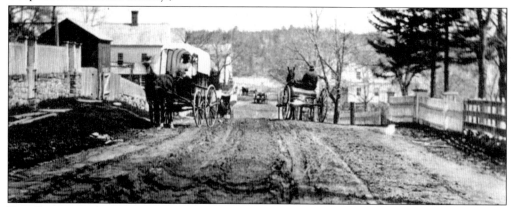

THE ROAD TO THE WATERFRONT. This 1868 photograph shows what is today Kirtland Street. This thoroughfare ended at Kirtland Rocks, at the riverfront. This road was originally Old River Street, effectively connecting the Middlesex Turnpike to the Great River. The stone wall on the left is in front of the John Saunders place. In the far center can be seen the Wahginnicutt House, a hotel built by Stillman Tiley in 1853. (Photograph courtesy of Deep River Historical Society.)

18

Capt. John Saunders and the Saunders Homestead. Capt. John Saunders purchased half an acre of land in 1840, from Eunice Williams, the widow of Capt. Calvin Williams, reflecting the methodical breakup of that estate. Saunders built his five-bay, central chimney house in an area that was soon to be dominated by the homes of sea captains. This house has touches of Greek revival in keeping with the style of the time. The house remained in the Saunders-Arnold families from the time of its construction to 1951. Its center chimney construction is not consistent with the central hallway houses that were built during this period. At this time there were several houses with the same center chimney construction in this satellite waterfront community. Saunders was master of several vessels and constructed others, such as the *Thomas Denison* and the *Charles Carroll*. (Photograph courtesy of Jeffrey & Linda Hostetler.)

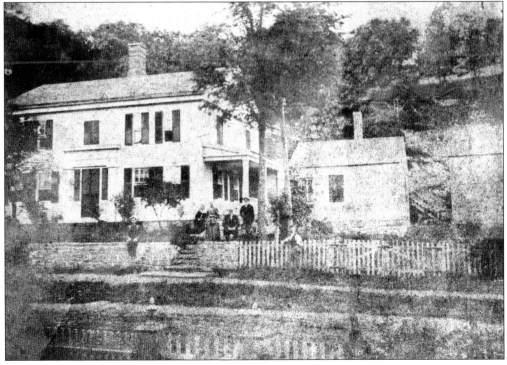

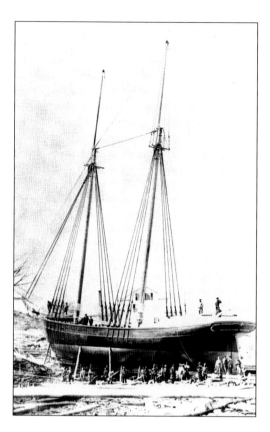

THE SCHOONER WILLIAM VAIL. This 181-ton schooner, built in 1866 in the Eli Denison Shipyard, was one of the last vessels constructed in Deep River. The Eli Denison yard (below) was partially taken over by the Connecticut Valley Railroad and the J.A. Smith Manufacturing Company in the 1870s and 1880s. The Deep River shipyards produced 67 vessels from 1794 to 1882, a significant number when compared with other valley towns such as Haddam and Lyme. By comparison, East Haddam, Essex, and Middletown produced as many as 600 ships each during this period. Eli Denison built a home in 1851, on what is today Phelps Lane. This two-story dwelling overlooked his shipbuilding empire and saw the construction of many sailing ships, including the *Henry B. Beach* (a steam propeller vessel), the *Scorpio* (a 247-ton steam side-paddle wheeler), and the 593-ton bark *Atlanta* (built for New York investors and the Atlantic Navigation Company). The last ship of consequence built here was the 155-ton schooner *Lizzie Evans*, completed in 1868. (Photograph courtesy of Deep River Historical Society.)

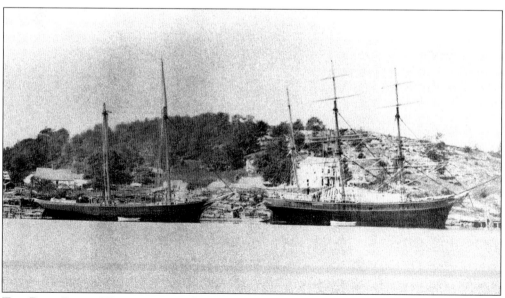

THE DEEP RIVER WATERFRONT. This *c.* 1900 photograph shows the Deep River waterfront. The Wahginnicutt House can be seen behind the ship on the right.

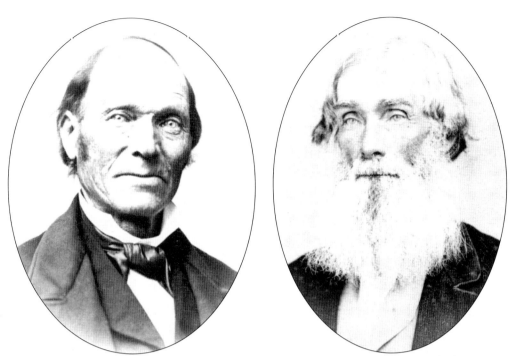

SHIPBUILDERS THOMAS AND ELI DENISON AND THEIR SHIPYARD. Thomas and Eli Denison built famous ships such as the *Theodore Raymond*, a 363-ton schooner in 1854, the *William Hunter*, a 299-ton schooner in 1859, and the *Woodland*, a 453-ton brig in 1862. Eli Denison's two-story, five-bay house still stands on Phelps Lane. It overlooked his shipyard, which ran to the river. The Denisons were the master builders for varied consortiums. The Industrial Revolution spelled the end of wooden shipbuilding. The world of interchangeable parts replaced an era when artifacts were custom built. A treeless Eustacia Island is seen in the background of the photographs below. (Photographs courtesy of Connecticut River Museum.)

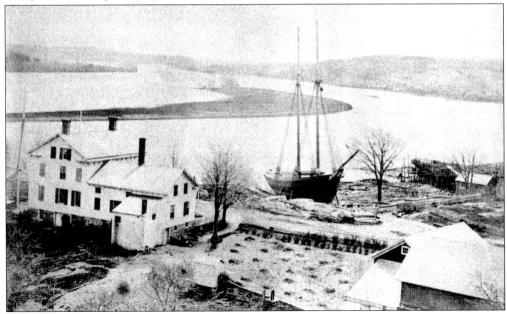

Capt. Justus Arnold and His Homestead. This relatively small house is located on River Street and was constructed by Justus Arnold in 1869. Ezra S. Williams sold him a small parcel of land for $35 and Justus built this place for about $500. The property was described at this time as being on the south branch of the road from Deep River Village to the landing. Then, 10 years later, it was referred to as land and buildings "near the railroad station." In 1909, Ann Arnold sold this property to the Russell Jennings Meeting House Fund of Saybrook. Capt. Justus Arnold (1817–1907) lived in the Deep River waterfront community, as did his brother Joseph Arnold, who was involved in the construction and ownership of the *Gertrude*, a 75-ton schooner. Arnold was master of the ship *Luna*, built in Deep River. Justus Arnold married Theresa Shipman in 1844. The Arnold homestead still stands on River Street. (Photograph courtesy of Deep River Historical Society.)

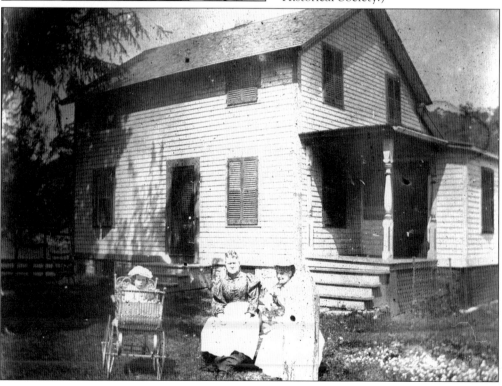

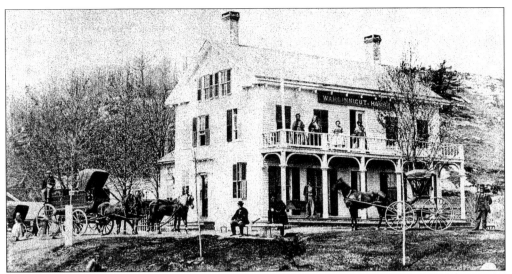

THE WAHGINNICUTT HOUSE. This was a hotel for many years. It was constructed *c.* 1854 by Stillman Tiley and accommodated about two dozen people. Subsequently, William Worthington and his family owned it. In the late 1930s, it was purchased by Dr. William Tate and has since served as the Tate family's homestead. The rear section of this building was Tate's office. A building of this nature built here in the middle of the 19th century attests to the importance of this waterfront location at that time. (Photograph courtesy of Deep River Historical Society.)

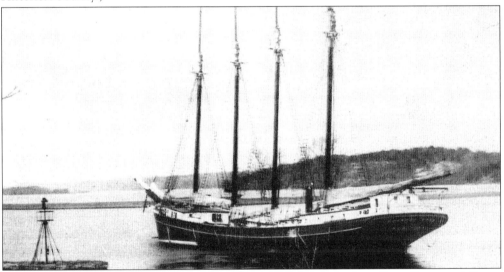

THE SCHOONER *FRANCIS HYDE.* Various types of ships were built in Deep River and Essex, including barks, brigs, brigantines, ships, scows, and schooners. Schooners represented the largest number produced for good reason. The majority of ships manufactured were designed for either coastal or West Indies trading, and the schooner was best suited for this type of activity. Sailing in these waters was not as demanding as transatlantic cruising, so schooners generally carried a smaller crew than the square-riggers, making them more financially feasible. As with all ships built locally in the 18th and 19th centuries, the *Francis Hyde* was built to specification. The idea of interchangeable production was still only a dream. (Photograph courtesy of Deep River Historical Society.)

THE JOHN LANE STORE. John Lane originally had a store on the waterfront where goods could be directly accepted from both steamboats and sailing ships. From 1823 to 1931, Deep River was a regular stop on the steamboat lines. Lane's store was located south of Calvin Williams's marine railway, and in 1870, the Connecticut Valley Railroad displaced it. He built a new store just west of the Wahginnicutt House and diagonally across from his dwelling. The store is a homestead today, adjacent to the stone entry posts to Mount Saint John School. This 1898 photograph shows John Lane at age 82 in front of his store. (Photograph courtesy of Deep River Historical Society.)

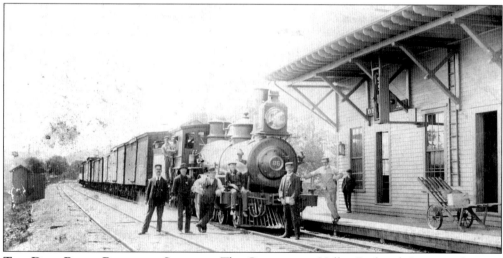

THE DEEP RIVER RAILROAD STATION. The Connecticut Valley Railroad Company became active in 1870 and transported people and freight from the main line in Saybrook to Hartford. It followed the riverfront, except from southern Deep River through Essex, where it veered through Centerbrook toward Old Saybrook. Deep River had two terminal buildings. The railroad was never a financial success. It became the New York, New Haven & Hartford line and finally the Penn Central. Today, the Valley Steam Train operates the railroad as a tourist attraction from Haddam to Essex and carries over 150,000 passengers per year, far more than ever before. (Photograph courtesy of Deep River Historical Society.)

Three

A MAN WITH A VISION

Ivoryton is a village born of the vision of one man, Samuel Merritt Comstock. Before Comstock was born in 1809, few people lived in the area known as West Centerbrook. At that time there were no more than a dozen houses within the land limits of today's Ivoryton, including the Capt. Edward Bull Homestead, on East Main Street; the Jonathan Parker and Andrew Clark Houses, on Walnut Street; and the Christopher Clark II House, on West Main Street—all of which are still standing. Agricultural pursuits, especially the cutting and processing of lumber, were the primary ways of making a living.

There were two dams on the Falls River. One was behind the Bull House, aptly called the Bull Dam, which alternately powered a gristmill, sawmill, and fulling mill. Farther upstream, the Clark family had a dam and sawmill near the intersection of West Main and Walnut Streets. By 1848, Samuel Comstock had taken control of both these dams to power his fledgling ivory shops.

The Beers 1884 *History of Middlesex County* states that "the village of Ivoryton, which a few years ago was almost a wilderness, is now one of the most beautiful villages in the state, and this has been accomplished mainly through Comstock's efforts." In 1834, Comstock went into business with Edwin Griswold immediately east of the Bull Dam, which supplied the power for their shop. The two entrepreneurs initially manufactured screwdrivers. After a very short time, however, they went into the production of ivory combs. Within a few years, this section on the east side of Ivoryton grew noticeably and became known as Whitesboro. By 1847, Comstock & Griswold broke up and Comstock bought a great deal of land adjacent to his boyhood home, one of the pre-1800 houses in Ivoryton, located slightly west of what is now the Tavern at the Inn. Comstock purchased the water privilege of the Clark Dam, moved that dam east a few hundred yards (opposite the homestead), and formed S.M. Comstock Company to manufacture ivory goods. These moves in the late 1840s essentially represent the start of the village of Ivoryton as it stands today.

Comstock's new business was reasonably successful but lacked capital to expand. In 1862, this problem was solved when ivory importer and salesman George A. Cheney, originally from Salem, New Hampshire, invested $4,500 with Comstock's firm. Out of this union was born the Comstock, Cheney & Company, which became the dominant economic and social force in the entire town of Essex, and perhaps the lower valley, for the next 90 years. Cheney was 20 years younger than Comstock and represented a more modern and broader economic outlook than his partner. Whatever the case, this firm was a tremendous success and it expanded accordingly.

Beers wrote of Comstock: "to his inventive and mechanical genius, Mr. Comstock united rare business qualifications, seldom found in any one man . . . He was large hearted, liberal, and generous." Comstock, Cheney & Company was firmly under the leadership of Samuel Comstock until his death in 1878. Cheney was in charge of a second firm owned by Comstock, known as the Centerbrook Manufacturing Company, as well as operating in the office at the ivory firm. The workforce was only slightly over 100 at the time of Comstock's death, and the large upper shop, where piano keyboards and actions were to be manufactured, had only recently been erected.

Under the leadership of George Cheney, the firm grew precipitously and came to be one of the two dominant forces in the manufacture of ivory-related products in the country. The rival plant was Pratt, Read & Company in Deep River. Cheney instituted many changes, both in the physical makeup of the factory, and in the workforce. During his era, from 1878 to 1900, the

company commenced building homes for workers. The Wheel Club was founded, as was the Ivoryton Library, and the recruitment of immigrants began. The upper factory was greatly enlarged, due to the increased demand for piano actions. These and similar actions were part of an industrial process known as welfare capitalism, which was prevalent throughout the eastern states. It sought to maintain the worker's loyalty by providing services above and beyond the immediate workplace, especially in a marketplace that was broadening. In order to do this effectively, the factory dominated the area in which it was located.

Samuel Comstock's idea was to build a village around his factory. George Cheney merely had to expand on the original visions of Comstock to maintain control of the workplace. By the end of the Cheney era, immediately after the start of the 20th century, Comstock, Cheney & Company was employing over 500 people at peak periods and business was still growing.

The next president was Comstock's son, Robert H. Comstock. He and his brother, Archibald W. Comstock, ran the factory well into the period of the Great Depression. Under their leadership, the concepts of Cheney were further expanded. In a very beneficial move, they supplied most of the funds for a new Ivoryton Grammar School, while their sister Elizabeth Northrup provided the land for this building, which stood where the Ivoryton Green is located today. In October 1910, a committee of three directors of the Comstock, Cheney & Company, including Robert Comstock, decided the company meeting hall, located over Rose Brothers Store, was inadequate and a new meeting place was endorsed. An architect was chosen and within a few months Comstock Cheney Hall was opened. Known as the Ivoryton Playhouse since 1931, it was sold in 1938 to Milton Stiefel, manager of the Ivoryton Players.

Comstock, Cheney & Company had a directed focus in forming a viable, self-contained, working community built around the factory. Ivoryton was truly a company town for almost 100 years and the focus of affluence and influence during this period. A review of the tax receipts for Essex consistently indicates that the village of Ivoryton, especially the factory complex, was paying up to 65 percent of the town's taxes during the period between the Civil War and World War II.

—Don Malcarne

S. M. COMSTOCK & CO.,
CENTER BROOK, CONN.,
MANUFACTURERS OF
IVORY COMBS,
IVORY TABLETS,
Ivory Tooth-Picks and Toy Combs,

THE S.M. COMSTOCK COMPANY COMB LABEL. The S.M. Comstock Company, founded in 1847, was the successor of Comstock & Griswold Company, which had manufactured combs since 1834. The reason for the dissolution of Comstock & Griswold was the departure of Edwin Griswold, Comstock's partner, to work for his brother, A.W. Griswold, who also manufactured ivory combs on the Falls River, but two miles downstream, in Essex Village. By the early part of the 19th century, shipping from Africa had progressed to such an extent that ivory was available on a consistent basis. Combs and toiletries represented a great part of early ivory production. (Photograph courtesy of Deep River Historical Society.)

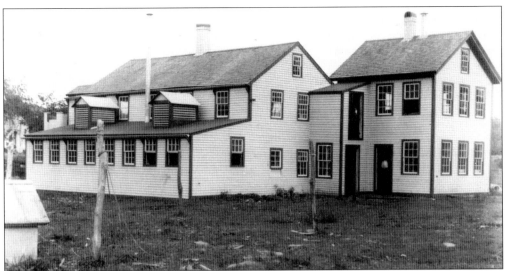

THE FIRST S.M. COMSTOCK COMPANY FACTORY SHOP, C. 1890. Built in 1847, this building was later part of the ivory shop. It was the first shop built by Samuel M. Comstock after the breakup of Comstock & Griswold. It was built about three-quarters of a mile up the Falls River from the Comstock & Griswold factory and represented the start of Comstock's vision of Ivoryton. Combs and toothpicks were almost exclusively the original products of this place, which was powered by water from the Falls River, backed up by a new dam Comstock had built almost directly across from his boyhood home, on what is now West Main Street. The dam was severely damaged in the flood of June 1982 and was never rebuilt, but this building is still standing. (Photograph courtesy of Connecticut River Museum.)

THE ORIGINAL HOMESTEAD OF SAMUEL MERRITT COMSTOCK. The two-story, five-bay, central chimney house (left) was built by Comstock's father (also Samuel) c. 1795. The elder Comstock was a part-time mariner, master of the sloop *Union*, built in Essex in 1797, and the sloop *William*, an 1801 Essex ship involved in the West Indies trade. The younger Samuel was born here on August 14, 1809, the ninth of ten children. This was one of fewer than a dozen houses in this section of Potapoug, which was once the name for an area that encompassed Essex, Deep River, Chester, Winthrop, Ivoryton, and Centerbrook. Samuel Comstock established his second factory, S.M. Comstock Company, directly across the street from this house. He purchased a great deal of land and created his factory town, with his boyhood home serving as a base. (Photograph courtesy of Jane Fuller.)

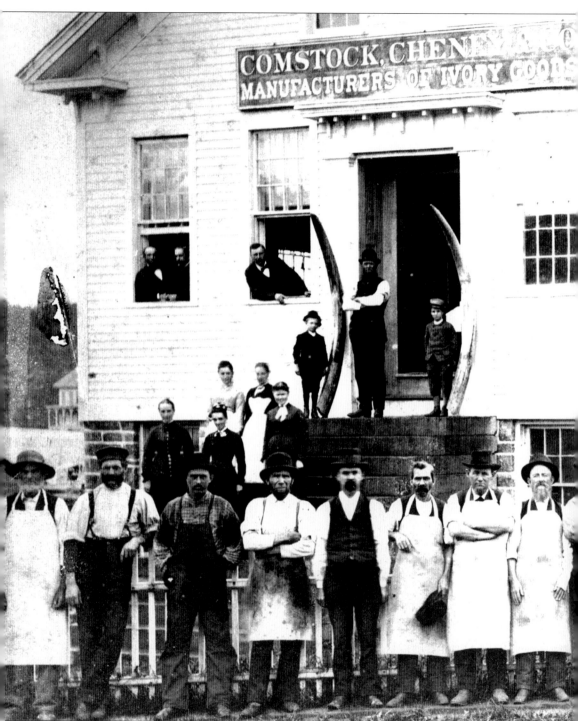

THE IVORY SHOP, ACROSS FROM THE IVORYTON INN. With the employees of the ivory shop shown in front, looking out the window at the southeast (left) corner of the building are supposedly, from left to right, George A. Cheney and Samuel M. Comstock. This dates this picture to prior to 1878, for Comstock died in Wilmington, North Carolina, on January 6,

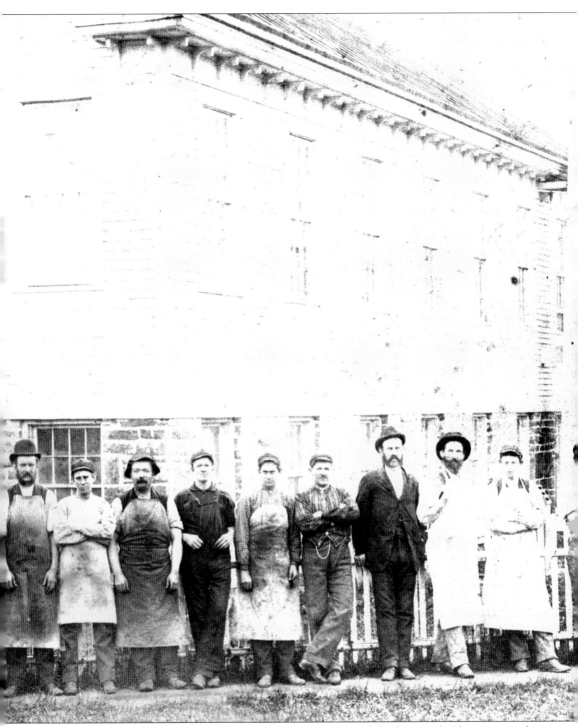

1878. At the time of this photograph, Comstock was president of the firm, with Cheney second in command. From 1878 through the end of the century, George Cheney was president. Women constituted an important part of the workforce at the Comstock, Cheney & Company. (Photograph courtesy of Ivoryton Library.)

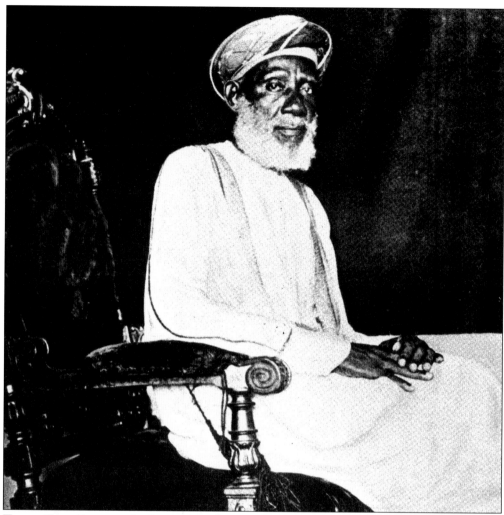

TIPPO TIB, ZANZIBAR'S INFAMOUS IVORY CZAR. Ambitious, shrewd, ruthless, witty, charming, and immensely successful, Tippo Tib was responsible, possibly more than any other individual, for producing the great quantity of raw ivory tusks transported to the factories of Ivoryton and Deep River. His expeditions into the interior of the continent continued over a 15-year period in the latter half of the 19th century. These forays required hundreds of locally captured or bought slaves to transport the ivory to the coast and were financed by the Arab business community of Zanzibar. The blessing of Zanzibar's Sultan, who controlled the coastal access, was another essential factor. Tippo Tib's friendships with the legendary western explorers—whose sentiments tended to be antislavery—at times approached veneration on his part. Among these were David Livingstone, Henry M. Stanley, Cameron, and the German explorer Wissman. These men were there to "discover" Africa's interior, virtually unknown to the Western world. However, the continent's foreboding heartland was already known only too well by the Arab traders, such as Tippo Tib, resulting from their years of pillaging the countryside. In addition to this knowledge of the geography and populations, Arab material support also was needed to mount the large caravans of exploration. It was largely because of Arab traders that Lake Victoria, Lake Albert, and Victoria Falls were discovered, that Cameron could become the first Westerner to cross the continent, and that Stanley was able to find Livingstone.

30

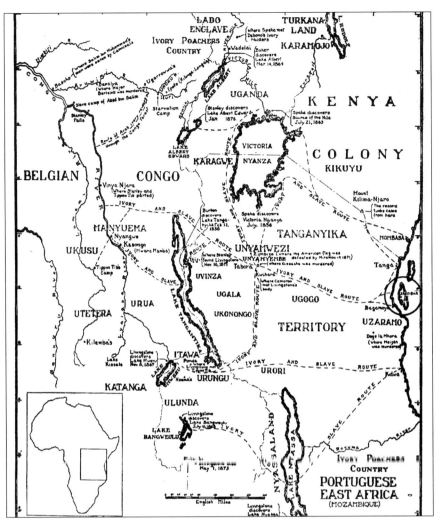

ARAB TRAILS OF EXPLOITATION AND DISCOVERY. Zanzibar (circled at right) lies roughly halfway between the Cape of Good Hope, Africa's southernmost point, and Cairo to the north. Located 20 miles off of the east coast, the island is readily accessible by both small coastal Arab dhows and seagoing ships. Zanzibar was the region's international trading center until the early 20th century. With the Royal Navy's antislavery patrols more active along the west coast of Africa and with the Arabs comfortably embracing slavery, the ivory trade had shifted to the east coast by the middle of the 19th century. The last formative stages of colonialism were at play in Africa during the latter part of the 1800s. Germany recognized Africa as the greatest piece of unclaimed real estate anywhere in the world, and acquired, with the complicity of the British, what is today Tanzania. Other modern states whose borders are at least in part holdovers from colonial times include Uganda, Burundi, Kenya, and Congo. Having been a British protectorate for over half a century, Zanzibar became the separate state of Tanzania in 1964. By the beginning of the 20th century, with their African possessions in place, the colonial nations, such as Britain and Germany, no longer needed the Arabs or the Sultan of Zanzibar, and licensed their own nationals to harvest the big game. The large ivory-poaching caravans were supplanted by smaller hunting parties, such as those in Kenya, where the last of the big tuskers were still roaming the bush. Legendary white hunters now hosted highly visible international sportsmen such as Theodore Roosevelt and later Winston Guest.

31

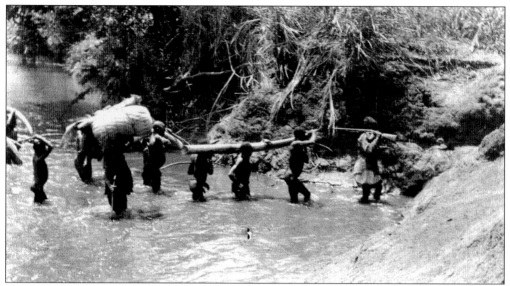

IVORY LEAVING THE HEART OF AFRICA. A heavy price was paid by humans and elephants alike. The great explorer Henry M. Stanley said that each elephant tusk that was brought to the coast cost at least one human life en route. Upon reaching the end of the trail near Zanzibar, those men and women still surviving were usually sold into slavery for Middle Eastern and Asian markets. (Photograph courtesy of Richard Moore.)

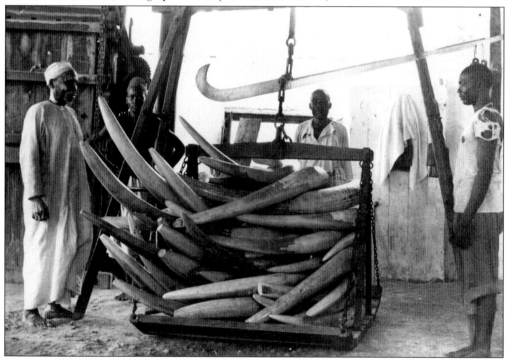

IVORY AT A MARKET IN ZANZIBAR. The once vast herds of elephants were rapidly depleted, a fact of little concern to or comprehension by the Western world. By the beginning of the 20th century, the numerous big tusks of the preceding decades had become a thing of the past. (Photograph courtesy of Richard Moore.)

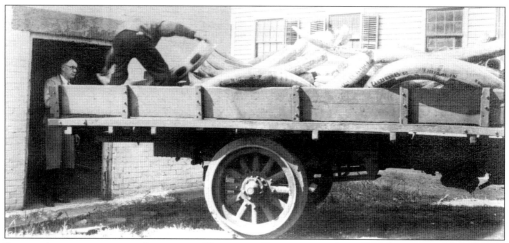

IVORY ARRIVING AT THE IVORYTON FACTORY. First, it came from Zanzibar to North America via Salem, Massachusetts, and other ports. Smaller coastal packets that could breach the shoals at the mouth of the Connecticut River then docked at Essex and Deep River. Later, the raw ivory often arrived by the new railroad. The tracks were laid not through Essex but through Centerbrook in order to better accommodate the factory. Here, the valuable tusks are being unloaded for storage in the vault at Comstock, Cheney & Company. (Photograph courtesy of Charlotte Comstock.)

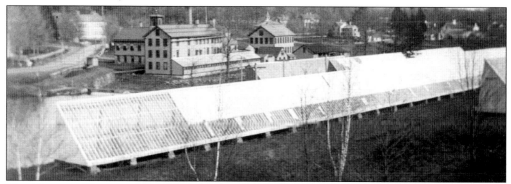

THE BLEACH HOUSES. The demand for a piano in the parlor of every respectable Victorian home kept Deep River and Ivoryton plants working to capacity. First, the thin, rectangular piano keys had to be carefully cut from the irregular round tusks. Then, they were soaked in a bleaching solution, such as hydrogen peroxide, and laid out in rows in the greenhouselike bleach houses. There, they were exposed to the sun for two weeks or so, depending on the season. At one time these buildings, which could be up to 300 feet long, covered the hill between West Main Street and Comstock Avenue behind the ivory shop, which is visible in the background. The last remaining bleach house in America has been reconstructed by Bill Nickse and Joe Miezejeski for the Deep River Historical Society. This section of bleach house was purchased from Pratt, Read & Company in 1920 by Joseph Suda to be used as a hothouse for his vegetables and flowers. It was discovered by David Shayt from the Smithsonian, who suggested that it be moved to the grounds of the Deep River Historical Society. During the move it collapsed, and it remained in that state until 1998, when Nickse and Miezejeski began restoration as part of the program The Towns That Elephants Built, a series sponsored by the Ivoryton and Deep River Libraries on the history of the ivory trade. It now stands in the rear of the Stone House property on Main Street in Deep River. (Photograph from Peter Comstock postcard collection, courtesy of Hanford Johnson.)

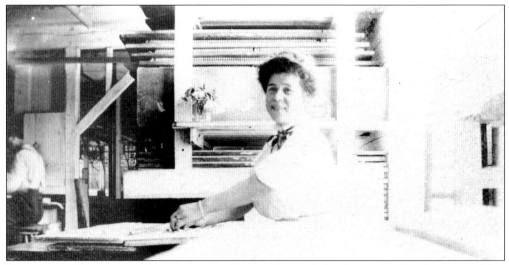

THE IVORY-MATCHING DEPARTMENT. Emma Chrystal is shown in the ivory-matching department at Comstock, Cheney & Company. Ivory went through rather elaborate and highly specialized steps from raw material to finished veneer for piano keys. Women played a significant role in this process, especially in the ivory shop, and represented a notable percentage of the total employment at the large factories in Deep River and Ivoryton. (Photograph courtesy of Tom Schroeder.)

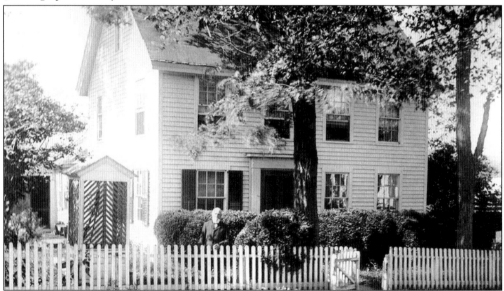

THE JOSEPH COMSTOCK HOUSE. Joseph Comstock, an older brother of Samuel M. Comstock, occupied this c. 1840 house on Mares Hill Road prior to 1850. Joseph Comstock was actively involved in the ivory business, occasionally with his brother. This section of Mares Hill Road became Walnut Street at the beginning of the 20th century. Housing was being built here at a rapid rate due to the expansion of business at Comstock, Cheney & Company. The Griswold family owned this home after Comstock, and Samuel Griswold became a well-known local schoolteacher, starting a private academy on Grove Street in Essex in 1855. A descendant of his (also Samuel Griswold) purchased a home in Essex in 1912 that was eventually given to the Essex Historical Society and is now Pratt House. (Photograph courtesy of Tom Schroeder.)

Comstock, Cheney & Co.
Manufacturers of
Ivory Goods, Piano Forte Keys, Action &c
Ivoryton, Conn March 20, 1929

Mr. Esli C. Leavenworth,

 Ivoryton

 Conn.

Dear Sir:-

 Wishing to show our appreciation of your long and continuous service with us, we are enclosing a check for $100.00. You have completed over fifty years of service with this Company and fifty years is a long time to serve. That service has been distinguished by a steady loyalty and unfailing zeal, and I especially want to congratulate you, as we have worked together all of this time.

 Yours truly,
 The Comstock, Cheney & Co.

A HALF CENTURY OF SERVICE TO COMSTOCK, CHENEY & COMPANY. Esli C. Leavenworth lived in the west section of Ivoryton past the upper factory at the foot of Bushy Hill. Robert H. Comstock was a son of Samuel M. Comstock and the third president of Comstock, Cheney & Company. This $100 gift was noteworthy since the company was starting to lose money rather severely. This letter was written in March 1929, seven months before the crash on Wall Street. (Photograph courtesy of May Sterling Rutty.)

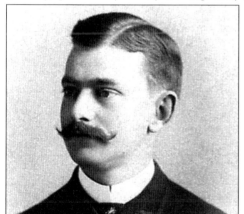
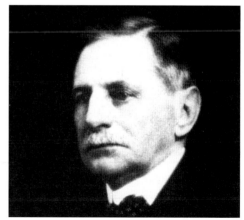

A.W. COMSTOCK AND R.H. COMSTOCK. Sons of Samuel Merritt Comstock, both men were active in the firm of Comstock, Cheney & Company. Robert H. Comstock (right) was the third president of the firm, having succeeded George A. Cheney. He passed away in the early 1930s, just prior to the time of the firm's consolidation with Pratt, Read & Company in 1936. A.W. Comstock (left) was also an executive with the company and, in 1936, became president of the Ivoryton Realty Company, formed to sell off the non-factory assets of the old Comstock, Cheney & Company. His home is now the Copper Beech Inn. (Photographs courtesy Harwood Comstock.)

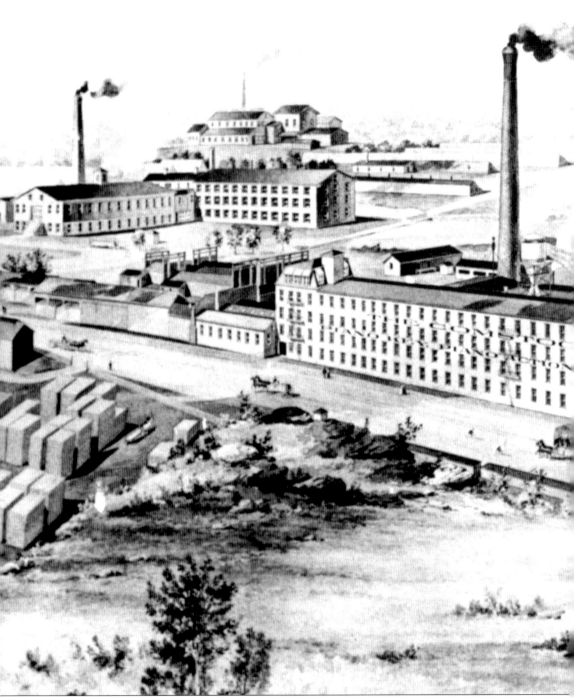

A Drawing of the Comstock, Cheney & Company. This lithograph of the Comstock, Cheney & Company, used for advertising purposes, completely glorifies the entire operation. The office is shown in the foreground, with the large upper shop behind it. The lower, or ivory, shop is to the far left, and the Bracket Shop is on a hill in the background. Actually, this last

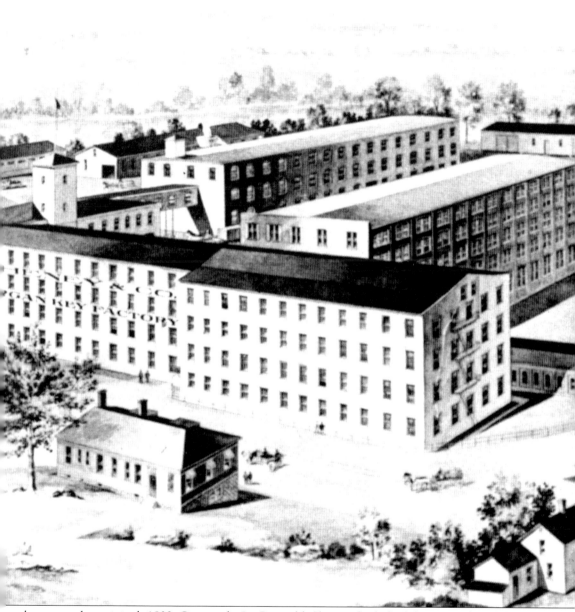

place was the original 1832 Comstock & Griswold Shop, which had been purchased by Comstock, Cheney almost 40 years after Samuel Comstock had abandoned this site. It was located nearly a mile east of the main plant on the Falls River, thereby hardly being visible as pictured here. (Courtesy of Edith DeForest.)

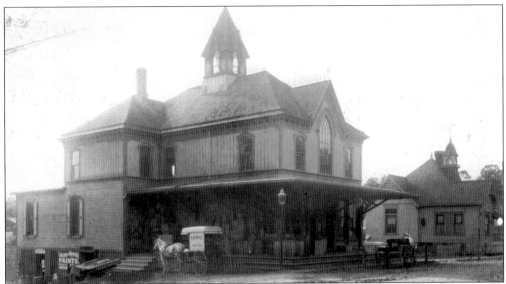

THE ROSE BROTHERS STORE AND WAGON. The Ivoryton Store was known as the Rose Brothers Store for many years. Franklin and Theodore Rose did operate this place, but Samuel M. Comstock built it in 1874, and the building remained in the Comstock family until World War I. Upon the death of Comstock in 1878, this building and its fixtures were valued in his estate at almost $5,000, a princely sum for the period. The establishment of this place was part of Comstock's paternal vision for West Centrebrook—as Ivoryton was named until the last quarter of the 19th century. A company meeting hall used for dances, weddings, and recreational events was located on the upper floor and served as such until 1911. Appropriately, it was known as Comstock Hall. The Ivoryton Post Office was also located here for many years. The trolley track ran in front of this store and west to the upper shop on West Main Street. (Photographs courtesy of May Sterling Rutty and Tom Schroeder.)

AN INVOICE TO CHARLES NEWTON. This invoice was for building the Ivoryton Library for $2,500 and $742 additional. The Ivoryton Library was the initial library in Essex and among the first in the lower valley. It was formed in December 1871 and existed rather informally before the present structure was completed in November 1889. Sarah L. Cheney was the librarian of the Ivoryton Circulating Library from 1871 to 1889, when the building was constructed. During that time, all library books were kept at her home, and she carried out the duties of the village librarian from there. Most of the officers of the Ivoryton Library Association had a connection to the factory, and the library was built on Comstock family land. For almost 50 years, Laura and Bessie Comstock, daughters of George Hovey Comstock and granddaughters of Samuel M. Comstock, ran this library. (Courtesy of Ivoryton Library.)

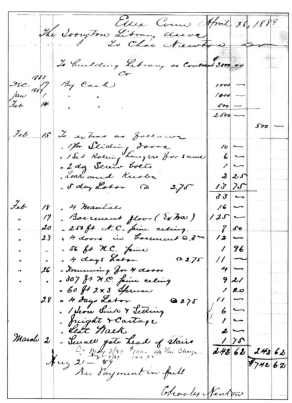

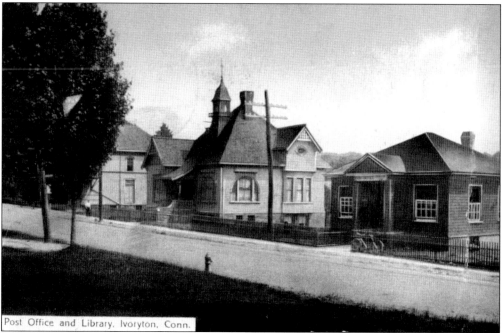

Post Office and Library. Ivoryton, Conn.

THE IVORYTON LIBRARY. Today the library, built in the Victorian style, has much the same physical character it had at the time of construction. The Ivoryton Post Office can be seen on the right, and the Ivoryton Store is to the left. (Photograph courtesy of May Sterling Rutty.)

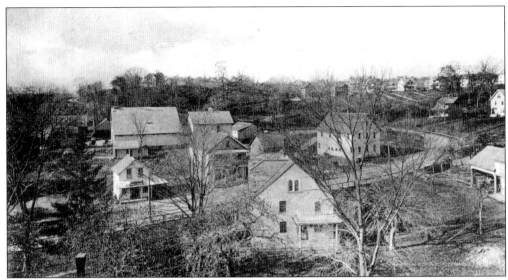

SUMMIT STREET. This view of Ivoryton was probably taken from the new Grammar School in the center of the village c. 1900. Chestnut Street, Blake Street, and Summit Street are shown. At the time, Comstock, Cheney & Company was either building houses for employees at a rapid rate or encouraging others to supply housing. The factory was directly, or indirectly, responsible for more than 200 housing units in Ivoryton and the surrounding area. Missing is the famous Comstock Cheney Hall, which was built in 1911 on the land shown in the foreground. (Photograph courtesy of May Sterling Rutty.)

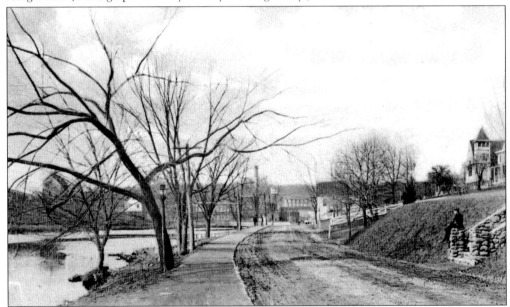

WEST MAIN STREET. This road led directly to the main factory of Comstock, Cheney & Company, seen in the background. It connected with Winthrop Street, known today as Bushy Hill Road. The Swedish Church is visible on the right, as is the stone walkway to All Saints Church. Lily Pond (Ivory Lake) is on the left, and a wooden sidewalk parallels the roadway. The Shoreline Electric Railway followed this road when it was in operation. (Photograph courtesy of May Sterling Rutty.)

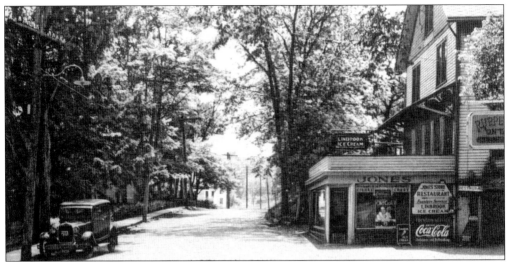

AG AND I, C. 1930. Chester Nickse purchased Jones Restaurant in 1947. He owned and operated the store as the Ivoryton Shoppe from 1947 until a few years before his death in 1968. The Ivoryton Shoppe was a small convenience store selling groceries, patent medicines, cold cuts, and magazines. Dry goods were stored on the second floor. There was a soda fountain in the back of the store, with ice-cream parlor tables and chairs. Workers from Pratt, Read & Company Inc. and other local businesses were regulars for lunch. In the summer, theatergoers converged on the fountain three deep for ice-cream confections before the show. Bill Nickse renovated the second floor as a pharmacy for his brother, Hugo, c. 1960. It has been Murphy's Parade Restaurant, Ag and I, Aggie's Place, Ivoryton Family Restaurant, Aggie's Again, and Characters. (Photograph courtesy of May Sterling Rutty.)

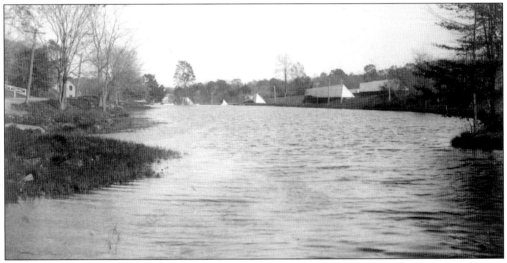

A VIEW FROM WALNUT STREET. West Main Street is clearly visible on the left, and bleach houses are on the right. The pond in the center resulted from a dam Samuel Comstock built in 1847 to supply power for S.M. Comstock Company. Comstock purchased a water privilege that had been owned by the Clark family, who had constructed a dam approximately where Walnut Street crosses the Falls River. Comstock destroyed this dam and effectively moved it a few hundred yards east. This body of water has been referred to many ways, but one name was Lily Pond. (Photograph courtesy of May Sterling Rutty.)

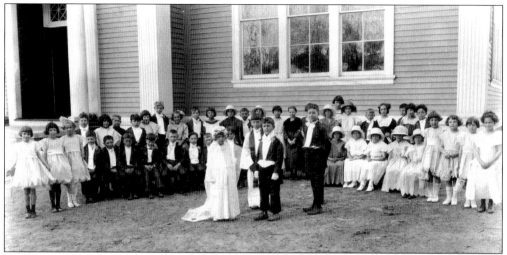

IVORYTON GRAMMAR SCHOOL STUDENTS. Shown here is a Tom Thumb wedding performance at the new Ivoryton Grammar School. Tom Thumb was a well-known circus performer highly promoted by Phineas T. Barnum of Bridgeport. Although Barnum died in 1891, the Barnum & Bailey Circus was very popular in the early part of the 20th century and obviously influenced certain cultural aspects of Ivoryton. The children are appropriately dressed. (Photograph courtesy of Tom Schroeder.)

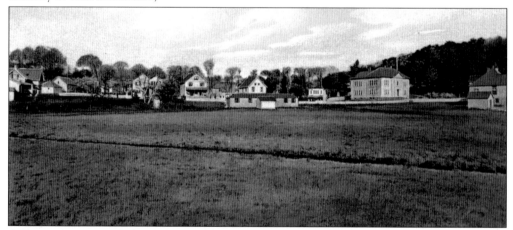

A BACK VIEW OF THE SCHOOL. In 1899, contractor Joseph Southworth and his son George completed this new school building in Ivoryton. This structure was located at the intersection of Main Street and the road to Deep River (North Main Street), where the town green is today. It was built on land given in part by Elizabeth Northrup, a daughter of Samuel M. Comstock, and built primarily with funds provided by Comstock, Cheney & Company. It was among the finest school buildings in Middlesex County at the time and featured a Palladian window over the main entry. This school was constructed under the direction of a committee that consisted of the entire Ivoryton School Board. The head of this committee was Robert Comstock, soon to become president of Comstock, Cheney & Company. Other members included factory official H. Wooster Webber, son of the factory superintendent. The factory purchased the old school building on the site for an exaggerated cost and moved it away. The new building was designed by an architect and was built in a balanced manner, featuring classical styling. It was destroyed after the Essex grammar schools were combined in Centerbrook in 1954. (Photograph courtesy of Ivoryton Library.)

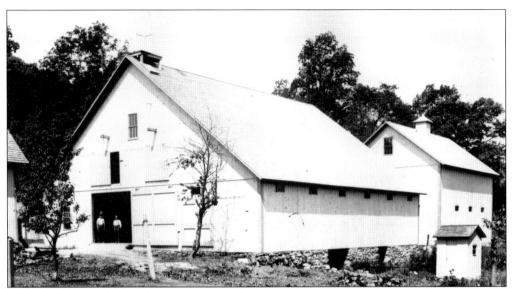

BLAKE & COMPANY. George Blake ran a livery and trucking service in Ivoryton and harvested ice from 1880 into the 1900s. He maintained a stable of more than 20 horses and sold coal, hay, and wagons. This firm was succeeded by the C.P. Burdick Company, a major construction firm through much of the 20th century that also sold coal and fuel oil. For many years, the Burdick and Johnson families of Ivoryton operated C.P. Burdick Company. (Photograph courtesy of Tom Schroeder.)

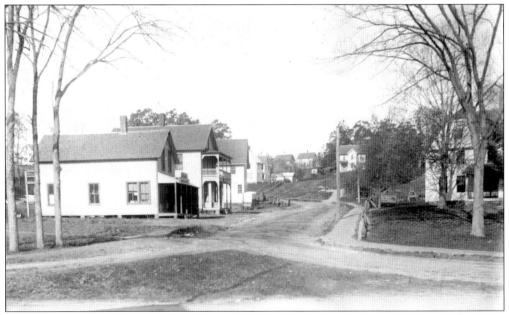

SUMMIT STREET, 1907. This 1907 view of Summit Street shows the store of John Frederickson (foreground), where footwear was sold and repaired. Frederickson also sold candy and tobacco products. Built in 1894, the store has been a pub in recent years. Across the street is the property on which Comstock, Cheney & Company built a new company hall four years later. The new hall replaced Comstock Hall, which had served as the company meeting place since 1874 and was located above Rose Brothers Store. (Photograph courtesy of Tom Schroeder.)

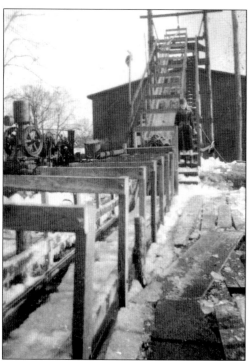

THE CLARK'S POND ICEHOUSE. Icehouses were a mainstay of most communities before the advent of mechanical refrigeration. This Ivoryton structure was just past the upper Comstock, Cheney & Company factory on Clark's, or Comstock, Pond, a dammed body of water made to supply power for the factory. Ice, harvested in the winter and packed with straw, could be stored and used through the warmer months. Clark's Pond was a well-known swimming hole for area youngsters, and the adjacent icehouse presented a dark and eerie place for exploration. (Photograph courtesy of Bea Fox McLean.)

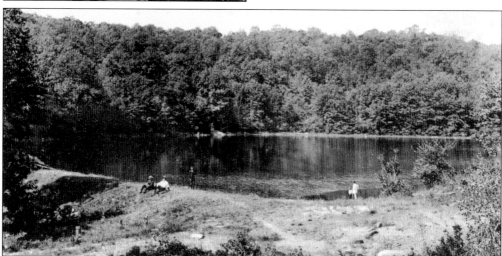

LORD'S POND. Lord's Pond was the result of a dam built by Samuel M. Comstock in 1852 to supplement power supplies to his ivory factory near the center of town. This was part of his genius, realizing the necessity of having a supply of power that would be consistent throughout the year. The fact that water was this power source meant that a succession of dams was required due to the seasonal availability of water. The name Lord was applied to the pond when a man by that name purchased part of this pond, as well as adjacent land, well after the construction of the dam. The saddest chapter in the history of this pond occurred in the 1920s, when a trolley conductor observed two boys playing near the pond. Soon thereafter, one of these boys, nine-year-old Gordon Dickenson, evidently slipped into the water and drowned. Ultimately, the adjacent land was developed as Highland Terrace and the dam was breached and never repaired. (Photograph courtesy of May Sterling Rutty.)

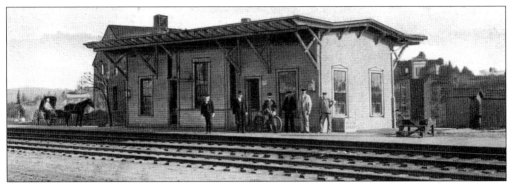

THE ESSEX TRAIN STATION. The Connecticut Valley Railroad went into active service in 1870 with a station located on the Middlesex Turnpike in Essex. This line ran south, close to the Connecticut River, through Deep River, where it turned inland and headed toward Essex and Old Saybrook. It is alleged that this routing (in the southern part of the county) was the desire of Samuel M. Comstock, the only director on this new railroad from the lower valley. He owned the Centerbrook Manufacturing Company at the time, a large manufacturer of drill bits, located a short distance from the tracks in Essex. In addition, Comstock, Cheney & Company soon commenced shipping finished goods by rail and ultimately received some ivory by this form of transportation. By 1900, Comstock, Cheney & Company owned six acres adjacent to the station, using it to store coal among other items. (Photograph courtesy of May Sterling Rutty.)

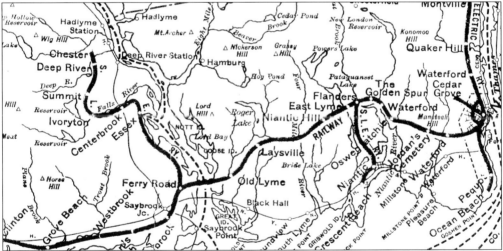

A MAP OF THE TROLLEY LINE. The Shoreline Electric Railroad operated in the second decade of the 20th century in the lower Connecticut River Valley. It originated in Branford and ran to Old Saybrook, where it turned north toward Essex. It was originally designed to go to Middletown. With the opening of the drawbridge across the Connecticut River, it did go to New London, Norwich, and eastward, but it never got north of Chester. Locally, it ran from the square in Essex Village, up North Main Street to the intersection with Denison Road and then followed Trolley Lane, crossing the Falls River and emerging on the Middlesex Turnpike near the railroad station. From that point it traveled to Ivoryton on Main Street to the main factory before turning right and going over Kelsey Hill, ultimately returning to the Middlesex Turnpike south of Deep River Village. It then followed this road northward through Deep River. Because it was too expensive for factory workers and because of the arrival of the automobile, the trolley survived only 10 years, failing before 1920. (Photograph courtesy of Edith DeForest.)

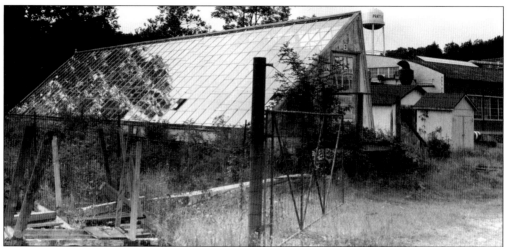

A DILAPIDATED BLEACH HOUSE AND PRATT, READ & COMPANY PRODUCTS. The last shipment of ivory arrived in Ivoryton in 1954. By that time, its importation had been outlawed in the United States. The factories could use the supplies they had on hand as long as they lasted. This bleach house (above) was no longer required when plastics replaced ivory. Pratt, Read & Company moved the action division plant to Central, South Carolina, and began to replace the pre-1900 wooden building. The growth of home entertainment in the second half of the 20th century made it more and more difficult to market pianos. Pratt, Read & Company was able to diversify (below) to an extent, in an attempt to blunt the decrease in piano action sales. They manufactured wood products in Laconia, New Hampshire, and Sounder golf clubs in Ivoryton. Overall, the most salient factor was that 100 years ago, up to half a million pianos and organs were sold annually in the United States when the population was less than 100 million persons. Today, the population has tripled and it is estimated that no more than 50,000 pianos are sold nationwide. (Photographs courtesy of Mary Bowers.)

Four

KEYBOARD CAPITALS OF THE WORLD

It was only 10 years after Connecticut had ratified the new U.S. Constitution in 1788 that Phineas Pratt I developed a machine that cut teeth in combs. Shortly thereafter, he and his son, Abel, were manufacturing combs in Abel's home in Potapoug Point, now called Essex Village.

About the same time, in 1802, Ezra Williams commenced making combs at the mouth of the Falls River in Potapoug. Abel Pratt and Ezra Williams became involved in a lawsuit over a labor problem, which was decided in Ezra's favor, but a foundation for the ivory business had been laid.

In 1809, George Read and his brother-in-law, Phineas Pratt II, started a comb business in the Deep River section of Potapoug. In 1816, Read left and joined Ezra Williams in forming what later was called George Read & Company. In 1839, Read began manufacturing ivory piano keys. This was in addition to continuing the manufacture of combs but was a first in the lower Connecticut River Valley. It started a chain of events that led to Deep River and Ivoryton becoming the leading ivory manufacturers in the country.

By 1856, Ulysses and Alexis Pratt had built a new comb manufactory on West Elm Street in Deep River, and in 1863, this Pratt Brothers Company combined with George Read & Company and the Julius Pratt Company of Meriden. Thus was born Pratt, Read & Company. By 1871, all operations ceased in Meriden and all the machinery was brought to Deep River.

The factory survived the panic of 1873, and on December 3, 1879, in a significant happening, Steinway & Sons of New York resolved to have portions of their keyboards made by Pratt, Read & Company.

Disaster struck on July 31, 1881, when fire totally destroyed the wooden factory. The question of rebuilding was of concern to the entire town of Deep River. A town meeting resolution offered tax abatements to the factory as an incentive to remain in Deep River. Company directors voted to rebuild there, and in less than 12 months, a sturdy brick factory was erected. Today, this stands as the Piano Works Condominium.

Business continued to increase, and in 1910, Pratt, Read & Company purchased controlling interest of Wasle & Company and Wasle Unique Player Action Company, both of New York. A year later, this business was moved to the brick factory, where a fifth floor was added to accommodate it. In 1914, a new building was put up for the manufacture of player action pianos. This building later housed a lighting manufacturer and UARCO Inc., a printing concern.

Pratt, Read & Company also purchased Sylvester Tower Company of Cambridge, Massachusetts, and Starch Brothers Company of New York, both makers of piano keyboards and actions. By the end of the 1920s, Pratt, Read & Company was in financial trouble, the result of a combination of circumstances including the worsening national economy and the falloff of the piano trade, due to radios and phonographs.

Drastic action was required at Pratt, Read & Company. The capital stock was reduced from $1.5 million to $900,000, and the player action division was eliminated. The stockholders unanimously approved these moves after explanations by a worried president, George L. Cheney. Further steps had to be taken, however, and in 1931, all salaries were cut 25 percent.

This still did not allow Pratt, Read & Company to become profitable. It was at this time that James A. Gould was named vice president and general manager of the company. A new epoch was on the horizon for Pratt, Read & Company.

Under Gould's leadership, it was decided to diversify output, and the company started building small wooden boats. Since Pratt, Read & Company was primarily a woodworking operation, this was a logical step. Naval expert George Crouch designed two models of wooden boats, under the brand name Harpoon. One model, the Sportsman, was priced slightly more than $200, and a larger boat, the Runabout, was made to sell for $350. These vessels were made in the empty player action building but were not competitively priced, and the venture was dropped within a year.

On February 4, 1932, George L. Cheney, who was the longest-serving company president, resigned, and James Gould was unanimously elected president. Gould studied the market possibilities and concluded that it was imprudent for Pratt, Read & Company and Comstock, Cheney & Company to compete. He felt that a merger of the two concerns would be beneficial to stockholders and employees. He wrote to Robert H. Comstock, president of Comstock, Cheney & Company, stating his views. Comstock was not receptive to a merger at this time, but Gould was not discouraged and managed to reduce expenses in Deep River. He closed the upper two floors in the west wing and the third floor in the north wing of the brick factory. The West Factory on West Elm Street was also closed, and the ivory-processing machinery was brought to the main factory. The remaining inventory of Harpoon boats was sold at 20 percent of original cost. Gould investigated a new electrically operated instrument, the Vivid-Tone, allotted $3,000 for its development, and contracted to produce an instrument known as the Emicon.

Pratt, Read & Company had not lost customers but had actually gained contracts—the newly merged Aeolian Piano Company and the American Piano Company. The problem was that the volume of business available was very low. On February 18, 1933, a little over a year after he had resigned, George Cheney died.

—Edith DeForest and Don Malcarne

JULIUS H. PRATT AND ULYSSES PRATT. Julius Pratt (left) was the youngest son of Deacon Phineas Pratt I, the inventor of the machine to cut combs. He operated an ivory shop in Meriden. Ulysses Pratt (right) was the grandson of Phineas Pratt I, and his father was Phineas Pratt II. Ulysses and his brother Alexis founded Pratt, Spencer & Company, later called Pratt Brothers, an ivory-cutting business. These Pratts were all descended from Lt. William Pratt, one of the first settlers in this area. (Photographs courtesy of Deep River Historical Society.)

GEORGE A. READ WITH COMB MACHINE INVENTED BY PHINEAS PRATT I. The invention by Phineas Pratt I of the machine to cut the teeth in combs gave rise to the ivory industry that was to begin in this area. Pratt lived in Potapoug Quarter near Phelps Corner when he invented the comb machine (below) designed to run by water. Before this, comb teeth were cut by hand. Pratt went into business with his son Abel from 1798 to 1809, but Abel Pratt had to close the shop when he lost a labor dispute with Ezra Williams. In 1816, Ezra Williams moved upriver and, with George Read (right), set up Ezra Williams & Company in Deep River. (Photographs courtesy of Connecticut River Museum and Deep River Historical Society.)

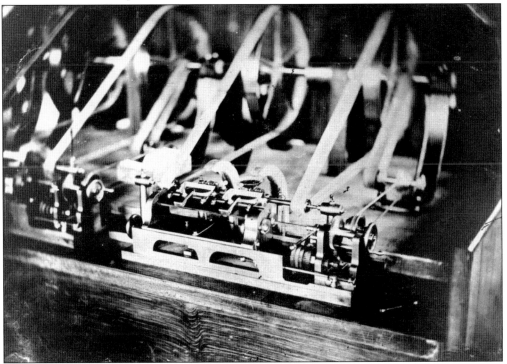

GEORGE READ & CO.,
Manufacturers of IVORY
COMBS
OF ALL KINDS AND SIZES.

MINIATURE IVORIES, PAPER FOLDERS, &C.,
DEEP RIVER, CONN.

COMB LABEL AND GEORGE READ & COMPANY. In 1809, George A. Read and his brother-in-law, Phineas Pratt II, made ivory combs on Main Street in a shop on the site of what is now Piano Works. Read joined Ezra Williams & Company in 1816, and in 1829, after the death of Williams, changed the name to George Read & Company. In 1839, George Read & Company began cutting ivory piano keys. Ulysses and Alexis Pratt, sons of Phineas Pratt II, built a new factory on West Elm Street in 1856 called the West Factory. In 1863, three ivory firms merged to form Pratt, Read & Company. The three firms were Julius H. Pratt of Meriden, George Read & Company of Deep River, and Pratt Brothers of Deep River. The home office of the new company was established in Meriden. In 1871, the home office was moved to Deep River. (Photographs courtesy of Deep River Historical Society.)

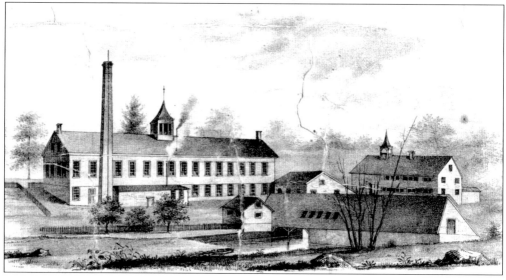

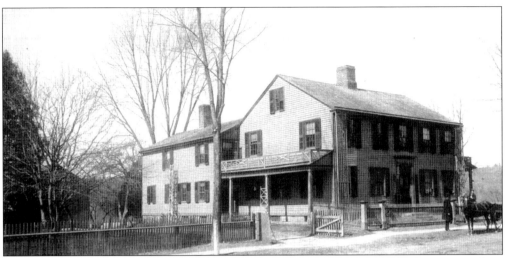

THE HOME OF GEORGE A. READ. Located on Main Street in Deep River, this house was a five-bay Georgian style, typical of Deep River in the first part of the 19th century, yet somewhat at odds with many Connecticut River Valley homes of the time, which featured dual chimneys and a central hallway. It stood near his factory and the home of his partner Ezra Williams, and it was a similar style. By the time Read's company merged in 1863 with two other ivory companies, George A. Read was deceased and his son, also named George A. Read, carried on. George A. Read Sr. was buried on the grounds of the Baptist church, and his remains were later moved to Fountain Hill Cemetery. George A. Read Jr. died in 1882. The former site of George A. Read's house is now the Presidential Apartments. (Photograph courtesy of Deep River Historical Society.)

DANIEL FISHER. Fisher, a 20-year-old slave, traveled along the Underground Railroad from South Carolina to Deep River in 1828. Deep River stationmaster George A. Read arranged for Fisher to change his name to William Winters. He acquired property on what was later called Winter Avenue, although by the time of his death, he had sold most of it. He died in 1899 and was buried in the Fountain Hill Cemetery, in the Crescent Hill section. On the wall of a building on the corner of North Main Street and Winter Avenue, a plaque reads, "Led by George Read, Founder of the Town's Ivory Industry, Deep River Became Known in the 19th century as 'All Abolitionist' and a Refuge for Runaway Slaves on the Underground Railroad." Richard Conniff's *When Music in Our Parlors Brought Death to Darkest Africa* explores the conflicting values of George A. Read. His participation in the Underground Railroad occurred at the time that his factory was purchasing ivory that was carried across Africa by men and women enslaved for that very purpose. (Photograph courtesy of Deep River Historical Society.)

PRATT, BROTHERS & CO.,
DEEP RIVER, CONN.,
MANUFACTURERS OF
IVORY TURNINGS,
FOR PIANO-FORTES AND MELODEONS.

IVORY OF DIFFERENT QUALITIES AND SIZES.

ALL ORDERS PROMPTLY ATTENDED TO.

PRATT BROTHERS & COMPANY. Owned by Ulysses and Alexis Pratt, and located on Main Street opposite the road to the wharf, Pratt Brothers & Company (below) had once been under the banners of Pratt & Worthington, U. & A., and Pratt, Spencer & Company, as well as Pratt Brothers & Company, as shown on the comb label (above). This factory produced only piano keys after the West Factory was built in 1856 on West Elm Street. As the industrial revolution forged ahead, smaller companies found it harder to compete. The 1863 combination of Pratt Brothers & Company with George Read & Company and Julius Pratt & Company resulted in Pratt, Read & Company. (Photographs courtesy of Deep River Historical Society.)

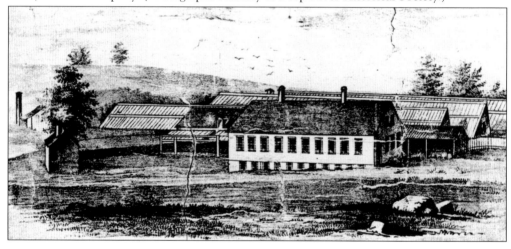

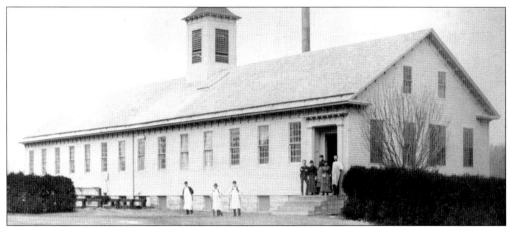

THE WEST FACTORY. This factory on West Elm Street was built in 1856. Combs were manufactured on the second floor. The ground floor was used for sawing the tusks into tops and fronts for piano keys and preparing the pieces for the bleach houses on the grounds, called Castle Garden by the factory workers. According to the recorded memories of Fred Comstock, aged 15 at the time he started working here under the tutelage of John Geffken, the ivory in the bleach houses "stunk like rancid kerosene light." The plates of ivory were cleaned in three successive baths of hydrogen peroxide and, according to Comstock, he was warned never to get his hands into the first two baths. The building now belongs to the Ensico-Triton Company. (Photograph courtesy of Deep River Historical Society.)

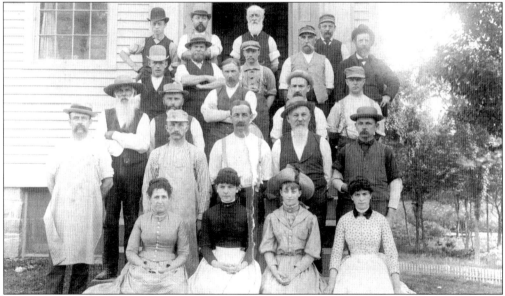

EMPLOYEES OF PRATT, READ & COMPANY COMB FACTORY, THE LATE 1800S. Shown are employees of Pratt, Read & Company, previously Pratt Brothers. From left to right are the following: (first row) Sarah Pratt, Maggie Desmond, Nathalie Pratt, and Hannah Desmond; (second row) Gilbert Watrous, Richard Ziegra, William Shipman, Casper Chapman, and Russell Stannard; (third row) Centa Denison, Frank Griswold, Wilbur Harris, and Fred Schlick; (fourth row) Chris Perucker, Richard Griswold, Miles Smith, Jabez Bushnell, and Marshall Comstock; (fifth row) George Geffken, John Geffken, Henry Chapman, and Thurber Harris. (Photograph courtesy of Deep River Historical Society.)

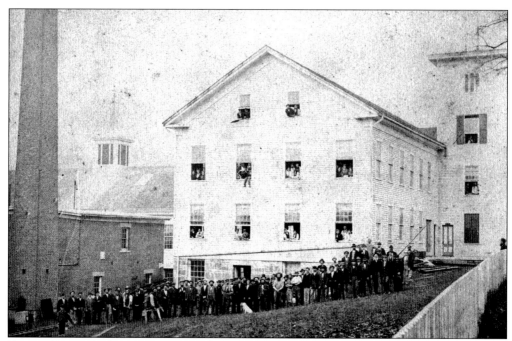

PRATT, READ & COMPANY. Located on Main Street, this wooden factory burned down in 1881. The brick building that replaced it was called the Red Shop. Wooden buildings were prone to destruction by fire. (Photograph courtesy of Deep River Historical Society.)

OFFICE OF PRATT, READ & CO.

Deep River, August 22d, 1881.

Mr. *Geo H Comstock*

At a meeting of the Directors of Pratt, Read & Co., held this day, the following Preamble and Resolution was adopted:—

WHEREAS, Our Keyboard Factory and adjoining buildings were totally destroyed by fire on Sunday, July 31st, therefore,

RESOLVED, To request the President of this Corporation to call a Special meeting of its Stockholders to be held at as early a date as possible, said meeting to take such action in regard to our present situation as may be lawful, proper, and for the best interests of the Company.

In accordance therewith, and by order of the President, a Meeting of the Stockholders will be held at the Office of the Corporation in Deep River, on Tuesday, August 30th, at 1 o'clock P. M.

GEORGE A. READ, Secretary

A LETTER TO STOCKHOLDERS OF PRATT, READ & COMPANY, 1881. A copy of this letter was mailed to all stockholders of Pratt, Read & Company shortly after the factory was destroyed by fire, advising them of a meeting in Providence, Rhode Island, to discuss whether to rebuild or move out of town. At the same time, citizens at a town meeting in Deep River were discussing the idea of offering a tax break to the company as incentive to rebuild. The stockholders voted to rebuild a brick factory, and the town voted for a 10-year tax break. (Courtesy of Deep River Historical Society.)

THE NEW BRICK FACTORY, COMPLETED IN 1883. This brick building replaced the wooden one that burned in 1881. At this site Pratt, Read & Company became one of the leading manufacturers of piano keys and actions in the world. Later, the building housed Hamilton's Furniture Factory, Ripley Manufacturing, and others. Currently, it is Piano Works Condominiums. (Photograph courtesy of Deep River Historical Society.)

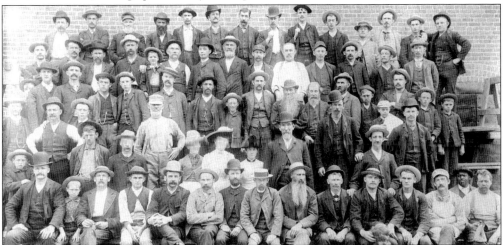

EMPLOYEES OF PRATT, READ & COMPANY. From left to right are the following employees: (front row) Jim Rankin, Harold Rankin, Albert Olin, Charles Wright, unidentified, Mort Curtis, M.M. Corwin, Fremont Bailey, Gustav Denison, Dan Damon, Alfred Dibbon, John Tyler, Frank Hurd, Charles Mitchell, and Henry Seaver; (second row) Charles Phelps, Frank Harris, George O'Brien, Milt Graves, Chauncey Comstock, John Hanneen, Maggie Barry, Emma Deluery, Net Graves, Ned Phelps, John Hanscomb, Len Baker, and Louie Pratt (paper boy); (third row) Tim Hanneen, George Bennis, Morris Galvin, Jim Rockwell, Bob Silliman, ? Burdick, John Bolman, Charles Larson, Tom Collins, Jim Hefflon, William Buckley, Hart Johnson, unidentified, Charles Burke, and Pat Shean; (fourth row) Ernest Ziegra, George Joy, Edson Brown, Bert Luther, Fred Joy, Ed Larson, Dan O'Brien, G.R. LaPlace, ?, Leonard Baker, Sim Francis, Oliver Carter, Charles Clark, and William Hurd; (fifth row) Bert Stevens, Sam Parker, Clem Griswold, Robert Bolman, Charles Shailer, Noah Starkey, Osmer Shailer, Frank Hefflon, Nordahl Pratt, Ed Phelps, Miley Smith, William G. LaPlace, Tom Baker, and Gene Pelton. (Photograph courtesy of Deep River Historical Society.)

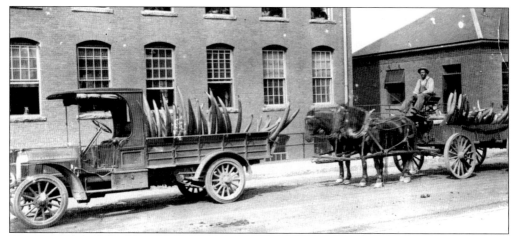

THE RED SHOP. This photograph of a truck and a wagon carrying tusks from the wharf shows the transition from wagon to truck. Tusks were a valuable commodity and were brought by ship from East Africa and other places to New York City, Salem, Massachusetts, Providence, Rhode Island. The raw ivory was then shipped to Deep River and Ivoryton by steamboat. Later, the railroads carried some of this raw material. The finished products were shipped mainly by rail by the early 20th century. In Deep River, the railroad station was adjacent to the steamboat stop on the Connecticut River. (Photograph courtesy of Deep River Historical Society.)

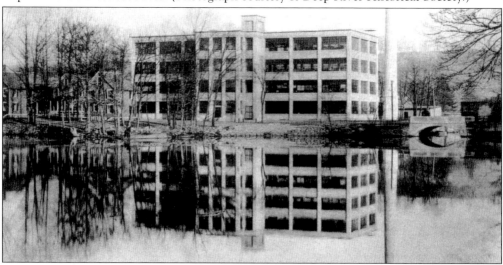

PLAYER ACTION BUILDING, BRIDGE STREET. Completed in 1914, this building was constructed to house the Wasle Unique Player Action Company of Bronx, New York, purchased by Pratt, Read & Company in 1910. In 1911, Wasle moved to Deep River and began manufacturing player pianos. In the early 1930s, business dropped off, due in part to the invention of the phonograph and radio and also to the depression. Pratt, Read & Company used the building to manufacture Harpoon motorboats, which were unsuccessful, and other types of products. During World War II, Pratt, Read & Company rented the building to the Sight Light Corporation, which manufactured signal lights for the navy. The building was vacant from the end of the war until 1947 when UARCO purchased it to print business forms. That firm remained in town for 50 years before consolidating in the Midwest. In 1999, this structure was sold to the Goodspeed Leasing Company and, today, it is rented by TriTown Precision Plastics. (Photograph courtesy of Deep River Historical Society.)

56

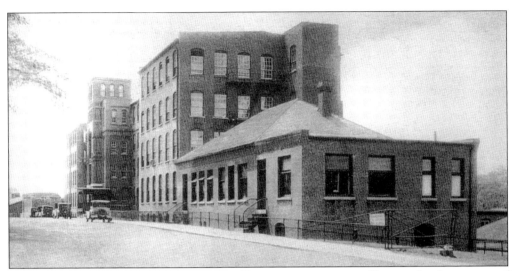

THE 1910 BRICK FACTORY, WITH FIFTH FLOOR AND WITHOUT TOWER. In the process of raising the factory tower to add a fifth floor for the manufacture of piano actions in 1910, a faulty crane caused the tower to fall, smashing the granite steps. George L. Cheney, president of the factory, threatened to sue the construction company for the smashed steps. The tower, however, was not a concern of Cheney's. It was never replaced, leaving a flat section where the tower had once stood tall. Cheney was the son of George A. Cheney, president of Comstock, Cheney & Company. (Photograph courtesy of Deep River Historical Society.)

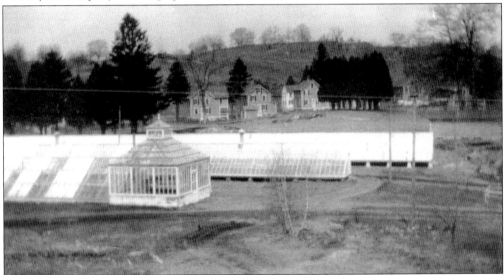

A VIEW OF THE BLEACH HOUSES. This view, looking toward Bridge Street, shows Pratt, Read & Company houses (background) that were built for the Wasle employees who moved to Deep River with the company. The rent, probably $15 or $20 per month, was deducted weekly from the employees' pay. Once located behind the shop between Bridge and Spring Street, the bleach houses were used to further bleach the ivory. After the pieces of ivory had been soaked in jars of peroxide and uniformity was reached, they were arranged on racks in the bleach houses for exposure to the sun. George Read's bleach house calendar, dated 1852, reads, "Oh Plates lift up your sides and sing praises for this day. Will the Sun Whiten ye up, and ye shall become as the driven snow." (Photograph courtesy of Deep River Historical Society.)

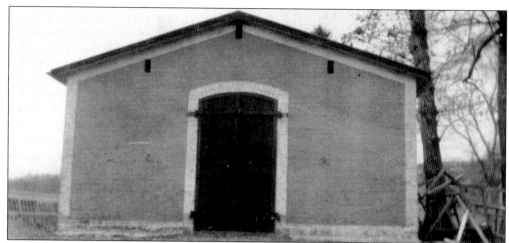

THE IVORY VAULT. After a shipment of tusks was received, it was stored in a vault, a small separate building where thick walls and no windows maintained temperature, darkness, and humidity. Tusks varied in size; one pair was recorded at 400 pounds, with the average tusk weighing 60 to 75 pounds. They were extraordinarily valuable. The ivory trade centered almost exclusively in Africa, and the cost in human lives outweighed the number of elephants killed. Originally, tusks were taken from the carnage of dead elephants, but with the value of each tusk reaching enormous heights in the late 1800s, the market for the Arab traders grew and the human destruction worsened. (Photograph courtesy of Deep River Historical Society.)

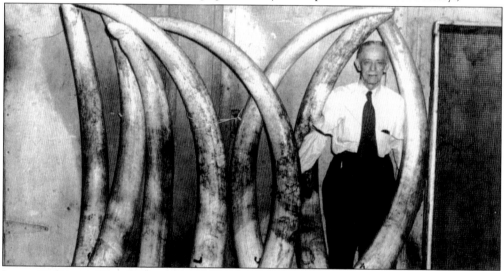

LOUIS E. PRATT, HEAD IVORY CUTTER. Louis E. Pratt selected the tusks from a warehouse in New York City. Soft ivory from the elephants of East Africa was preferred for piano veneers, but Egyptian, Cape, and Angola ivory were also used. The tusk was toted from the vault to the junker operator, who used a converted band saw to cut the tusk into four-inch sections, or the approximate size required for key tops. The blocks were then sawed into rough shape before they were sliced to produce the wafers that become the final product. Louis E. Pratt, known as Professor Pratt, conducted a dancing school and, in 1920, built the Deep River Motion Picture Theater, which burned in 1967. Other ivory cutters were Oscar Lynn, Oscar Anderson, William Booma, O. Ray Carter, Thomas Flaherty, and Lewis Stannard. (Photograph courtesy of Deep River Historical Society.)

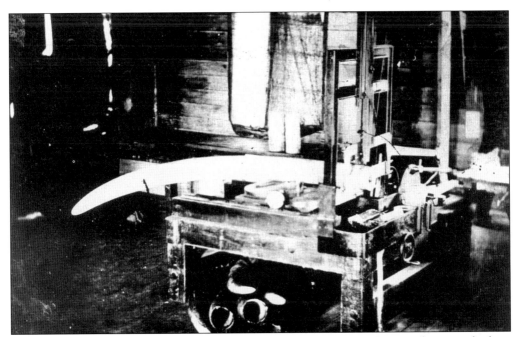

A MACHINE FOR JUNKING TUSKS, INVENTED BY GEORGE READ. Cutting the ivory for keys required skill, patience, and time. It was necessary to make specialized tools that applied directly to the handling of ivory. In a search for interchangeable parts, the Springfield (Massachusetts) Armory encouraged businesses to adjust and invent machinery. The saws for cutting the tusks were maintained for precision. (Photograph courtesy of Deep River Historical Society.)

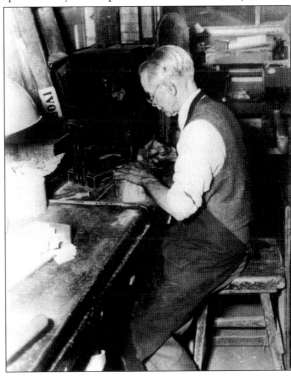

LOUIS E. PRATT, JUNKING AND MARKING. After Louis E. Pratt sawed the tusk into blocks, he would mark the sections for the heads and the tails. The heads are the wider pieces, which on the piano keyboard would be the section to be played, and the tails are the narrower pieces, placed between the sharps. The leftover pieces were used for ivory novelties. (Photograph courtesy of Deep River Historical Society, taken at Pratt, Read & Company Inc. in Ivoryton.)

OSCAR LYNN, LOADING THE RACKS WITH THE HEADS AND TAILS. Raw ivory is naturally yellowish in color. Generally, the ivory was placed in large jars of peroxide and water for two to four days. It was packed tightly into wooden boxes to prevent warping and was slowly dried for two to seven days. The ivory was then removed from the boxes, laid on the bleach frames, and put to the glass in the bleach house, where it remained for 30 sunny days. The racks were unloaded, the ivory was turned over, and the racks were hung against the glass for another two weeks. The average tusk provided ivory for 45 keyboards. The ivory from each tusk was racked and kept together during processing to ensure uniformity of grain. The number of sun hours was carefully recorded. Bleach racks held 200 heads (the wider forward part of a piano key) and 166 tails (the longer narrow key). Bleach houses were built with their 45 degrees angle facing south. (Photograph courtesy of Deep River Historical Society, taken at Pratt, Read & Company Inc. in Ivoryton.)

THE MATCHING ROOM. From the Bleach House the tusk is delivered to the Matching Room in two cartons, one for heads and one for tails. Here George Drennan, Eunice Sizer, and Ida Samuelson sort and match the pieces into keyboard units. The sets are then matched to six different grades from Grade 1 to "shoddy" or streaked ivory. Grain is matched so that the transition from grainless to grain is unnoticeable. Heads were matched with tails for grain and butted together at the thick ends. After the set was arranged for a specific keyboard order, with the variations in grain and color being graduated for the center, diagonal lines were drawn so that the arrangement would always be known. The work was not heavy, but it required years of experience to properly grade ivory, which was then reflected in the price. (Photograph courtesy of Deep River Historical Society, taken at Pratt, Read & Company Inc. in Ivoryton.)

EMPLOYEES OF PRATT, READ & COMPANY. Employees with 50 years of service were honored at the annual banquet in September 1954 with a music box in the shape of a small wooden grand piano. From left to right are the following: (front row) Sherman Chrystal, Frank Wooster, James A. Gould (president), Fred Comstock, Louis Pratt, John Zanni, and Burdette Parmelee; (back row) Asa Gilbert, Henry Grieder, John L. Stone, C. Rowland Post, Hinek Kokojan, Frank Santi, and Edward Hilley. The death of Robert Comstock, president of Comstock, Cheney & Company, in 1933 led to the elevation of his brother, Archibald W. Comstock to that position. A.W., as he was called, was more amenable to a merger of Pratt, Read & Company with Comstock, Cheney & Company than his brother had been. The Deep River firm had been downsizing in response to the poor economic conditions, having sold the west factory for a soldering iron place, for example, and was slowly improving its financial position. In a relatively complicated business move, the two firms merged by vote of their stockholders on December 15, 1936. The formal merger went into effect two weeks later. This new company paid two dividends in 1937, but in an unfortunate move for Deep River, the piano key department was moved entirely to Ivoryton. The ratio of employees vis-a-vis Deep River and Ivoryton was to remain the same, according to James Gould. In another consolidation move, the Ivoryton ivory shop was sold to the Ernest Bischoff Company, and by the end of 1938, all operations were centered in the upper shop in Ivoryton. The advent of World War II dramatically shifted the economic and social forces of Pratt, Read & Company and of the villages of Ivoryton and Deep River. The company had long been primarily a woodworking place, and Gould seized upon this asset when he discussed with Roger Griswold of Old Lyme the place that plywood gliders would play in the upcoming conflict. The stage was set for the entrance of Pratt, Read into the field of glider manufacturing and during the war, two types of these machines were produced: the Waco CG4A, of which 925 came off the line, and 76 LNE01 U.S. Navy training gliders. Employment at Ivoryton and the reopened Deep River shop rose to 3,600, and in six months, a building specifically designed for glider production was assembled behind the brick shop in Deep River. This was sold after the war to the Brass Goods Manufacturing Company of Brooklyn, New York, and subsequently housed firms such as Monsanto and Silgan Plastics. (Photograph courtesy of Deep River Historical Society, taken at Pratt, Read & Company Inc. in Ivoryton.)

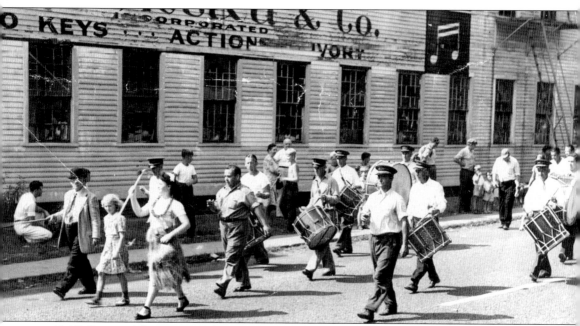

1947 STRIKE. The 1940s and 1950s were high-water times for unions across the country. Descendants of an earlier immigrant labor force, these workers were third-generation stock, much more secure than their parents or grandparents. The war had eliminated all piano production, so a pent-up demand after 1945 led to new thinking by Pratt, Read & Company. Peter H. Comstock, the grandson of A.W. Comstock, had come on board in June 1936 and learned the business from the factory floor up. He rose through the company hierarchy to become president in 1954. With business doing well after the war, some of the effects of the breakup of the old factory policies by the 1936 merger surfaced. In 1947, labor problems arose and a five-week strike ensued, which was costly to both factory and workers. On July 21, 1947, the Pratt, Read Union Local 105 of the United Furniture. Shown is the Deep River Drum Corps entertaining the strikers on the picket line. To prevent any violence, 30 state police officers under Commissioner Edward Hickey and Lt. Carroll Shaw reported to the plant. Over 500 strikers attended a meeting on August 21 in the town hall and voted to end the strike. It was not a unanimous vote; there was one dissenter. Peter Comstock and James Gould realized the changing nature not only of their field but also of business in general. As a result, new sales approaches were inaugurated with a new sales manager, F. Kelso Davis (who later became first selectman of Essex), and diversification of the product line was considered. As a result, contracts were obtained from the Kaman Corporation of Bloomfield to manufacture helicopter blades in 1952. Upon assuming control of Pratt, Read & Company, Peter Comstock instituted policies that would completely change the face of the company. The piano action division was moved to a new building in the town of Central, South Carolina, and the old five-story wooden plant built by Samuel Comstock and George A. Cheney in 1872 was demolished. Various companies were absorbed, including F. Kelly Company of Derby, Tech-Art Plastics of Morristown, New Jersey, and Allen-Rogers of Laconia, New Hampshire. Vocaline Company of America, with headquarters in Old Saybrook, merged with Pratt, Read in 1968. The great flood of June 1982 tested the mettle of the company and its employees. The factory bore the brunt of the dam failure on Bushy Hill, with water crashing through up to the second floor. Although much damaged, the factory was saved, production resumed, and Peter Comstock, after nearly 30 years as president, stepped down in 1982. Comstock's nephew, Harwood B. Comstock, took over and continues Pratt, Read manufacturing today, but in Bridgeport. (Photograph courtesy of Deep River Historical Society, taken at Pratt, Read & Company Inc. in Ivoryton.)

GEORGE L. CHENEY AND JAMES A. GOULD. George L. Cheney (left), whose father, George A. Cheney, had been president of Comstock, Cheney & Company, became president of Pratt, Read & Company in 1908. Cheney resigned in 1932 and recommended James A. Gould (right) to succeed him. Gould had arrived in Deep River in 1931 and had been elected vice president and general manager. Thus came about a new epoch when, in 1936, Pratt, Read & Company merged with Comstock, Cheney, & Company to form Pratt, Read & Company Inc. Pratt, Read & Company's total capital stock value was $600,000, while Comstock, Cheney & Company's was $630,000. At the time of the merger, the two companies employed a total of 500 people and gross production was below normal. (Photographs courtesy of Harwood Comstock.)

PETER HARWOOD COMSTOCK AND HARWOOD BROOK COMSTOCK. In September 1954, James A. Gould resigned as president but remained chairman of the board. He recommended Peter Harwood Comstock, grandson of A.W. Comstock and great-grandson of Samuel Merritt Comstock, to succeed him. In 1936, Comstock graduated from the Choate School and was looking forward to entering Dartmouth College in the fall. His grandfather told him he was instead going to enter the employ of the company. He trained under Charles Frederick Stein of Chicago, who was somewhat of a one-man piano manufacturer and later consultant to the company. Comstock was taught all phases of the business so that he could perform all operations of the factory. In 1954, he became president and served in that capacity until 1979. He became chief executive officer and retired in 1982. Harwood Brook Comstock has been president of the Pratt, Read Corporation since 1982. He is the great-great-grandson of Samuel Merritt Comstock, the founder of Comstock, Cheney & Company. (Photographs courtesy Harwood Comstock.)

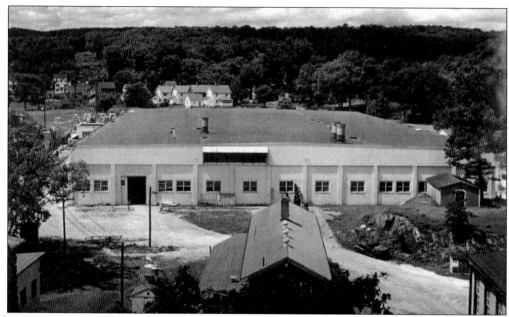

PRATT, READ, GOULD AERONAUTICAL DIVISION, THE GLIDER FACTORY. Built in 1942 in six months and employing up to 4,000 workers during World War II, the glider factory was the dominant war production facility in the lower valley. A glider was primarily made of wood, which fit well with Pratt, Read & Company, as piano actions are primarily wooden parts. (Photograph courtesy of Deep River Historical Society.)

NAVY GLIDER LNE-01 AND WACO CG4A. When World War II broke out, Pratt, Read & Company Inc. could not continue making pianos. James Gould, along with Roger Griswold, who was interested in a motorless plane, designed the navy glider (left). The prototype was still flying at Dart Airfield in New York until 2000 and is currently exhibited at the Soaring Museum in Elmira, New York. Under the supervision of Gordon Wheeler, 956 waco CG4A gliders (right) were manufactured. In 1943, the Royal Canadian Air Force took one of the Pratt, Read & Company gliders and towed it by a Dakota 47 from Canada across the Atlantic. They made several stops along the way and the glider arrived in England in good condition. The glider was to be put into a museum. While the glider was being ferried, a storm came up and the glider was smashed. The pilot said, "It is a tragic ending for a gracious lady." A Pratt, Read & Company Side-by-Side Navy Training glider is currently on exhibit at the Air Museum at Bradley International Airport in Hartford. (Photographs courtesy of Deep River Historical Society.)

Five

A THOUSAND TONGUES

They originally came by sailing ship or overland and then occasionally by steamboat or train. Who were they? They were the great group of immigrants who have populated the United States and the lower Connecticut River Valley over the past 350 years. Initially, the first group of permanent settlers in the lower valley area was exclusively from England and carried names such as Pratt, Bushnell, Clark, Hide, Lord, Starkey, Hayden, and Kirtland. They spread north from Saybrook Point through the towns that comprised the original land area of the Saybrook Colony (Lyme, Westbrook, Essex, Deep River, and Chester), and the Puritan Church reigned supreme. In the latter part of the 18th century. a few French settlers arrived, some from Long Island, with names such as L'Hommedieu and LaPlace. In the early to mid-19th century, Irish immigrants located in the valley. Many of them labored in the Portland brownstone quarries. It was not until the power of the Industrial Revolution had been established that immigration, as we currently understand it, occurred.

In the latter part of the 19th century, the great ivory manufactories of Deep River and Ivoryton featured large, modern factory buildings that were capable of great production. A limitation was the number of workers available, a common problem throughout industrial locations of the United States. Through the end of that century, the workforce in Ivoryton and Deep River was mostly comprised of Yankees (the English descendants) and Swedes who had migrated in fairly substantial numbers during the Civil War era and shortly after. As the century drew to a close, the greatest exodus of people from other parts of the world to the United States took place. Referred to as the Ellis Island era, it actually started somewhat before that port of entry was established.

This new group was generally from European countries such as Italy, Hungary, and Poland, and when people arrived in Ivoryton or Deep River and found employment, it was only a short time before their extended family came over and settled here. In this manner they were establishing cultures they were familiar with, which would sustain them while they were seeking a better life with the opportunities offered in the United States. This settlement pattern was repeated in many places across the country.

The first-generation immigrants exhibited extreme loyalty to the local factories, which made them very valuable employees. They regarded Pratt, Read & Company in Deep River, and Comstock, Cheney & Company in Ivoryton, as the only places to work. A distinctive social order arose locally between the managers, bosses, and immigrant workers, as well as between the nationalities of the immigrants themselves. This was especially true in Ivoryton, where housing, owned by the company, was provided for these newly arrived workers and the locale of these houses was distinct to the nationality of the people living there. In effect, satellite communities were established. Many of the Polish people lived on Warsaw Street, which connects Ivoryton and Deep River. In this area two Polish community groups were organized, the Sobieski Club and, later, the Polish Falcons Club. In another part of Essex, an Italian American Club, the Loggia Piava, was started, and in Deep River, the Scandinavian United Society.

Many questions have been asked about the quality of treatment of the immigrants by these great ivory factories. The general consensus is that it was reasonably good, and, as indicated, housing was often provided at a low cost. There was entertainment offered by the factories, and, in general, the welfare of the workers was considered. This all fell under the heading of welfare capitalism, an industrial philosophy that preached that everything provided above and beyond

strictly employment accrued to the betterment of the factory. There is no doubt that it was a form of control, but the immigrant makeup of the workforce allowed it to function.

There was an essential social difference between Pratt, Read, & Company and its competitor in Ivoryton, Comstock, Cheney & Company, particularly in the handling of the immigrant population and the ultimate absorption of it into American culture. In Deep River, the factory was part of a relatively thriving and diverse community. It was the most important economic factor and perhaps the most significant social force, but not the only one. In Ivoryton, Samuel Merritt Comstock, the founder of Comstock, Cheney & Company, had envisioned a village built around his factory. He was, by all accounts, a very paternalistic person, cognizant of his employees' wishes and needs. Beers *History of Middlesex County* (1884) states that "he was kind and considerate to his employees and took an active interest in everything that concerned their welfare or happiness." Ultimately, Ivoryton became a relatively self-contained village, with the welfare of the people, village, and factory closely intertwined. This worked well for many immigrants, for security was now tied to opportunity. In addition, a few of these newly arrived people set up retail stores that tended to cater to other immigrants while others went into skilled trades such as masonry and construction. There was a great demand for people to fill jobs in this area, specifically heavy construction, as a highway system was rapidly expanding and factories were being built.

The question may be fairly asked as to how quickly these immigrants accepted the American way of life and how much wealth they accumulated. A few very distinct patterns emerge. Initially, virtually all immigrants had a savings account and most purchased small plots of land. This may have been indicative of an agricultural background in Europe and trust in real estate as an investment. A local study of those first-generation immigrants who lived until the 1950s indicated estates that were the equal of the local population in general. The Depression of the 1930s took a horrendous toll on the assets of almost everyone. For example, from 1920 to 1930, the average immigrant estate was $3,390, and from 1930 to 1940, this figure dropped to $2,193. By the end of the 1950s, this average had risen to $16,938.

After World War I, foreign immigration to the lower valley ceased to a large degree. The great flow of people seen in the period from 1890 to 1915 was now only a memory and historical fact, and the factories had been demolished or made into shops and condominiums. Many of the people who arrived in the second half of the 20th century and into the 21st century came from familiar places such as Boston, Massachusetts, New York City, Fairfield County, Connecticut, and Westchester County, New York, and seemed to be retreating from an urban mode of life. The rural atmosphere of Deep River and Ivoryton remained appealing, proving that immigration has many faces.

—Don Malcarne

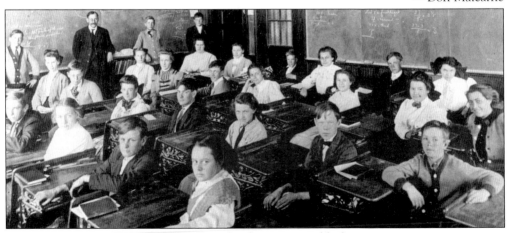

THE IVORYTON SCHOOL. This grammar school was responsible for many immigrant youngsters.

ROMAN AND JOSEPHINE BORKOWSKI. The Borkowskis took in boarders and entertained family and friends in their nine-room house. The attic of the house was finished to accommodate sleeping children while parents gathered below. A vital aspect of life was maintaining homeland identities, especially for the first generation. Friends of the Borkowskis included the Kobylenskis, Majeskis, Biedryzkis, Hmielewskis, Budneys, and Zabielskis, among others. (Photograph courtesy of Helen Zabielski MacWhinney.)

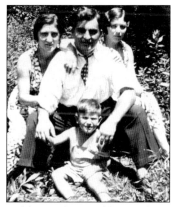

THE GAUDENZI FAMILY, BLAKE STREET, 1932. This house, rented by Fred and Alda Gaudenzi from Comstock, Cheney & Company for $12 per month, had a hand water pump in the kitchen, a coal stove for heat, but no inside toilet. Electricity was installed in these dwellings c. 1920, with each home having a single circuit, a relative luxury at the time. The Gaudenzis' second home, also on Blake Street, extends to Lord's Pond. The pond drew children from that neighborhood, as well as children from the Polish area and Little Italy, which was in the Pond Meadow section of Ivoryton. Lord's and Clark's Ponds were used for swimming and skating. During the winter, Gaudenzi was one of the men who harvested blocks of ice from Clark's Pond. The Gaudenzis' backyard vineyard supplied grapes for wine making, and its fruit trees yielded produce for jam, jellies, and pies. The factory built over 100 houses for employees and encouraged other building of a similar type. Other than milk and flour, everything that the family ate (vegetables, fruit, chicken, and even rabbits) was produced at home. As the production of piano actions and keyboards increased at the end of the 19th century, more and more housing was required for the growing workforce. (Photographs courtesy of Alda Gaudenzi.)

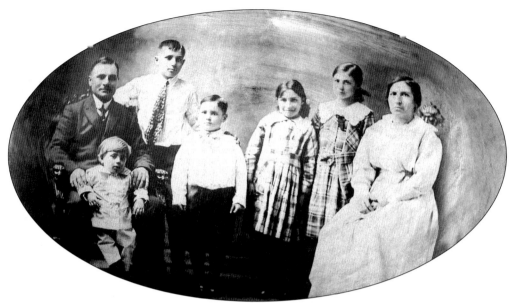

THE CUTONE FAMILY, C. 1922. At age 15, Luigi Cutone (left) emigrated from Italy and, in 1898, he went to work making piano actions at Comstock, Cheney & Company. He boarded on Bokum Road in Centerbrook, walking the several miles round trip to work six days a week, and laboring 10 hours a day for 10¢ an hour. With him, from left to right are Jerome Ferdinando (in his arms), John Anthony, Charles Lewis, and Isabelle, Carrie, and Angela Iannatelli Cutone. When the Loggia Piave (today's Children's House) was built in 1925 by local Italian families, Carmelo Carnabuci, Frank Barbaresi, Anthony Renzoni, and Fred Gaudenzi were masons who lent their skills to erecting the building. The Pieretti brothers were also active in the lodge, raising money, running dances, and planning special weekend and holiday activities, such as the Labor Day Festival. Members of the board of directors included Louis Pieretti, Joseph Fiorelli, Silvino Malcarne, and Bennie DiConda. (Photograph courtesy of Jerome and Jennie Cutone.)

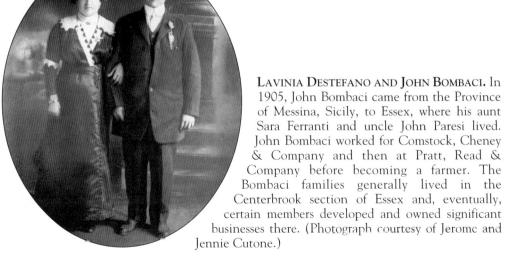

LAVINIA DESTEFANO AND JOHN BOMBACI. In 1905, John Bombaci came from the Province of Messina, Sicily, to Essex, where his aunt Sara Ferranti and uncle John Paresi lived. John Bombaci worked for Comstock, Cheney & Company and then at Pratt, Read & Company before becoming a farmer. The Bombaci families generally lived in the Centerbrook section of Essex and, eventually, certain members developed and owned significant businesses there. (Photograph courtesy of Jerome and Jennie Cutone.)

THE LAST IVORYTON GRAMMAR SCHOOL. Used for more than 50 years, the last Ivoryton Grammar School educated a great number of immigrant children. It was demolished in 1959 after the Essex Elementary School was established in Centerbrook in 1954. This new central school finally accomplished what had started as early as 1869 in Essex, when thoughts were first given to putting the five grammar schools under one roof. By 1912, each of the three villages of Essex had a single school, down from a grand total of eight separate schools in 1812. (Photograph courtesy of Mary Bowers.)

THE IVORY HOTEL. The Ivory Hotel was originated in 1865 to house male employees and was part of the vision that Samuel M. Comstock had for the development of Ivoryton. New immigrant employees were housed here until their families were able to follow them. As the families arrived, a shortage of family housing led to the building of factory houses. (Photograph courtesy of Mary Bowers.)

THE LOMBARDI FAMILY, POND MEADOW ROAD. Many Italian immigrant families settled in the western section of Ivoryton in the Pond Meadow area. It was close to the Comstock, Cheney & Company where most worked and had land available for gardens. As with most immigrant groups throughout the eastern United States, Ivoryton immigrants developed what were essentially satellite communities, where many of the traditions of their original homelands

could be maintained. From left to right are Mary Lombardi Giardini, Lena Lombardi Orsina, Lucy Lombardi Boggio, Annie Lombardi Torrenti, Julia Filippi Lombardi, Rocco Lombardi, Anthony Lombardi, Philip Lombardi, Paul Lombardi, and Daisy the cow. (Photograph courtesy of the Lombardi family.)

THE IVORYTON BASEBALL TEAM, 1890. Baseball was an American sport and truly foreign to most European immigrants. As the children of these newly arrived citizens went to school and became acclimated to the sport, they often excelled. One of the finest local baseball players on the high school level was Marion "Monyack" Hmieleski from Ivoryton, who attended Pratt High School in the early 1940s. From left to right are the following: (front row) Billy Hughes, Bill Bohling, Herb Robinson, Gus Carlson, and Ed Dunn; (middle row) Fred Miller, Dr. C.I. Winne, Carl Samuelson, and Mike Dunn; (back row) Al Saffery and E.W. Samuelson.

IVORYTON GRAMMAR SCHOOL, SEVENTH AND EIGHTH GRADE. This c. 1934 picture captures the immigrant spirit of Ivoryton. The influx of immigrants at various times in the history of the country has generally had many beneficial and long-lasting effects. The potpourri of names listed reflects the demographics of the Ivoryton and Centerbrook sections of Essex. From left to right are the following: (front row) Charles Johnson, Gino Filippi, Francis Peterson, Russell Daniels, Rose Filippi, Anna Werner, Arline Ferris, Frances Crane, and Betty Bull; (middle row) Herbie Gannon, Walter Beniever, Charles "Chubby" Clark, Helen Zebielski, May Sterling (Rutty), Beatrice Fox, Alberta Beldon, and Jerome Wilcox; (back row) Marion Fields, Ethel Peterson, Joseph "Lenny" Malcarne, Wayland Champlain, Leroy "Ray" Carter, Lewis Banning, Clemmons Borkowski, Irene Zebielski, Susie Barbarisi, Josephine (Teet) Malcarne, Weldon Cade, and Lewis Holly. (Photograph courtesy of Helen Zebielski MacWhinney.)

Six

QUEEN OF THE VALLEY

Even in the 21st century, the term "good old days" tends to recall the Gay Nineties and the beginning of the 20th century. Those surely were good old days for Deep River. By that time, the town was fast becoming the leading commercial center in the lower Connecticut Valley, and unparalleled economic and social prosperity made for an enviable way of life.

The crown jewel of Deep River manufacturing was Pratt, Read & Company, which had existed in one form or another since 1798. By the start of the 20th century, despite the 1881 fire that destroyed the company's principal building on Main Street, new construction and the demand for ivory piano keys kept between 300 and 400 workers on an ever increasing payroll. The building of the Valley Railroad in 1870 efficiently brought ivory into town to be processed, supplementing the old river route.

In 1896, James A. Jones established the Niland Cut Glass Company in the factory in which Calvin B. Rogers had operated an ivory novelty enterprise. Utilizing a turbine water wheel and a horizontal engine, the company turned out a wide variety of cut glass items (examples of which may be seen today at the Deep River Historical Society), which garnered a widespread reputation and were successfully retailed in Niland's New York showroom and even to foreign markets.

Other important manufactories included the Russell Jennings Company, founded before 1837, which by the 1890s had become a leading maker of auger bits; Horace P. Denison's organ stops; and Potter & Snell, a producer of bright wire products at a factory located conveniently next to the railroad depot.

Although there is nothing at all romantic about wire or auger bits, it was on industrial products like these that America ran, and they produced substantial fortunes. In the late 19th century, large Gothic Revival houses blossomed all over Deep River, tangible testimony to increasing wealth. The town's two banks, the Deep River National Bank and the Deep River Savings Bank, flourished—the assets of the latter in August 1899 were more than $1.4 million, remarkably almost all of this sum due to depositors alone. It was the town's capital that lured the New Era away from Chester to Deep River in 1879 to become one of the lower valley's most successful newspapers.

Yet, for all its burgeoning industry, Deep River was still a small town with cozy small-town businesses. Along Main Street were Charlton M. Pratt's men's clothing store; the Deep River Boot and Shoe Store, owned by J. B. Banning; Susie A. Clark's notions shop; Thomas L. Parker's drugstore; the general merchandise dealers L'Hommedieu and Comstock; Julia L. Desmond's Millinery, supplying fashionable hats to the town's ladies; Leroy H. Shailer's grocery and grain mercantile, one of the busiest concerns in Deep River; the bicycle repair shop in which C.W. Gilbert serviced the hundreds of cycles that wheeled Deep River's streets; and the magically named Wonder Store, in which H.H. Mather sold dry goods, fancy goods, hats, shoes, and notions. It is safe to say that the proprietors of these shops knew their customers' names.

Together with economic prosperity came increased leisure time and activities. The Fernleigh Golf Club was organized in 1898 near the present Devitt Field, and a clubhouse (the Casino) was built in 1902. After the beginning of the 20th century, the Deep River Young Men's Club sponsored Masquerade Balls, a Tennis Club was established, and the Deep River Wheel Club in 1895 grew out of the booming bicycle craze of the 1890s.

However, if there was one symbol of Deep River's prosperity—and its fiscal self-sufficiency—

it was the new 1893 town hall, built in a graceful, sweeping triangular shape at the corner of Main and Elm Streets. William H. Jennings had offered to construct the edifice at no cost to the town, but this proposal was rejected at a town meeting in favor of raising the needed funds by public subscription. By August 1893, individuals and Deep River civic organizations had contributed a substantial $14,756 to the building fund, and more cash kept rolling in. Architect G.W. Cole and contractor Charles D. Kinney had already gone to work, and the new Deep River Town Hall was dedicated in April 1893. The only outright gift to the project was the construction of a Maine granite fountain at the rounded apex of the building, erected in 1905 by Samuel F. Snow as a tribute to his wife, Mary Hart Sill. The town hall became not only the administrative center but also the social nexus for a Deep River that had bloomed like a springtime flower—in a spirit of optimism, growth, and confidence in the future. If towns, like ships, can be regarded as female, then Deep River truly was the Queen of the Valley.

—Philip A. Shreffler

NILAND CUT GLASS. This cut-glass business was unique to the lower river valley. The factory on Roger's Pond once housed Calvin Rogers's ivory goods manufactory. Niland Cut Glass Company was founded in 1896 by Thomas A. Niland and later owned and operated by James Jones and his son Ansel. James Jones came to Deep River from Illinois and became a legislator from Saybrook. Calvin Rogers's shop was a spin-off from Pratt, Read & Company. Rogers died suddenly in 1883 and his son-in-law James A. Jones continued the business. James Jones's niece, Elizabeth Barnes Callender, donated this pitcher to the Deep River Historical Society. The butterfly design became a trademark of the company. It was designed by Thomas Mortensen for Niland when Anna Peck from Deep River mentioned to Mortensen that a moth she had seen on a screen door would make a nice cut glass pattern. The historical society owns 140 pieces of Niland cut glass, and 27 of those pieces have the butterfly pattern. Other companies have copied the pattern. (Photograph by Bill Nelson.)

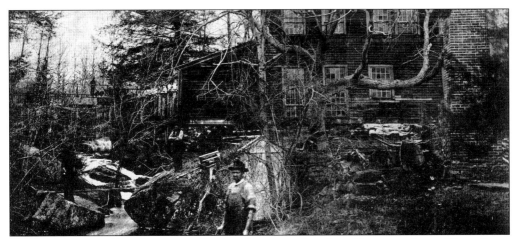

JENNINGS AUGUR BIT COMPANY. Stephen Jennings, founder of Jennings Augur Bit, suffered through financial loss in the panic of 1837 and, later, a fire that occurred after his insurance had lapsed. However, he endured and moved part of this Deep River factory to Chester when his brother, the Reverend Russell Jennings, invested money in the firm. After Stephen died, Russell took over the business in 1851 and changed its name to the Russell Jennings Company. He secured a significant patent on a bit named the Russell Jennings extension lip auger bit. Products of this factory were in demand nationwide. There were five factories: three in Chester and two in Deep River. (Photograph courtesy of Deep River Historical Society.)

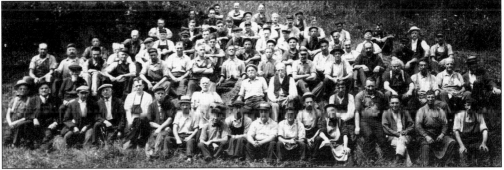

JENNINGS FACTORY WORKERS. This factory expanded during the latter part of the 19th century and produced a vast number of the bits made in this country. The invention of the single-twist auger bit by Ezra L'Hommedieu in 1815 was instrumental locally in the manufacture of wooden sailing ships, and set a foundation for this industry. From left to right are the following: (first row) Dick Champion, Henry Shailler, Oliver Bishop, Sam Shailler, Joe Gates, Irving Lund, Heman Crook, Arthur DeVoe, unidentified, William Ladd, Charles Pollacek, John Peterson, Fred Dittmar, Paul Shailler, Gus Williams, and Gus Lund; (second row) John Alexander, Frank Stimpson, Frank Sawyer, Charles Wooster, Jack Bowie, and Charles Strodt; (third row) Ed Epright, Clem Bailey, William Trowbridge, Lang Arnold, Dan Fox, Fred Hatch, two unidentified men, Angelo Radicchi, Clarke Bailey, Joseph Parker, Louis Wright, William Wooster, James Bushnell, Frank Parker, Joe Schlick, and Ernest Jennings; (fourth row) Edwin Smith, ? Reiger, Fred Parmelle, two unidentified men, Archie Rockette, Ed Clark, Roscoe Cone, Peter Montana, George Weisman, ? Swartz, Edgar Williams, Warren Church, Brophy Daniels, Frank Lund, and Primo Rolliri; (fifth row) Richard Church, unidentified, George Wilcox, unidentified, Jim Henry, Malcolm Shailler, George Egeter, John Smith, Oscar Anderson, Henry Ayers, two unidentified men, Clifford Parker, Griswold ?, Bill Stoddard, unidentified, and Louis Montana. (Photograph courtesy of Deep River Historical Society.)

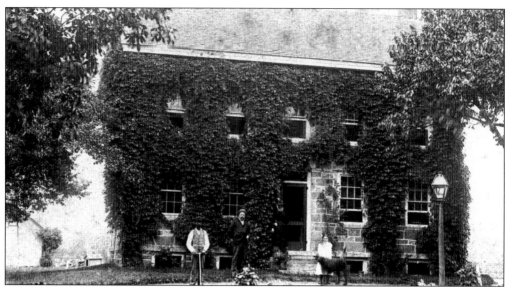

THE STONE HOUSE, BUILT IN 1840. Ezra Southworth built this four-room house for his bride, Eunice Post. It originally was a flat-roofed, Palladian-style structure with two rooms downstairs and two up. The conversion to a gable roof was the first of many substantial changes made to the house over the years. The Southworth's son, Ezra Job Birney Southworth, was a partner in the L'Hommedieu and Southworth General Store, at Main and River Streets. He served in the legislature and, in 1882, married Fanny Shortland of Chester. Their daughter Ada, born here in 1892, married Charles Munson. The Munsons' only child, a son, lived only 16 days. When Ada Munson died in 1946, she left the property to the Deep River Historical Society to be used for historical purposes. (Photograph courtesy of Deep River Historical Society.)

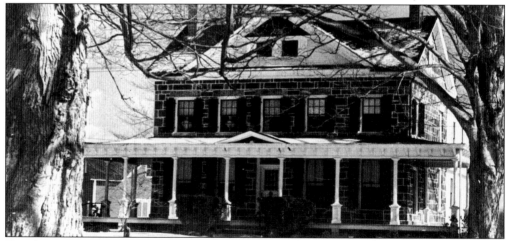

THE STONE HOUSE, 1899. The building of the large wooden ell was begun in 1881 as Ezra Job Birney Southworth was preparing to move into the house with his bride and his widowed mother. The piazza and attic dormer facing Main Street were added in 1899. The house is maintained by the Deep River Historical Society as a museum, staffed by volunteers and open on weekend afternoons in July and August. Exhibits include a room devoted to local mariners; a piano and a chest of drawers made from wood of the Charter Oak; Victorian furnishings in parlor, dining room, and bedroom settings; and products of local industries, including ivory processing and cut glass. (Photograph courtesy of Deep River Historical Society.)

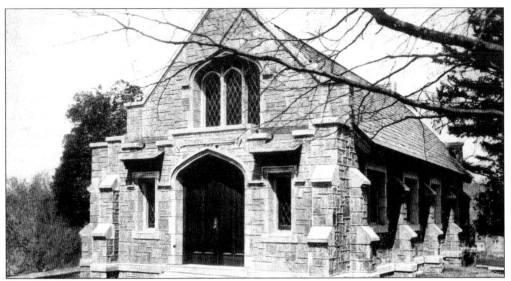

THE WOOSTER MEMORIAL CHAPEL. This chapel was built in 1912 on the grounds of the Fountain Hill Cemetery with money donated by Mary McCellan Wooster, granddaughter of George A. Read Sr. The more-than-3,000 stones making up the chapel were quarried and cut by Hugh Campbell of Deep River in the quarry adjoining the cemetery grounds. The chapel was open to the public for the first time in 1915. Quarrying was once an important industry in Deep River, with products being shipped to the major eastern cities of New York, Philadelphia, and Boston. (Photograph courtesy of Deep River Historical Society.)

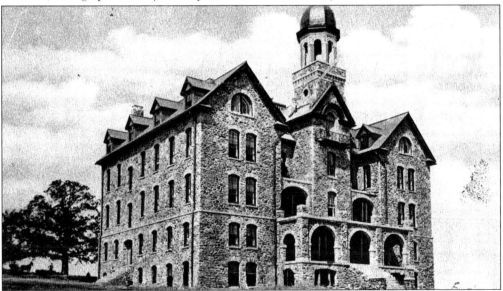

MOUNT ST. JOHN SCHOOL. In 1906, the Catholic Diocese of Hartford built this school to house orphans. The land was donated to the Catholic Church by the Duggan family, who in the late 1800s had purchased it along with other property once owned by Calvin Williams and his family. The school has operated for nearly 100 years and is now partially subsidized by the state and administered by the Catholic Diocese of Norwich. This postcard was distributed by E.R. LaPlace, who ran a drugstore in the center of Deep River. (Photograph courtesy of Deep River Historical Society.)

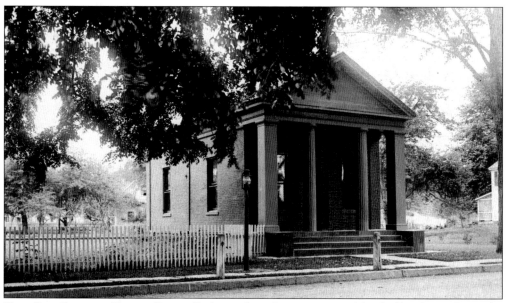

THE OLD SAVINGS BANK. Originally located in the store owned by Sedley Snow (now the Short Stop), the old savings bank was called simply the Bank. In May 1851, a charter of incorporation for the Deep River Savings Bank was granted to George Read, Capt. Joseph Post, Joshua L'Hommedieu, Alpheus Starkey, Zebulon Brockway, Sedley Snow, John C. Rogers, Henry Wooster, Henry W. Gilbert, Samuel P. Russell, Joseph H. Mather, Ulysses Pratt, Ezra S. Williams, and Calvin P. Rogers—all residents of Deep River, Chester, and Hadlyme. The Deep River Savings Bank purchased the original building of the Deep River National Bank in 1879. Deep River and Essex were the first towns in the lower valley to have banks, indicating the strength of the shipbuilding and later the ivory industries. (Photograph courtesy of Deep River Historical Society.)

BANK BURGLAR KILLED BY H.D. TYLER. A burglar, whose identity has never been discovered, was killed by night watchman H.D. Tyler at the old Deep River Savings Bank at 2:00 a.m. on December 13, 1899. The burglar has always been referred to as XYZ. Tyler shot XYZ with a Winchester Repeating Riot gun, purchased at the Winchester Repeating Arms Company in 1899 in New Haven. This photograph was taken in the basement of the town hall in a room used by W.G. LaPlace as a funeral parlor. The burglar is buried in Fountain Hill Cemetery with a stone that says XYZ. Folklore has it that H.D. Tyler received a letter from a woman asking that a marker be put on the dead man's grave. A story that became local legend was that a woman dressed in black would get off the train on the anniversary of his death, put flowers on his grave, and get back on the train. (Photograph courtesy of Deep River Historical Society.)

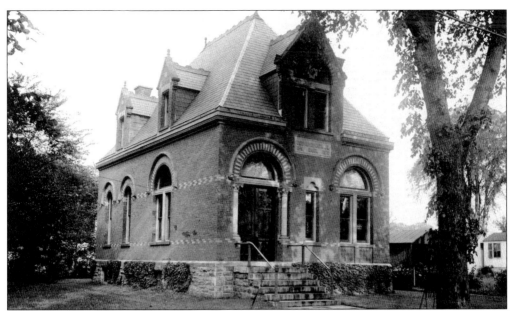

THE NATIONAL BANK. This bank was chartered in 1849 with Joshua L'Hommedieu as first president. Many of the same people involved with the later Deep River Savings Bank were directors here. This structure was built in 1879 but has seen enormous renovation since 1960. Originally, the business of this firm was carried on in the home of George Read, diagonally across the street. Interestingly, Comstock, Cheney & Company in Ivoryton carried on much of its business with the Deep River National Bank. (Photograph courtesy of Deep River Historical Society.)

THE NEW ERA OFFICE BUILDING. This newspaper had great importance in the lower valley for 100 years. In 1879, New Era founder Francis Sheldon moved the newspaper from Chester to Deep River. Charles A. Kirtland became publisher in 1885. Later, it was moved near the location of the present Deep River Hardware Store. Under Ernest Prann and his son Wallace, the company included a printing company, which remained one of the leading printers in the lower valley long after the newspaper was gone. They printed everything, including the monthly programs of the Deep River, Essex Square, and Clinton Theaters. Curtiss Johnson became publisher and moved the newspaper to the former A.R. Jones garage on Main Street. Later, it was owned and operated by Henry Josten and John Colbert. Since the Pictorial purchased it in 1977, Josten has continued to write for it. The original issues of the New Era, from 1874 through 1977, are not available to the public because of their fragile condition. They were put on microfilm by the State of Connecticut Newspaper Project in the late 1990s and can be viewed at the Deep River Library. (Photograph courtesy of Deep River Historical Society.)

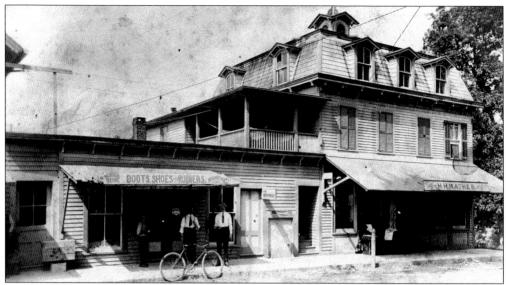

H.H. MATHER'S WONDER STORE. This business enterprise on North Main Street store was typical of stores that emerged in more progressive rural areas at the end of the 19th century. Operated from 1895 by Herbert H. Mather, it carried a broad line of dry goods and occupied the main floor of a building owned by Milon Pratt, which is still extant. The Mather family was prominent in the lower valley. Mather and his son, Gilbert, were local historians. (Photograph courtesy of Deep River Historical Society.)

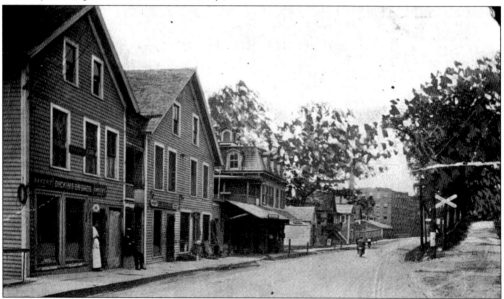

NORTH MAIN STREET STORES. This postcard of North Main Street in Deep River indicates how active this town was as a retail center in the early 20th century. Mather's Wonder Store can be seen in the center. Behind these buildings was Keyboard Pond, a power source for Pratt, Read & Company, still there today. Deep River developed a commercial area along the Middlesex Turnpike, which ran through the center of town. The turnpike, which was extended from Saybrook to Hartford in 1801, defined the location of the center of Deep River. (Postcard courtesy of Deep River Historical Society.)

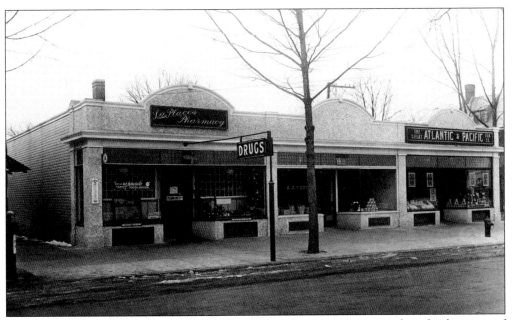

THE DURR BLOCK. This 1923 photograph indicates the continuing growth and refinement of the area along the west side of Main Street (Middlesex Turnpike) in Deep River, near the intersection of Village Street. Carl M. Durr, who was in the electrical business, built the Durr Block. Blocks such as this one were often built for retail purposes. A national chain, the Great Atlantic & Pacific Tea Company (A & P), established an early supermarket in town. Heiney Troeger later operated LaPlace's drugstore for many years. (Photograph courtesy of Deep River Historical Society.)

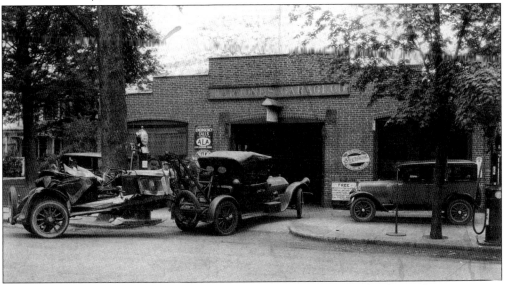

THE ANSEL R. JONES GARAGE. Today, Mike's Bakery on the west side of Main Street occupies what was once a thriving automobile business. A.R. Jones sold Overland cars after constructing this building in 1914. Robert Harrison and Harry Glass operated a DeSoto car agency here after World War II. The *New Era* was located here after the demise of this car agency. (Photograph courtesy of Deep River Historical Society.)

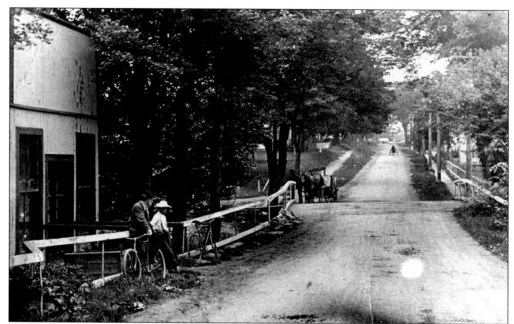

NORTH MAIN STREET, LOOKING SOUTH, 1906. This building was once the Star Theater, owned and operated by Campbell and Desmond. It was used for movies, roller-skating, and ice-skating. For entertainment, a pig was let loose on the ice, customers were blindfolded, and the customer who found the pig was the prizewinner. The Beauchene family purchased the building in 1914. (Photograph courtesy of Deep River Historical Society.)

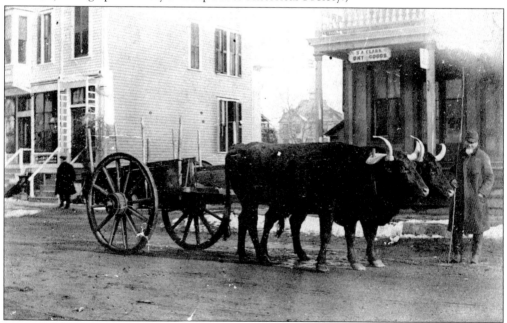

SARAH A. CLARK'S NOTION STORE. This store was located in the Union Block on the east side of Main Street in Deep River. Jewelry, notions, and candy were sold here. This building was demolished in the 1960s. It was once the home of Strick's Bakery and had tenements in the upper floors. (Photograph courtesy of Deep River Historical Society.)

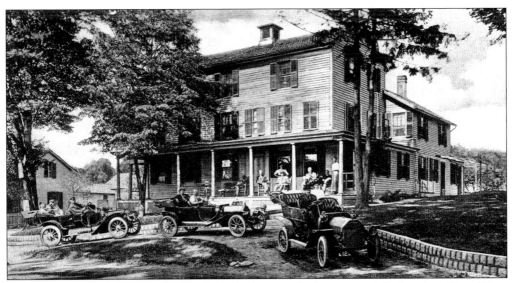

THE CHRISTENSEN HOTEL. This Hauser Bob photograph shows one of the hotels in Deep River at the beginning of the 20th century. The other was the Wahginnicutt House on the waterfront on Kirtland Rocks. The Christensen was located on the south corner of the Middlesex Turnpike and Kirtland Street and, as with most hotels of the day, operated a livery service. This hotel was very convenient to the leading industry of Deep River, the Pratt, Read & Company. The livery allowed it to connect to steamboats that stopped at the Deep River Landing. Hauser Bob was a well-known local photographer in the early part of the 20th century who lived above Robinson's Funeral Home near the railroad tracks in Centerbrook. (Photograph courtesy of Deep River Historical Society.)

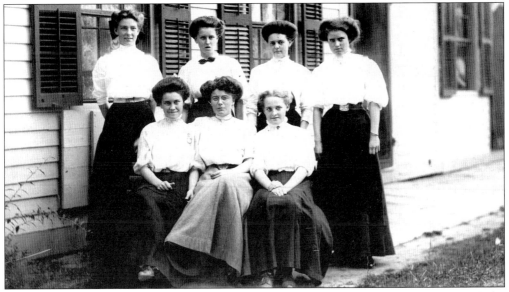

EMPLOYEES OF THE CHRISTENSEN HOTEL. Shown are some of the employees of the Christensen Hotel. From left to right are the following: (front row) Jennie Beauchene (Clark), Ethel Duryea (Meade), and Agnes Olsen; (back row) Cecelia Campbell (Eagan), Grace Starr, Lottie Waterman (Joy), and Maude Dickenson. (Photograph courtesy of Deep River Historical Society.)

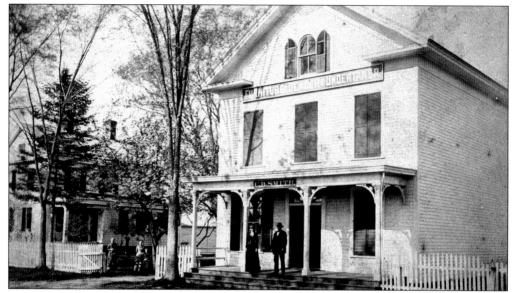

THE CHARLES D. SMITH FURNITURE STORE. This building was located on the east side of Main Street in Deep River in the south end. Charles D. Smith manufactured furniture from 1841 to about 1873. His daughter sold the store to William G. LaPlace, who moved it to the center of town on the opposite side of Main Street nearly 100 years ago. It soon became LaPlace's Furniture Store, and it has been operated over the years by William G. LaPlace's son, Simon LaPlace, his grandson, William B. LaPlace, and his great-grandson, Simon LaPlace. (Photograph courtesy of Deep River Historical Society.)

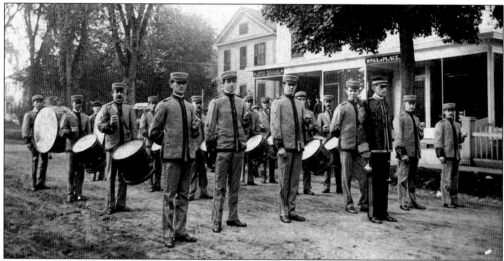

LAPLACE'S NEW FURNITURE STORE. The opening on October 4, 1901, of William G. LaPlace's new store was cause for celebration. LaPlace took over the building of C.D. Smith and continued the same general lines of merchandise. He was also an undertaker and the originator of the firm that later became LaPlace, Ziegra & Price. The updated store is shown, as is the homestead of Dr. Devitt (left background). The store was added to in 1906, 1964, and 1967, and it was entirely destroyed by fire in 1981. At 26 years of age, Louie Pratt (front right) is a member of the Deep River Drum Corps. (Photograph courtesy of Deep River Historical Society.)

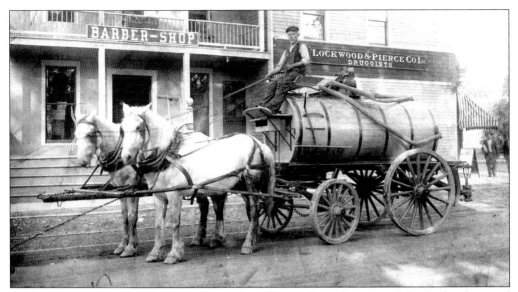

THE BARBERSHOP AND DRUGSTORE, 1914. This is the side view of the barbershop and drugstore at the corner of River and Main Streets in 1914. A billiard hall was located on the top floor above the barbershop. The drugstore (today, the Short Stop) is one of many similar establishments located in the building over the years. (Photograph courtesy of Deep River Historical Society.)

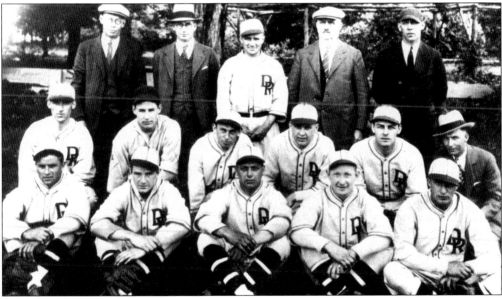

THE DEEP RIVER QUEENS. Baseball was a leading recreation in the late 19th century and through the first half of the 20th century. Industrial leagues were formed, and they played relatively high-quality baseball. The Comstock, Cheney & Company team in Ivoryton was a fine example. The Deep River Queens was a town team, representing Deep River in the Middlesex County League. They played at Devitt Field, among other places, and often attracted large crowds in an era before television and radio. Legendary player Paul Hopkins of Deep River, who once pitched for the Washington Senators in the American League, played in this county league. (Photograph courtesy of Deep River Historical Society.)

THE DEEP RIVER TOWN HALL. This is one of the most significant public buildings in Middlesex County. Built in 1893 on the site of old Read Hall, the Deep River Town Hall conformed to the diagonal street layout. Samuel Snow donated the granite fountain in memory of his wife. Originally, it housed private businesses, such as Charlton Pratt's clothing store, and the post office. Town offices were located on the second floor. The post office remained here until the current post office was constructed in the early 1960s. This building, with an auditorium on the third floor, was avant-garde at the time of its construction and was testament to the affluence and the influence of Deep River economically. (Photograph courtesy of Deep River Historical Society.)

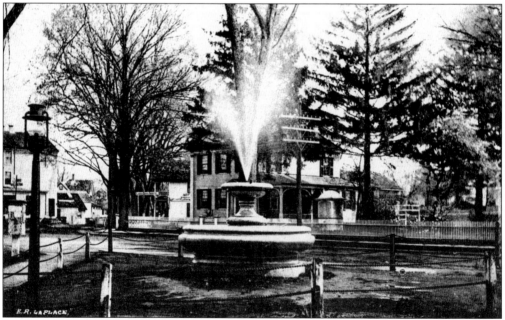

THE MEMORIAL FOUNTAIN. This fountain, set on the north side of the town hall, was donated in 1905 by Samuel F. Snow in memory of his wife. Using granite from Blue Hills, Maine, Snow paid $2,000 to the White Granite Company of New York for the design and all materials. Chester Water Company offered to supply water for the memorial fountain for free. (Photograph courtesy of Deep River Historical Society.)

Seven

BEAT, DRUMS, BEAT

The towns of Deep River and Ivoryton have sent many people to fight in foreign and domestic wars. This chapter is a tribute to those who have served over the years and to those who have honored them and their memory by building monuments and honor rolls. Through the past three centuries, they have gone forth, a few never to return. The citizens of Deep River and Ivoryton can be very proud of their many veterans.

From the 1637 Pequot War to the present, people have come from their communities to defend causes that represented their beliefs and to oppose perceived threats to established cultures. Lt. William Pratt, often thought of as the founder of Potapoug Quarter (currently the towns of Essex, Deep River, and Chester), was a leader among the group of Englishmen and Nehantic Indians that attacked the Pequot nation in the Mystic area in 1637. Although he was from Hartford at the time, he later moved to Saybrook and his military reputation was instrumental in his becoming one of the leading local citizens in the 17th century.

The population was sparse in these two villages at the time of the Revolutionary War, and the number of those fighting for independence was low. Ensign Nathaniel Kirtland, who died in the service in late 1777, commanded a company that included Asa Pratt (soon to become a well-known local blacksmith), Reuben Clark from the Bushy Hill section of Ivoryton, and Samuel Comstock, also of Ivoryton. Comstock served throughout the entire conflict, including the Battle of Saratoga, and in Groton during the British attack there on September 6, 1781. He had also served in the French and Indian War, along with Ivoryton residents Thomas Pratt, and Peter, John, William, and Christopher Clark. Notably, he was the grandfather of Samuel Merritt Comstock, one of the most prominent industrialists ever to live in Middlesex County. Another young Ivoryton citizen, William Comstock, Samuel's eldest son who was only 16 years old, was killed in the battle at Groton. Cyrus Graham, who lived on Book Hill Road, served in the company of Capt. John Ely of Lyme. Most of these Revolutionary War and French and Indian War veterans are buried in River View Cemetery in Essex and in the Old Winthrop Cemetery. The latter burying ground is the subject of *A Watch to Keep*, by Jeanne Spallone, which clearly defines the Revolutionary War veterans buried there.

The War of 1812 was largely without political and popular support in Connecticut. In fact, Gov. Roger Griswold would not allow the Connecticut Militia to be used out of state, and a move to secede from the Union was actually supported but never enacted. Ironically, one of the most significant actions of this war took place in the lower valley when the British burned the ships in the harbor at Potapoug Point on April 8, 1814. This was a terrible defeat for the Americans, resulting in one of the largest financial disasters of the war. No citizens or militia were injured or killed.

The Civil War represents the first massive use of soldiers and sailors in our nation's history. Gen. Alpheus Williams, son of ivory entrepreneur Ezra Williams, became, perhaps, the most famous of Deep River's native sons to fight in this war. He had been a Michigan resident for over 20 years and had fought in the Mexican War, prior to 1861. Capt. Bela Post, another ivory manufacturer from Ivoryton, died in the conflict in September 1863. Two Deep River men, William Lane and George Bailey, were killed at Antietam on the same day, September 17, 1862. In all, more than 10 men from Deep River died, from all causes, in the Civil War, including the well-known mariner Capt. Samuel Mather, who was shot in Florida while in command of the ship *Henry Andrews*, His significant marble Egyptian obelisk memorial stands in Fountain Hill Cemetery in Deep River. The others were Frederick Ingham, Frederick

Stillman, Gilbert Hefflon, George Bailey, William Lane, Oscar Daniels, Henry Southworth, Samuel Rice, Charles Beman, Edmund Doane, and Henry Lyman.

The wars of the 20th century involved more persons than ever before, as well as a different cultural makeup of the armed forces. In World War I, newly arrived immigrants, most of them ivory factory workers, were conspicuous by their presence. Fourteen first- or second-generation immigrants served from Ivoryton, including eight who were born overseas. The same applied to Deep River, although in this case, there were more people of Swedish descent. The Ibell-Jacobson American Legion Post was named for two who perished in World War I, and to honor those who served in that war, both villages instituted honor rolls. A wooden honor roll in Ivoryton was located at the intersection of Main and North Main Streets; in Deep River an honor roll was placed in Library Park, at the intersection of Main and Essex Streets. A painting of the Ivoryton Honor Roll memorial hangs in the Ivoryton Library. The Ivoryton memorial was only for that section of Essex.

In 1923, the Deep River Honor Roll was replaced by a different memorial, a large stone in the same general area. It featured a bronze eagle on top and a commemorative plaque on the face. Behind the plaque rests a copper container, listing all the donors to the memorial (it cost $1,000), as well as those who served in both World War I and the Civil War. The money was raised by popular subscription, and the boulder was found locally in Essex.

World War II required the services of over 400 Deep River residents. Clarence D. Batchelor, a prominent cartoonist, artist, and local resident, designed and painted a life-size figure of Columbia, which stood embracing the names of those who participated in World War II. This memorial initially stood on the front lawn of the Deep River Library and was dedicated in November 1943. Originally, it contained 315 names and one gold star, for Corp. Joseph Smith, the first person to be killed from the town in World War II. His name was added to the title of the American Legion Post. A total of 12 people never returned to Deep River from this conflict.

A committee was formed in 1985 to replace or repair the weather-damaged Columbia memorial. The memorial was subsequently moved to Library Park, which was renamed Veterans Memorial Park and was expanded and rebuilt to hold the names of Korean and Vietnam War veterans. The park was dedicated on November 11, 1990. The white bricks on the patio memorialize those who died in the last three wars. A total of 62 people are now listed who served in Korean War, plus 130 from the Vietnam conflict.

Ivoryton veterans of 20th-century wars are now remembered individually on a granite memorial in Veterans Park in the Centerbrook section of Essex. This monument was dedicated on Memorial Day of 2001 and includes the names of nearly 1,000 veterans, including those from Essex Village and Centerbrook as well as Ivoryton.

—Don Malcarne

BRIG. GEN. JOHN E. WATROUS. During the Civil War, John E. Watrous was appointed brigadier general of the 2nd Brigade by William W. Ellsworth, captain-general and commander in chief in 1838. Watrous was killed by a friend in a hunting accident in 1872, when he was age 60. His son, Irving Watrous, was married to the daughter of shipbuilder Eli Denison. (Courtesy of Deep River Historical Society.)

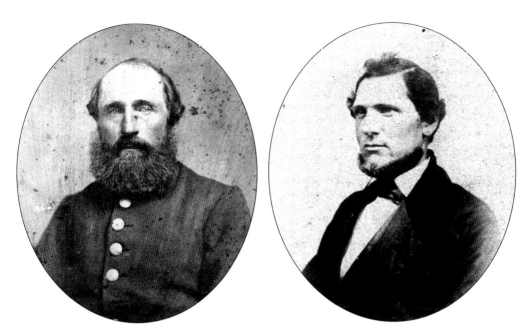

WILLIAM LANE AND GEORGE E. BAILEY JR. These two Deep River men were killed in the Battle of Antietam in September 1862. George E. Bailey Jr. (left) was 38 years old, and William Lane (right) was 52 when they were killed just hours apart. Lane was the brother of Deep River waterfront merchant John Lane. They were members of the 11th Infantry, which included many Deep River people (as reported by Daniel Connors in his 1966 book *Deep River*). Lane and Bailey had joined the 11th Infantry on the same day as 15 other men from Deep River. During the Civil War, the town offered increasing bounties to recruits to meet enlistment quotas set by the federal government through the state. These bounties were paid directly from the town treasury. They started out at $10 and rose to $200 per man near the end of the conflict. (Photographs courtesy of Deep River Historical Society.)

CIVIL WAR VETERANS. After the Civil War and with the establishment of a Decoration (Memorial) Day, parades and tributes to members of the Grand Army of the Republic (GAR) became popular. The Civil War had been the first conflict in our nation's history that had involved such a large percentage of the country's population, including immigrants. It was something that was not to be forgotten. Among other soldiers from Deep River who died were Henry Southworth, born in 1837, and Charles Beman, who died in 1862 of typhoid in Newbern, South Carolina. Their bodies were returned to Deep River for burial. Identified in this view are Ambrose Miner (back, fifth from left) and Willoughby Hull (seventh from left). (Photograph courtesy of Deep River Historical Society.)

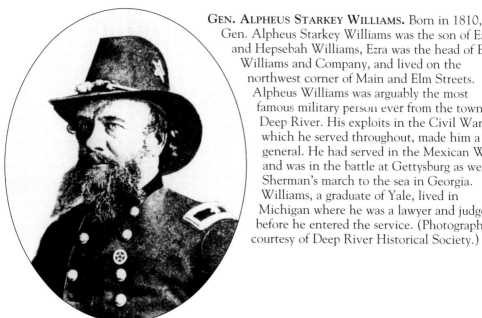

GEN. ALPHEUS STARKEY WILLIAMS. Born in 1810, Gen. Alpheus Starkey Williams was the son of Ezra and Hepsebah Williams, Ezra was the head of Ezra Williams and Company, and lived on the northwest corner of Main and Elm Streets. Alpheus Williams was arguably the most famous military person ever from the town of Deep River. His exploits in the Civil War, in which he served throughout, made him a general. He had served in the Mexican War and was in the battle at Gettysburg as well as Sherman's march to the sea in Georgia. Williams, a graduate of Yale, lived in Michigan where he was a lawyer and judge before he entered the service. (Photograph courtesy of Deep River Historical Society.)

MEMORIAL DAY, 1914. Included in this picture are Civil War veterans Sylvester DeForest, William Henry Epright, and Willoughby Hull at the Fountain Hill Cemetery, members of the Mather Post GAR, which preceded the America Legion Post. (Photograph courtesy of Edith M. DeForest.)

IN MEMORY OF AMBROSE P. WATROUS, 1917. The Mather Post GAR issued this document, Resolutions of Respect, upon the death of Civil War veteran Ambrose P. Watrous. The officers of the post signed the document.

Below begins a list of veterans who served in World Wars I and II, Korea, and Vietnam. The list continues on pages 93, 95, 97, and 98. Note: Those who died in the war are identified with a star (*). (Courtesy of Deep River Historical Society.)

WORLD WAR I

Essex
*Anderson, Edward A.
Antonson, Theodore A.
Babcock, Lemon F.
Babcock, Lloyd D.
Barbaresi, Frank
Baroni, Joseph R.
Baroni, Louis J.
Beebe, Orville N.
Berg, Albin
Blair, Walter D.
Blair, William G.
Bombaci, Antonio
Bowie, Edward V.
Bradeen, Frederick B.
Brown, Charles N.
Brown, Frederick W.
Brown, George C.
Budney, Frank
Budney, Stephen P.
Bump, Frank L.
Burdick, Alfred E.
Burnap, Arthur E.
Burnap, Raymond J.
Burnap, Robert S.
Bushnell, Arthur A.
Bushnell, Elliott E.
Cade, Dorothy K.
Canessa, Louis N.
Canessa, Sevenee
Carlson, Carl A.
Carlson, Philip C.
Carnabuci, Carmelo
Carter, Adelburt W.
Carter, Frank V.
Champlin, Clarence B.
Chapman, Maurice S.

Christnagle, Wellington E.
Chrystal, Sherman H.
Clark, Burt R.
*Clark, Charles E.
Clark, Henry M.
Clark, Ralph N.
Comstock, Leonard E.
Cone, Willis
Cronkhite, Henry M.
Darling, Lawrence W.
DiCara, Carmelo
Dickinson, Albert E.
Dickinson, Edward E., Jr.
Dickinson, John W.
Dickinson, Leslie R.
Edburg, Walter A.
Emmons, Wilson J.
Fenn, George A.
Fenn, Samuel R.
Ferranti, Turey
Field, Adelburt C., Jr.
Fordham, Orrin F., Jr.
Frederickson, John G.
Gardner, Burton
Graham, John
Hall, James F., Jr.
Hall, John H.
Hayden, Kenneth A.
Hayden, Sidney
Hillsinger, Earl
Hillsinger, George
Hoadley, Ernest
Howard, Daniel A.
*Hubbard, George C.
Hubbard, John T.
Hunt, Willis R.
Hyatt, Charles F.
Hyatt, Edward C.
Johns, Paul M.

Johnson, Axel R.
Johnson, Carl E.
Johnson, Edward J.
Johnson, Ernest B.
Johnson, George M.
Johnson, John A.
Johnson, Robert E.
Jones, Ernest R.
Keller, Frank J.
Kobylinsky, Joseph
Koehler, Frederick H.
*LaPlace, Robert A.
Larson, Axel L.
Leavenworth, Charles A.
Lewis, Frank W.
Lewis, William F.
Lindgren, Henning A.
Lindsten, Hilmer
Looby, Charles F.
Looby, George F.
Lord, Burt R.
Lynn, Clarence R.
Maas, Joseph
Mack, Lewellyn E.
Martelli, Pasquale
Messick, Donald W.
Mileski, John
*Mileski, Marian
Miller, Francis J.
*Miller, Frederick W.A.
Moore, Joseph P.
Morrissey, John J., Jr.
Morse, Harry B.
Mowry, Charles H.
Nelson, Ernest E.
Norman, Edward J., Jr.
Palau, Henry
Palau, Louis
Palm, A. Julius

Parmelee, Frank H.
*Pearson, Randolph W.
Peck, Carroll W.
Peck, Clifford A.
Pelton, Graham
Perkins, Herbert R.
Peterson, David, Jr.
Peterson, Elmer
Pierce, Harry E.
Pierson, Carl A.
Pierson, John A.
Pinelli, Arthur M.
Post, Henry K.
Post, James W.
Potter, John T.
Potter, Mildred A.
Powers, David J.
Prann, Stuart M.
Prescott, Wilbert P.
Price, Earl W.
Rackett, Robert P.
Rawson, Jewett R.
Reynolds, Harry B.
Richards, John M.
Ridgeway, Charles L.
Riggio, Alessio L.
Roger, Harry P.
Rogers, Smith O.
Rosedale, Oscar G.
Royce, Carl N.
Salzgeber, John W.
Sampsell, Paul L.
Samuelson, Elizabeth D.
Santi, Zairo
Saunders, William B.
Seely, George C.
Spencer, Daniel W.
Spencer, Gilbert H.
Stannard, Gilbert

Stannard, Russell E.
Stevens, Elmore C.
Tibbals, Julia A.
Tiley, Albert V.
Tiley, Charles A.
Tiley, Morton C.
Tolx, George E.
Tripp, George D.
Tripp, Merle A.
Tucker, Lewis H.
Tyler, Harry R.
*Vanamee, Parker
Von Hegan, Ensley A.
Walden, Alfred L.
Walden, Harry L.
Wallace, Clarence E.
Watrous, Frank A.
Webber, Lorenzo D.
Webber, Wooster W.
Williams, Frederick S.
Wright, Northam L.
*Wyant, Leroy A.

Deep River
Ahlstrin, Elmer
Anderson, Lawrence A.
Bahr, Herman G.
Bartman, Kenneth E.
Beckwith, Willis A.
Berg, Gustaf R.
Berdensey, Arthur
Berg, Albin
Berg, Hjalmer
Berg, Philip
Blong, Michael
Bowie, Edward
Caples, Jesse W.
Carini, Anthony J.
Carini, Edward J.

91

THE DOUGHBOY STATUE. After both the Civil War and World War I, bronze statues were often erected as a tribute to those who had served. This doughboy was placed in front of the Deep River High School and was posed for by Thomas Latham of Deep River. From Deep River, Pvt. Clarence Jacobson was killed in action and Lt. Richard W. Ibell died as a result of injuries. Pvt. Edward Anderson from Deep River also died during World War I. From Ivoryton, Pvt. F.W.A. Miller, a 26-year-old teacher at Cornell, and Pvt. Leroy A. Wyant, the principal of Ivoryton Grammar School, died while serving.

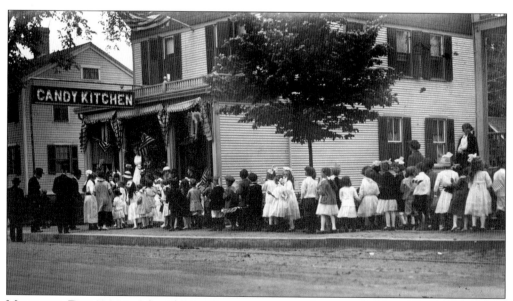

MEMORIAL DAY, 1914. After placing flowers on veterans' graves, children received ice cream at the Candy Kitchen, a well-known local eatery later located on Main Street at the south corner of River Street in Deep River. (Photograph courtesy of Edith M. DeForest.)

Carlson, Carl
Carlson, Lawrence
Carstens, Harry C.
Classen, Perlee
Conklin, Carroll E.
Cooper, Harry Ray
Costello, Raymond H.
Dudek, Andrew J.
Eagan, Thomas F.
Earle, Frederick
Eckhoff, Henry A.
Edwards, Ernest M.
Edwards, William L.
Faith, Raymond M.
Flanagan, William P.
Frank, Albert C.
Gardt, Charles
Gesner, Milton
Gladwin, Leroy W.
Gratta, Victor
Graves, Percy L.
Hagan, Paul
Harris, Archie B.
Harris, Donald W.
Hatfield, Byron M.
*Ibell, Richard W.
*Jacobson, Clarence
Johnson, Edward J.
Johnson, Gustaf C.
Johnson, Harold M.
Johnson, Raymond
Johnson, Richard A.
Judson, Luchard
Judson, Proal, Jr.
Kelley, John J.
Kinrade, Ambrose A.
Kirst, Frederick E.
Kurze, John J.
Lamb, Arthur L.
Landers, Eugene
Lebert, George H.
Lewis, Frank A.
L'Hommedieu, Charles F.
L'Hommedieu, Frank E.
Looby, James F.
Lund, Ernest M.
Lund, Philip F.
Malcolm, William A.
Markman, Otto P.
Marks, William J.
Marvin, Harry B.L.
Marvin, John K.L.
Mather, Ellery L.
Meyer, Martin
Mook, John W.
Moore, Jarius A.
Morton, Howard A.
Norton, Edward E.
Norton, Fred A.
O'Leary, Eugene T.
O'Connor, William S.
O'Leary, Patrick E.
O'Leary, Timothy S.
Olin, Reuben A.
Olsen Harry
Olsen, Carl Harry
Olsen, Carl Robert
O'Shea, John A.
O'Shea, Joseph M.
O'Shea, William
Ott, Arthur C.
Pearsons, Harry G.
Pearsons, Hugo Walter
Petterson, Frans L.
Pratt, Philip R.
Richards, John M.
Rutty, Samuel W.
Saunders, William B.
Schlick, Leon C.
Schlick, Orville J.
Shappell, Raymond E.
Shea, John J.

Sizer, Charles F.
Sizer, S. Oliver
Spencer, Chauncey J
Spencer, George S.
Stalsburg, Bertha C.
Stalsburg, Charles O.
Stevens, Richard W.
Stevens, Thomas A.
Stevens, William B.
Stoll, Henry J.
Sudder, Henry M.
Syme, Norman
Taber, Henry E.
Taylor, Charles L.
Trabucchi, Paul
Tracy, Seymour
Troeger, Henry
Tyler, Charles L.
Weihe, Henry D.
West, Nelson
Wiman, Joseph G.
Wimovsky, Abram
Wimovsky, Gerald J.
Wimovsky, Louis J.
Woodland, Stuart
Wunschel, William F.
Zebrosky, Alexander
Ziegra, Louis R.

WORLD WAR II

Essex

Ackerman, Charles W.
Ackerman, John J.
Ackerman, Lester V.
Ackerman, William J.
Adams, F. Irving
Adams, Priscilla
Agostinelli, Augustine
Allard, George S.
Allen, Clifford O.
Allen, Francis W.
Allen, George V.
Allen, John E.
Allen, Walter
Anderson, Richard A.
Appleby, Ernest N.
Appleby, George H.
Baldwin, Alan A.
Bangs Arthur S.
Banning, Gilbert P.
Bannister, Wilfred A.
Barbaresi, Frank B.
Bargnesi, Joseph A.
Barnes, Mary F.
Barnett, Frank C.
Bartman, Earl L.
Bates, John S.
Bean, Harold E.
Bella, Anthony G., Jr.
Bella, Joseph
Bella, Joseph E.
Bella, Mario J.
Bella, Samuel M.
Bilfinger, Ernest L.
Bishop. Lyle C., Jr.
Blair, John E.
Blair, Reginald
Blair, Robert R.
Blake, Clifford A.
Blucher, William C.
Boenig, Leonard D.
Boggio, Fred
*Bombaci, Anthony J.
Bombaci, John S.
Bombaci, Joseph F.
Bombaci, Louis M.
Bombaci, Santo C.
Bombaci, Thomas G.
Bongiorni, Charles L.
Bonneviar, Walter H.
Bonnier, Albert J.

Booth, James A.
Borkowski, Klemns E.
Bosworth, Robert P.
Bowers, Dexter K.
Bowie, Carl E.
Brainard, John C.
Brockway, Elmore L.
Brooks, Leslie A.
Brown, Charles N., Jr.
Brown, James W.
Brown, Robert C.
Brown, William E.
Browne, Aldis B.
Browne, Gilbert C.
Budney, Lorraine A.
Budney, Robert W.
Budney, Stephen L.
Budney, Walter R.
Budney,Victor J.
Bump, Clayton R.
Bump, Frank L., Jr.
Bump, John M.
Bumstead, Alvin W.
Burdick, Alfred E., Jr.
Burnette, Edward A.
Bushnell, Albert H.
Bushnell, Francis H.
Bushnell, Frederick H.
Bushnell, Harold H.
Buxton, James E.
Buxton, Peter J.
Cade, Arthur W.
Caminati, Bruno J.
Caminati, Renato V.
Carfi, Charles
Carfi, Turey L.
Carlson, Edward A.
Carnabuci, Louis P.
Carr, Frank J.
Carr, John W
Carter, Graham M.
Carter, Leroy C.
Cerruti, James C., Jr.
Cerruti, Jerry E.
Chalker Edward G.
Champlain, Daniel D.
*Champlin, Everett H.
Champlin, Wayland R.
*Chance, Robert T.
Chapman, Dennison
Chitwood, Robert L.
Chrimes, Thomas H.
Chrystal, George S.
Chrystal, Ralph E.
Churchill, Burton F.
Clark Ralph N., Jr.
Clark Rodney C.
Clark, Charles V.
Clark, Dudley W.
Clark, Elbert M.
Clark, Maurice H.
Clark, Richard A
Clark, Sidney C.
Clark, Verdun F.
Cocopard, Sam
Cole, Francis R.
Cole, Gordon, Jr.
Comstock, Merritt M.
Comstock, Samuel M.
Cook, Ernest W., Jr.
Cook, Roland V.
Costa, Bennie
Crane, Edward E.
Crivelli, Aldo D.
Cunningham, Chipman W.
Cunningham, David E.
Cutone, Albert J.
Cutone, Jerome F.
Dahlstrom, Carl H.
Dahlstrom, Gustave, S.
Davis William H., Jr.
Davis, Carl R.

*Davis, Charles C., Jr.
de Redon, Frederick J.
Dickinson, Alan P.
Dickinson, Edward E., III
Dimelow, Grace
Doane, Errol C., Jr.
*Doane, John
Doane, LeRoy C., Jr.
Doane, Robert L.
Doane, William E.
Dolph, Paul B.
Dolph, James K.
Donahue, John H.
Downing Frank M.
Downing, John W.
Doyle, Richard K.
Drudi, Richard Jr.
Dubin, Emanuel P.
Duffy, Harold J.
Dunkirk, Seymour
Dutka, Walter J.
Ek, Carl R.
Emanuelson, John L.
English, Robert B., Jr.
Esposti, Dino W.
Esposti, Lino L.
Everitt, James E.
Fauntleroy, Calvin I.
Fazzino, Joseph V.
Fenn, Frank J.
Fenn, Raymond L.
Fenn, Richard H.
Ferranti, Richard T.
Field, David L.
Field, Robert L.
Filippi, Gino L.
Filippi, Lawrence R.
Filippi, Philip
Fletcher, Robert
Fletcher, Wesley E.
Florman, Myrtle P.
Ford, Thomas H.
Fortin, Ellsworth
Foster, Edward P.
Fox, Daniel M.
Frame, Dorthea
Frame, Ralph R.
Franson, Leonard J.
Fredrikson, Sven F.
Freeman, Fred W.
French, Warren E.
Fresia, Joseph C,
Fulmine, Camelo A.
Gannon, Erma A.
Gannon, Herbert R., Jr.
Garrity, Joseph C.
Gaudenzi, Bruno G.
Gay, Clarence W.
Geis, Frank H.
Gerich, Richard F.
Goff, Leon S., Jr.
Good, Donald K.
Goss, Horace B.
Graff, Franklyn A.
Grant, Arthur A.
Grant, Francis E.
Grant, Royal E.
Grassl, Godfrey
Graves, Enar W.
Graves, Russell G.
Green, Nathan J., Jr.
Greenberg, Herbert
Greenwood, Shirley D.
Grief, Stanley F.
Griggs, Chester H.
Griswold, Alfred
Griswold, Robert H.
Gualazzi, Aldo D.
Guertin, Aldor J., Jr.
Guertin, Clarence J.
Guertin, Ovila H.
Guidi, Joseph M.

Guptill, Newman C.
Guptill, Page R., Jr.
Gutosky, Walter
Hall, John H., Jr.
Hall, William F.
Hanks, Edgar F.
Hansen, Paul S.
Hare, Roger J.
Harrington, Earle C., Jr.
Harrington, Leslie J.
Harris, Donald H.
Harris, James, Jr.
Harris, John
Harris, Raymond
Harris, Selden
Hayden, Kenneth W.
Haynes, Charles M.
Haynes, Gordon W.
Henry, Frank C.
Herel, Edward J.
Higgins, Richard W.
Hilley, Robert M.
Hinrichs, Dunbar M.
Hmielewski, Marion S.
Hmielewski, Michael V.
Hoadley, Charles F.
Hoadley, Nelson S.
Holland, Herbert S., Jr.
Holle, Louis C.
Hollwedel, Henry F.
Hosp, Joseph F.
Hyde, Strickland K., Jr.
Ibsen, Soren C. Jr.
Ingraham, Kenneth B,
Issac, Coy
Janoski, Louis C.
Janoski, Walter L.
Jennings, Russell
Jewett, Allen C.
Jewett, Ulmer M., Jr.
Johnson David A.
Johnson, Charles F., Jr.
Johnson, Jay K.
Johnson, Joseph R.
Johnson, Sverre
Johnson, Ward V.
Jones, Paul F.
Jones, Wendell R.
Josten, Henry E.
Kalinowski, Eugene A.
Kalinowski, William T.
Kelley, Roy D.
Kenel, Joseph J.
Koehler, Phillip A.
Koehler, Ralf G.
Koritkoski, Henry B.
Koziy, David
Lagrezi, Richard N.
*Lannon, Donald J.
LaRosa, Joseph S.
Larson, Everitt N.
Larson, Harold A.
Larson, Herbert J.
Leitner, Edward
Lewis, Charles R.
Libby, Clemmons W.
Litchfield, Grace N.
Little, Robert S.
Littlefield, Merton
Lojeski, Joseph H.
Lombardi, Rocco F.
Lott, John F.
Lovell, Arthur W., Jr.
Lundgren, Lawrence W.
Lyle, David F.
Lynn, Walter L.
Lyon, Basil R.
Lyon George C.
Lyon, William D., Jr.
MacWhinney, Escott H.
MacWhinney, Thomas M.
Magee, Morton G.

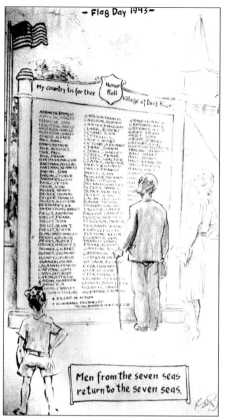

COLUMBIA DEEP RIVER HONOR ROLL. The plaque on the Veterans Memorial Green reads, "Columbia, painted by C.D. Batchelor, Pulitzer Prize winning cartoonist, was dedicated by Gov. Raymond Baldwin in Nov. 1943 on the library grounds." By 1969, weather and time had caused decay in the wooden frame. A committee was formed to relocate Columbia from the library grounds to Library Park and reset it. The name of Library Park was later changed to Veterans Memorial Park. In 1970, the movement of Columbia and its resetting in brick was completed. In 1985, a new committee was organized to add wings to the Columbia plaque to honor Deep River residents who served during the Korean and Vietnam conflicts. On November 11, 1990, the adjutant general of Connecticut rededicated Columbia. The curbstones around the plaque's platform were those originally installed on Kirtland Street almost 100 years ago. The 15 white marble bricks represent the 15 men who lost their lives in World War II and the Vietnam War. Committee members were Alice Johnson, Nell Johnson, Richard Johnson, John Hulteen, Joseph Miezejeski, Raymond Mozzochi, Edmund Negrelli, Robert Stalsburg, Cliff Taber, and Ronald Tower. The following died while serving on the committee: Harry Suozzo, David Johnson, and Larry Graves. In 1994, the name of the park was changed to Veterans Memorial Green.

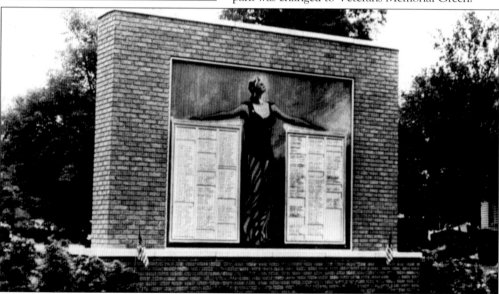

Maikowski, Edward
Makuck, Gregory
Malcarne, Guido S.
Malcarne, Joseph O.
Malcarne, Victor D.
Manee, Ferry H.
Manee, James F.
Manee, Webster
Markham, Leslie H.
Markman, Arthur V.
Markman, Frederick E.
Marston, Howard
Marston, Thomas R.
Mason, Edward G.
Mason, Roy
McNally, Arthur F.
Meyerjack, Howard S.
Miezejeski, Peter P.
Mills, John T.
Millspaugh, Charles S.
Miner, Edmund O.
Miner, Frank E., Jr.
Moeller, Charles H.
Morris, Clifford R., Jr.
Mosby, Jack L.
Muscolino, Pasquale
Muscolino, Pasquale P.
Nesto, John P.
Nihill, James S.
Nolting, Walter H.
Norton, Thomas E.
Nuhn, Charles K.
Nuhn, Robert P.
Oatley, Charles W.
Oberg, Carl
Olsen, Robert A.
*Owens, John F.
Owens, Marshall E.
Owens, Wilbur W.
Pagano, Charles
Pagano, George J.
Parisi, James
Parisi, Turey
Pearson, Harry A.
Pelton, Marshall P.
Perkins, H. Ross
Perkins, Raymond L.
Perzanowski, Wallace J.
Peterson, Francis J.
Peterson, Robert A.
Phelps, Russell E.
Phelps, Vernon S.
Pianta, Guido J.
Pianta, Alden A.
Pianta, Arthur L.
Pierce, Richard H.
Pierce, Phillip M.
Pierce, Walter R.
Pieretti, Peter J.
Pike, Charles B.
Pike, Robert G., Jr.
Pinckney, Chaziz
Pink, John S., Jr.
Platt, Raymond C.
Pliner, Saul
Poindexter, Joan N.
Pond, Richard G.
Posik, Gustave
Potter, James A.
Potter, Jane E.
Potter, Robert F.
Potts, Alan S.
Powers, William S.
Prann, Richard A.
Pratt, Charles N.
Pratt, Henry A.
Quagliata, Joseph
Randall, Roger E.B.
Redfield, Charles K.
Redfield, George O.
Redfield, James
Redfield, Robert F.

Redfield, Warren, B., Jr.
Regan, Walter J.
Rice, James Q
Riggio, Ernest L.
Riggio, Joseph C.
Riggio, Richard
Riggio, Samuel
Rockwell, Lawrence D.
Rowe, Walter F.
Rutan, Charles T.
Sadler, Joseph W.
Samuelson, Charles A.
*Sandberg, Einar G.
Sangster, Donald
Sangster, Douglas W.
Santi, Frank J., Jr.
Santi, Gene A.
Sarazin, Gilbert B.
Sarazin, Marie A.
Schellens, Eugene P.
Schmelke, Richard H.
Schneller, Richard F.
Scholes, Clinton S., Jr.
Scholes, James F., Jr.
Scholes, Lloyd D.
Scott, James C.
Scott, Wallace G.
Shannon, Haskell A.
Shepard, Allen E., Jr.
Shepard, Donald S.
Sinaguglia, Ignazio
Sizer, Edson L.
Smith, Addison R.
Snype, James
Southworth, Edmund N.
Spears, Leonard
Spencer, George R.
Spencer, Lawrence C.
Spencer, Leslie R., Jr.
Spencer, Raymond
Sprigg, Edwin A.
Spring, George B., Jr.
Spring, Robert B.
Spurr, Robert J.
Stahl, Rolf
Stanford, Alfred B.
Stanford, John
Stanford, Peter
Stannard, Charles F.
*Starr, Robin C.
Stevens, Douglas E.
Stevens, James T.
Stewart, Raymond O.
Sticht, Arthur
Stiffle, Donald E.
Strecker, Arthur
Strukus, Michael M.
Tiley, Morton D.
Tripp, Erwin J.
Tucker, James H.
Tucker, John W.
Tucker, Lewis B.
Udoff, Stephen A.
Usher, Malcolm
Van Ostrand, John
Walden, Joseph J.
Walden, Calton H.
Walden, Harry L. Jr.
Walden, Winthrop J.
Watrous, Carroll J.
Weaver, LeRoy J.
Webber, James F.
Weiler, Otto F., Jr.
Whitney, William S.
Whittlesey, James P.
Wightman, Standish R.
Wilcox, Earl C.
Wilder, Hal V.
Williams, Russell K.
Wilson, Walter S.
Wind, Charles R.
Wind, Thomas E., Jr.

Wright, Alvin W.
Wright, Martin W., Jr.
Wright, Milton F.
Wright, Mortimer D.
Wright, Northam D.
Wright, Percy W.
Wright, Richard W.
Zanni, John L.
Zimmer, Charles
Zuppe, Charles R.

Deep River

Adamcyk, John
Adamcyk, Raymond
Adamcyk, Stanley
Ahlstrin, Herman
Anderson, Charles R.
Anderson, Edith May
Anderson, Harold E.V.
Arnold, Alfred C.
Aronson, G. Walter
Bailey, Charles B.
Ball, John
Baloise, Andrew
Baloise, Ernest
Bangs, Arthur
Barbiery, Louis R.
Baroni, Angie
Baroni, George
Baroni, John F.
Barrett, William
Bartman, Douglas J.
Bartman, Kennneth
Bartman, Malcolm L.
Batko, Peter
Bayor, John
Becker, Augustine
Becker, Francis
Becker, Henry
Becker, Thomas
Beckwith, Willis A.
Belluardo, Raffaele
Benedetto, Dominic
Benedetto, Joseph
Berdensey, Harold K.
Bernstein, Charles
Bick, August J.
Bick, Frank
Bick, Paul
Bielot, Alvin T.
Bielot, Andrew
Bielot, Frank
*Bielot, John
Bielot, Joseph
Bielot, Ralph J.
Blanchard, Harold
Brainard, Oliver E., Jr.
Breslin, Joseph H.
Briggs, Albert D.
Briggs, George
Brooks, Harvey J.
Browne, Gilbert C.
Buckridge, Alan C.
Budney, George
Budney, Zigmund
Buracchi, Oscar
Burr, Henry
Calamari, Carrol A.
Calamari, Ernest J.
Capitani, Louis
Capuciati, Rose
Carini, Attiglio
Carini, Charles J.
Carini, Ercole A.
Carini, Warren
Carlson, Donald
Carlson, Douglas V.
Carlson, Francis B.
Carlson, Robert G.
Carlson, Victor D.
Carter, Malcolm
Clark, Robert

Cofrancesco, Alfred
Cole, Elizabeth
Cole, Richard D.
Cole, Theodore S., Jr.
Comstock, Paul M.
Cosmos, John
Costello, Laurence
Crocker, Howard
Croft, Noyes M.
Cutone, Arthur
Cynar, Frank J.
Cynar, John M.
Czapiga, Walter V.
Czepiel, Charles
Czepiel, Frank
Czepiel, Walter
Darcy, Francis B.
Darcy, John F.
Darcy, Richard P.
Dengler, Truman I.
Drag, Steven
*Dreher, Theodore P.
Drennan, Vincent J.
Dudley, James R.
Dutka, John A.
Dutka, Walter
Eagan, Thomas
Eagan, William W.
Elkins, Ralph L.
Elston, Harold C.
Emanuelson, Carl
Emanuelson, John
English, Charles C.
English, Larry N.
Euston, Charles B.
Euston, Walter H., Jr.
Everett, Clarence
*Ferguson, James A.
Ferrandi, Sevino J.
Fiorelli, Louis
Fleming, Keith
Francis, Lewis E.
Francoeur, Marin
Frank, Albert C.
Gambini, Frank
Gambini, Joseph
Garbarino, Nicholas V.
Garbarino, Paul V.
Garbarino, Angela P.
Geffken, Philip
Gelinas, Walter
Gesner, Eugene
Gilson, Carroll
Giza, Edward
Giza, Frank
Giza, Joseph
Giza, Walter
Glascow, Leslie
Gleason, Herbert B.
Glidden, Walter B.
Glowac, Napoleon
Glowac, Stanley
Godfrey, Warren
Goff, Edward A.
Goodrow, Ernest
*Gorecki, Edwin
Gorecki, Jeanette
Gorman, Raymond
Graves, Enar W.
Greeney, Charles F.
Greeney, Henry G.
Gregory, Geoffrey
Grief, Frank
Grief, John
Gripps, Robert E.
Gualazzi, Geno C.
Guertin, Aldore J., Jr.
Gutoski, Walter
Haling, Henry G.
Hall, Harry
Hall, Henry
Hall, Kenneth

Hall, Merton
Hall, Robert H.
Hamilton, Francis
Hammer, Allan
Handy, Woodrow W.
Harazda, Raymond
Hardwick, Donald
Haser, Louis
Hazuka, Charles R.
Hazuka, George
Hazuka, John
Hazuka, Rudolph
Hazuka, Joseph
Heidtmann, Rudolph
Henry, James M.
Henry, Richard B.
Hesser, Ellen Ann
Hesser, George
Hesser, Henry
Hesser, John
Hesser, Paul
Holmes, John P.
Hotkowski, Albert
Hotkowski, John
Hotkowski, Walter
Hotkowski, Joseph
Hotkowski, Stephen
Hulteen, John W.
Hurlbut, James O'L.
Isben, Soren C., Jr.
Jacobs, Frederick W.
Jacome, Dorothy
Jacome, Herbert A.
Jacome, Walter
Janoski, Anthony
Jazo, Charles
Jazo, Joseph J.
Jazo, Walter
Jennings, Russell
Jennings, Theresa M.
Jennings, William M.
Jesse, Elmer A.
Johnson, David A.
Johnson, Harry E.
Johnson, Harry M.
Johnson, Hugh C.
Johnson, Louis
Johnson, Philip
Johnson, Robert F.
Johnson, Douglas
Jones, Everett W.
Joy, Geroge A.
Joy, Harold E.
*Julian, Harry F.
Kane, Edward K.
Kelsey, William
Kennedy, Douglas J.
Kessell, Walter
Klimaszewski, Walter G.
Knox, Howard
Knox, John W.
Koch, Frederick
Kolakowski, Stanley
Kolakowski, William
Kowalski, Frank
Kurze, Herbert
Kurze, John
Kurze, William
LaMay, John
LaMay, William
LaPlace, William B.
Larsen, Ole
Larson, Howard S.
Larson, Raymond E.
Lauer, Carl
Lebert, George
Lebert, Raymond
Lebert, Robert
Lebert, Stanley
Lebert, Warren
Lebert, James C.
*Lebowich, Francis

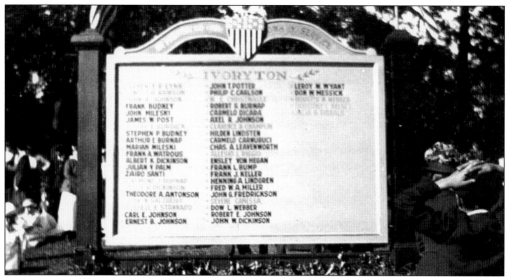

IVORYTON HONOR ROLL. During World War I, this wooden memorial was set up near F.M. Rose's Store, at the intersection of Main and North Main Streets in Ivoryton. Some 300 people participated in the dedication. A parade formed at Comstock, Cheney & Company, marched down Comstock Avenue, and gathered at the site of the memorial. It was headed by Marshal Fred J. Miller (mounted) followed by the R.M. Comstock drum corps, the Essex company of State Guards, eleven cars carrying the relatives of the men and women whose names appeared on the roll and driven by Red Cross representatives, two cars carrying veterans of the Civil War, the Red Cross led by Liberty, the Chester Military band, the Ivoryton YMCA, a section carrying the Italian flag, Beacon Light circle of the King's Daughters, children led by their teachers, the Phoenix Benefit Society, the Ivoryton Wheel Club, and representatives of the Modern Woodmen of America lodge. On the board were the names of 47 people, one of whom, Marian Mileski, was given a gold star signifying that he had been killed. When the board deteriorated, a three-foot by four-foot painting by a New York artist was made of the wooden background with the names printed in the original colors. It was decided that this painting would hang in the Ivoryton Library and a rededication took place. It hangs there today.

THE ESSEX WAR MEMORIAL. This 12-foot by 8-foot by 1-foot granite memorial was put in place just prior to Memorial Day in 2001 and includes the names of Essex Village, Ivoryton, and Centerbrook veterans of World War I, World War II, Korea, and Vietnam. It is located adjacent to the Veterans Hall in Centerbrook.

Lebowich, Michael
Lee, Robert E.
Linder, Ernest
Linder, Paul K.
Lloyd, Darcy B.
Luca, Ferdinand R.
Lundmark, Olaf
Machado, Manuel
MacMahon, Robert
Maikowski, Henry F.
Maikowski, Raymond A.
Maiofes, Sidney
Majowski, Edward
Malcarne, Leno H.
Malcarne, Victor
*Malchiodi, Dom
Malchiodi, Rudolph
Martin, William G.
Marvin, Reynold L.
Marvin, Reynold P.
May, Salvatore
Meyers, Milsterd
Miezejeski, Edward
Miezejeski, John
Miezejeski, Vincent
Miezejeski, Joseph
Miezejeski, Peter P.
Miller, Charles R.
Miner, Frank E.
Mislick, Marty
Mitchell, Edward
Molander, Francis E.
Moore, Andrew J.
Moore, Robert M.
Moutzouris, James
Mozzochi, Albert C.
Mozzochi, Attilio
Mozzochi, Paul D.
Mozzochi, Raymond
Mozzochi, Sevino J.
Mucha, Philip
Mucha, Stanley S.
Mucha, Steve
Murphy, Thomas W.
Negrelli, Bernard J.
Negrelli, Edmund T.
Neilson, Fredrick
Netolicky, Josephine
Netolicky, William
Newth, Arthur
Nolan, Edward
Nucci, Dino
Nucci, Joseph
Nucci, Michael
Nucci, Peter
O'Leary, Eugene T.
O'Leary, Harry M.
Olin, Leon
Olsen, Ernest
Olsen, Russell
O'Shea, Daniel
O'Shea, Francis
O'Shea, Laurence
Palmer, Robert
Pandiani, Frederick
Pandiani, John
Parodi, Frank
Pearson, Richard W.
Peckham, Everett J.
Pelton, Marshal
*Petterson, Leonard
Phelps, Richard
Pitts, Charles H.
*Post, Eugene W.
Post, Robert
Ragaglia, John P.W.
Rankin, Robert R.
Ray, Ossian
Ressler, Edward H.
Ressler, Robert
Ressler, George M.
Richards, Raymond

Roos, Betty
Roos, Francis L.
Roos, Leonard
Rosenblad, Harry
Rutty, Edward
Saunders, Walker A.
Schlott, Henry A.
*Scobey, Wilfley, Jr.
Scovell, C. Talcott
Scovell, Henry H.
Scudder, Henry M.
Scweitzer, Otto C.
Scweitzer, Richard P.
Scweitzer, Edward G.
Shumway, Charles M.
Silverman, Leonard
Siskowski, Edward
Smith, Brainerd
Smith, Cornelius B.
*Smith, Joseph
Smith, Louis J.
Smith, Philip E.
Smith, William
Sokolowski, Walter
Sokolowski, Edward
Sokolowski, Theodore
Spencer, Alvin
Spencer, Bentley
Spencer, Norman F.
Stalsburg, Charles O.
Stalsburg, Robert
Standish, R. Rexford
Stannard, Lewis F., Jr.
Starkey, Felix
Stevens, Howard
Stevens, Kenneth R.
Stevens, Thomas A.
Stocek, Henry
Stoddard, William H., Jr.
Stokes, George
Stokes, John N.
Stoll, Edward
Stopa, Andrew
Stopa, Frank
Stopa, Stanley
Stopa, William
Strempel, Alfred
Suozzo, Harry
Taber, Clifford
Tate, William J., M.D.
Tatko, Chester
Tatko, John
Tourville, Dorothy
Tourville, Kenneth
Tourville, Robert
Tower, Billy
Tower, Harold J.
Tower, Howard W.
Trojan, Joseph T.
Turner, June D.
*Turner, Richard
Von Deck, Charlton
Warner, George E.
Warner, Wesley H.
Waterman, Norris
Watkinson, Harry
Watkinson, William
Watrous, Charles E.
Watrous, Frederick
Watrous, George H.
Watrous, James
Watrous, Richard
Watson, Margaret
Watson, Martin
Waz, Frank C.
Waz, Joseph
Waz, Martin
Waz, Stanley
*Whiting, Butler, Jr.
Whiting, Edgar B.
Wollock, Charles
Wollock, John

Wollock, Paul
Wollock, Stanley
Woodland, Elizabeth J.
Wulff, John J.
Yazo, Charles
Yedrysek, Joseph F.
Yedrysek, Mark
Yedrysek, Walter A.
Zack, Mathias C.
Zaremba, Anthony
Zaremba, John
Zaremba, Joseph
Zaremba, Stanley
Ziegra, Albert W.
Ziegra, Louis R.
Ziegra, Sumner R.
Ziobron, Walter
Ziobron, William F.

KOREA

Essex
Adams, David J.
Adams, Richard I.
Agostinelli, Joseph, Jr.
Bach, Arthur H., Jr.
Bach, Valentine J.
Bagnold, A.F.
Baldoni, Charles A.
Beardsley, James E., Jr.
Beiser, Charles E.
Bosnak, George P.
Bouton, Harold F.
Boyle, Benjamin B.
Brink, William A., Jr.
Budney, Eugene T.
Budney, Richard F.
Bump, Gerald C.
Burd, Charles R.
Burke, Carroll J.
Burton, James H.
Cade, Donald F.
Cade, Merton K.
*Carnabuci, Primo C.
Carter, Charles M., Jr.
Cerruti, Edward F.
Cerruti, Robert F.
Chambers, Newman
Chrystal, Harold E.
Chrystal, James M.
Clark, David M.
Clark, Melville C., Jr.
Comstock, Walter J., III
Cook, Earl M.
Cousins, John W.
Davis, Francis C.
Davis, John F.
Davis, Richard A.
Davis, Robert E.
Doyle, Charles
Doyle, Donald H.
Doyle, Duane
Dudley, LeRoy S.
Durant, Raymond O., Jr.
Dzubilo, Anatole F.
Edwards, Ernest L.
Ek, Harold E., Jr.
Fordham, Albert T.
Foster, Edward W., Jr.
Furfuro, Francis J.
Furfuro, Joseph
Gaetano, Raymond T.
Galvin, Arthur F.
Grisky, Richard J.
Hall, Burton, J.
Hall, Wilbert A.
Hall, William H.
Hanks, Edgar F.
Harriman, Arthur L.
Hartigan, Ronald F.
Haskell, Leslie C.
Higgins, Donald M.

Holland, Stanley
Homer, Dudley B.
Hull, Rodney E.
Hunt, Robert H.
Johns, Mortimer M.
Johnson, Andrew
Johnson, George E.
Johnson, Hanford A.
Johnson, Murwin A.
Johnson, Robert S.
Kessell, Henry L.
Kobylenski, Ronald M.
LaPlace, Robert A.
Lee, Ernest J., Jr.
Lombardi, Philip J., Jr.
Mack, Elwyn E.
Maclean, Robert A.
Magowan, Robert E.
Manee, William H.
McGrath, Francis J., Jr.
McNally, Francis E.
McNally, John H.
Messick, Charles W.
Mills, Jack
Monahan, Frances A.
Nesto, William J., III
Nielson, Raymond C.
Nielson, Robert K.
Norton, Joann M.
Perzanowski, Edmund L.
Pfander, William D.
Pianta, Robert C.
Picchione, Adam
Pond, William H., Jr.
Potter, Donald T.
Radziwon, Robert W.
Ramistella, Eugene A.
Renzoni, Anthony A.
Reynolds, Robert V.
Rolf, Freeman L.
Rutty, Donald W.
Segee, Donald K.
Silverman, Leonard J.
Southworth, Bruce H.
Spencer, Alfred J., Jr.
Stahl, Ralph A., Jr.
Stanford, Richard
Stannard, Judson S.
Steen, Harold J., Jr.
Stielau, Robert A.
Strukus, Michael M., Jr.
Strukus, Richard M.
Sturke, Stanley E.
Symonds, Charles H.
Sypher, Harold H.
Sypher, Raymond A.
Thibeau, Roy J.
Tooker, Thaddeus W.
Usher, Albert L., Jr.
Varney, Edward W., Jr.
Vitari, Robert J.
Walden, Raymond L.
Wells, John A.
Wright, Harold
Young, Charles G.
Zuppe, John

Deep River
Benson, Robert C.
Berdensey, Richard L.
Bowie, Bernard W.
Budney, Edward A.
Buracchi, Oscar A.
Calamari, Louis R.
Calarco, Anthony E.
Champion, Elwood F.
Cox, Thomas F.
Daniels, Richard R.
Dicks, James L.
D'Lizarraga, William K.
Dube, William
Eagan, James J.

Edwards, Richard K.
Finan, June Samuelson
Glowac, Paul A.
Grandsire, Francis A.
Graves, Larry T.
Hardwick, Donald
Hazuka, Charles R.
Hines, Donald G.
Hines, Robert N.
Hopkins, Paul M., Jr.
Johnson, Donald R.
Johnson, Richard G.
Johnson, Roger C.
Kensel, Walter H.
Laliberte, Elizabeth Zanni
Linder, Robert H.
Marvin, Richard C.
McCauley, Francis B.
Mondani, Paul F.
Morrow, Richard H.
Mozzochi, Sevino J.
Mucha, Joseph J.
Negrelli, Edmund T.
Nelson, Henry D.
Nucci, Vincent E.
Peel, Robert J.
Phelps, Charles W.
Pitts, William C.
Ressler, Charles N.
Samuelson, Arthur J.
Schneider, William N.
Scott, Arthur D.
Sepega, Bernard F.
Sokolowski, Steven E.
Spencer, Bentley
Stoddard, William H., Jr.
Streit, Arthur C.
Tate, William J.
Tower, Ronald D.
Turner, David C.
Turner, Robert T.
Turner, Arthur L.
Waz, John H.
Winschel, Arthur C.
Winschel, Kenneth J.
Ziegra, Summer R., M.D.
Ziobron, John J.

VIETNAM

Essex
Ackerman, James J.
Ackerman, Jerome J.
Allen, Charles D., Jr.
Allen, Gary F.
Allen, Scott W.
Ames, Jonathan S.
Baldwin, Robert F.
Barnes, John T.
Beach, Charles
Belanger, Richard
Bella, Anthony G.
Benham, John R.
Bergh, William
Berry, Edwin D., III
Black, Barbara A.
Bleau, Francis E.
Blomerth, Kenneth P.
Boggio, Louis A.
Bombaci, Charles A.
Bombaci, Lawrence R.
Bosworth, Ronald C.
Breitschmid, Willy A.
Broeker, Paul G.
Bulgini, Carl G.
Calamari, Gerald J.
Caminati, Peter V.
Carlsten, Warren A.
Chapin, Bruce
Chrystal, Robert A.
Churchill, Burton F., II
Clark, Jerry F.

97

Clark, Merrill
Clough, Allison C., III
Connerat, George H., Jr.
Conwell, Bobbie L.
Crawford, Peter
Crysler, David J.
Cutler, Orrin L.
Cutone, Anthony J.B.
Dahlstrom, Gary S.
Danks, Gary H.
David, Warren G.
Davis, Richard A.
Deere, Thomas C.
Dexter, Douglas
Dickinson, Dale
Dickinson, Dexter A.
Dillon, Peter H.
Doane, Charles N., III
Doane, Timothy C.
Drag, Thomas S.
Dudley, James A.
Dunn, Henry, III
Dutka, Michael W.
Echtman, William C., Jr.
Edwards, LeRoy V.
English, Richard G.
English, Robert B., III
Evans, Richard E.
Falivene, Carmine
Fanslau, Edmund
Fanslau, Harry A.
Fazzino, Joseph J., Jr.
Fenn, Richard L.
Filippi, Phillip L.
Finkleday, John A.
Fisher, David
Flagg, Henry L., VI
Foggitt, Robert L.
Fraim, Ernest L.
Fraim, Thomas S.
Garrity, Dennis J.
Going, Jeffery W.
Good, William H.
Goodale, Gerald T.
Goodale, Harold
Goodale, John F.
Greene, Elizabeth A.
Greene, John C.
Greene, Robert C.
Gregoire, Michael
Grieder, James R.
Grose, Thomas P.
Guptill, Donald W.
Hamill, Brenda H.
Hamilton, David
Haney, Thomas E., Jr.
Hanks, Kevin E.
Harrah, David E.
Harris, Daniel J., Jr.
Havens, Samuel H.
Helenek, Paul
Helm, Henry E.
Hinch, Nicolas J.
Hollwedel, Allen J.
Hollwedel, Robin J.
Hotkowski, Michael F.
Hyde, Strickland K., III
James, Jack W.

Johnson, Jay R.
Jones, Eugene P.
Jones, John W.
Kaiser, William C., Jr.
Karkheck, David J.
Kavanaugh, James L.
Kelting, Donald L.
Kenyon, Richard M.
Kerrick, Vernon M.
King, Libre J., Jr.
Kinrade, William A.
Kleczkowski, Frank B.
Kleczkowski, Stawomir
Kleczkowski, Thomas
Kraaz, Lester J., Jr.
Krajewski, Joseph M.
Kranich, Jules A., Jr.
Lancraft, George I., III
Lee, James D.
LeMay, Hanford A.
*LeMay, Richard D.
Libby, Belden S.
Libby, Edwin A.
Libby, Ernest M.
Lietgeb, Albert J., Jr.
Loizeaux, Robert J.
Lord, Parker N.
Lott, Paul S.
Lovell, Henry O.
Ludwig, Robert C.
Machado, James L.
Marciniec, Robert S.
Marston, Robert L.
May, John D.
Maynard, Leonard P.
McCabe, Patricia
McNally, Russell F.
Miezejeski, John C., Jr.
Milardo, David A.
Milardo, Robert L.
Mockler, Nedd J.
Monroe, Julius S.
Monte, Sandra C.
Morse, William K.
Murphy, Danny E.
Murphy, James W.
Murphy, Maurice J.
Muscolino, Peter P.
O'Brien, Bruce S.
O'Dell, David A.
Pagano, Frank N.
Palau, Ronald E.
Pape, Edwin H., III
Parker, James T.
Parker, John S.
Parker, Robert W.
Parker, Sheldon C.
Pelton, Melville A.
Perkins, Mark A.
Perry, Brewster, Jr.
Perry, Duncan
Pianta, John A.
Pierce, Carolyn D.
Pierce, James A.
Pierce, Mark C.
Pike, Robert G., III
Pike, Thomas J.
Pollock, Robert

Pollock, William
Pope, David J.
Post, Charles H.
Prann, John W.
Pratt, Gary A.
Ready, James L.
Riggio, Samuel J.
Rogers, John M.
Rome, Frank W.
Ross, Richard A.
Rowe, Arthur L.
Rowland, Charles E.
Rudewicz, Henry J.
Saglimbeni, Anthony A.
Saglimbeni, Anthony P.
Sangster, Sara E.
Sangster, William D.
Saunders, Michael D.
Scholes, Peter P.
Scholes, Robert C.
Scholes, Stephen P.
Shannon, Daniel R.
Shannon, Thomas H.
Sigersmith, John J., III
Silver, Bruce
Simpson, Donald R.
Simpson, Dorville F.
Sizer, Ronald W. L.
Smith, Walter E.
Spada, Joseph G., Jr.
Spada, Michael F.
Spence, Matt L.
Spencer, Craig A.
Sprigg, Timothy B.
Spring, George B., III
Spring, Thomas C.
Stanley, Albert F., Jr.
Stanley, Richard J.
Stawicki, John L.
Stebbins, David W.
Stevison, Craig B.
Sticht, Glenn A.
Stopa, Stanley L., Jr.
Sumner, Charles A., II
Swain, Alexander M., III
Taylor, Kenneth A.
Temple, Christopher
Tower, Jonathan R.
Tracktenberg, Stephen
Tracy, David O.
Traynor, James J.
Tyler, Ruth Anne
Urban, Rudolph J., Jr.
Von Deck, Charlton J.
Walden, Harry J.
Walker, Marshall K., Jr.
Walker, Samuel G.
Weaver, Robert R.
Weaver, Thomas H.
Wernicke, Thomas M.
Weselcouch, James D.
Wilson, Roger G.
Wind, Peter G.
Wind, Thomas E., III
Wollschleager, Edward R.
Wollschleager, Paul C.
Work, John C., III
Woronick, Daniel

Woronick, Phillip E.
Wright, Edward L.D.
Ziemba, Thomas A.

Deep River
Becker, George B.
Becker, William J.
Benson, Robert C.
Bond, James H.
Burns, James F., III
Bushnell, Edward F
Carini, Hohn V.
Carini, James A.
Carlson, Donald R.
Carlson, Robert D.
Carrier, Ronald F.
Clarke, Kenneth E.
Cloutier, Armand A.
Czepiel, Patricia M.
Daniels, Robert C.
Darcy, James J.
Demerchant, Harold L.
Dickinson, James R.
Dickinson, Thomas B.
Diffendall, Bruce S.
Dolle, Paul R.
Dolle, William C.
Duplessis, Gary H.
Dzurenka, John J., Jr.
Dzurenka, Richard L.
Echtman, Carl F.
Elston, Harold, Jr.
Emanuelson, Leonard A.
Evans, Albert
Faraci, Louis J.
French, Michael R.
Gilbert, Frederick I., Jr.
Gilbert, John M.
Gilbert, Thomas R.
Glidden, Ronald B.
Grandsire, George V.
Graves, Donald G.
Gustafson, Brian J.
Harger, George E.
Haser, Thomas H.
Hesser, John J.
Heughins, William T., Jr.
Hirsch, Harold R.
Hirsch, Thomas A.
Hotkowski, Joseph J., Jr.
Hurlburt, Joseph D.
Johnson, Neil E.
Joy, Barry A.
Joy, George E.
Joy, Harry E., Jr.
Joy, Kenneth W.
Kelly, Martin J.
Kelly, Roy
Kelsey, Peter W.
Kensel, Robert
Kerkes, Raymond S.
Klein, Philip H.
Kortikowski, Paul J.
*Kortikowski, Peter T.
LaPlace, William O.
Lebert, William E.
Lippincott, Dean
Lippincott, Richard P., Jr.

Lobb, John R.
Looney, John L.
Lynch, Eddie M.
Maikowski, Raymond A.
Malcarne, Paul M.
Malcarne, Terry D.
Malchiodi, Robert J.
Mather, Paul D.
Merrill, Gary C.
Milton, Steven D.
Moorhouse, Johathan H.
Motta, Albert R.
Mozzochi, Louis P.
Mozzochi, Sevino J.
Mucha, Ralph S.
Nucci, Kernan M.
O'Brien, Bruce S.
Pallon, Michael E.
Paul, Arthur G.
Pearson, Robert A.
Pelton, Melville A.
Perkins, Mark A.
Pitts, Steven E.
Price, Steven E.
Pulcini, Edward L.
Redfield, Ronald E.
Ressler, Jon W.
Robida, Richard E., Jr.
Russell, Charles M.
Rutherford, Lowell R.
Sbrolla, Richard J.
Schmidt, Ernest D.
Seibert, John
Sepega, John
Shaw, Dennis E.
Shaw, Kevin B.
Shaw, William R.
Simcheski, John L.
Smith, Rodney W.
Stalsburg, Harold J.
Swan, Frederic C., Jr.
Swanson, Mark W.
Thompson, David M.
Tiezzi, Raymond A.
Tisdale, Wayne C.
Tisdale, Brian A.
Tower, Charles W.
Tuthill, Raymond W.
Tuthill, Royal F., Jr.
Uneegar, John J., Jr.
Vitari, John A., Jr.
Walden, Russell J.
Wallace, Robert B.
Waz, Robert S.
Weglarz, Richard D.
White, John D., Jr.
Wollack, Stanley P.
Yedresex, David J.
Young, Richard M.
Young, Richard O., III
Ziobron, Edward C.
Ziobron, Jeffery P.
Ziobron, John A.
Ziobron, Robert S.
Ziobron, Scott G.
Ziobron, William F., Jr.

Eight
THE MOP-AND-BUCKET BRIGADE

The firefighting needs of the village of Deep River began when the first homes were built there in 1723. As fire was the number one cause of accidental death and loss of property, when the shout of fire was heard around the village, citizens would assemble with their wet mops and fire buckets. They would consider themselves successful if they prevented the fire from spreading to surrounding structures.

In 1854, a group of young men led by George Bogart organized the first volunteer fire company in Deep River. Within three years these young men had acquired a building at the north end of Main Street to house their hand pump, had successfully petitioned the state to be incorporated, and had doubled their membership. Good times, however, did not last. In 1862, seven members enlisted in the army and the company disbanded. Newspaper reports of the time refer to the disinterest of the men, the lack of fires, and the unfulfilled promise of new equipment as possible other reasons for disbanding the company. The community again had to rely on neighbors to bring out the mops and buckets in an emergency.

A series of major fires in the summer of 1881 dealt severe economic blows to the village. C.D. Fitch's new salt warehouse burned to the ground in June. The mop and bucket brigade "turned out in force" according to the local paper, but "with water all around had no effective way to apply it". A month later the Pratt, Read factory on North Main Street burned for 28 days. Fortunately, for the 160 employees of the company, the Pratt, Read factory was rebuilt in town. This was followed by the third fire in as many months, as the H.G. Jones Woodturning Factory, located on the Winthrop Plain, was destroyed.

H.G. Jones relocated his factory out of town temporarily. Later, he returned to the area and rebuilt his factory in Ivoryton on the Falls River. However, he maintained his home in Deep River and successfully ran for the office of tax collector and then selectman. As first selectman in 1895, Jones spearheaded a plan to purchase a Hollowell Chemical Engine for the town. Minutes of the first meeting of the Chemical Engine Company No. 1 read, "At the insistence of the First Selectman, businessmen met in the selectmen's office to form a volunteer fire company." Frank Howard was elected foreman of the company. Within five years, this company had acquired an engine house, a ladder wagon, doubled the company's roster, and received state recognition from the legislature with incorporation papers signed 1899. At the beginning of the 20th century, the Chemical Engine Company was a center of community activities and socials. The engine house also served as a third-grade classroom to ease the burden of overcrowding at the school.

The first motorized fire engine arrived in Deep River in November 1914 in the form of a used Pope Hartford Touring Car, modified by Behrens and Bushnell Company of Ivoryton to fit the firemen's needs. The chemical tanks had been removed from the Holloway Chemical Engine and placed on the back of the Pope Hartford car. There was room for the driver and one passenger in the front, but it was possible for several additional firemen to ride on the running boards and the back platform. In 1928, the department purchased a new fire engine specifically designed for pumping water and fighting fire in rural towns. Affectionately known as *Beulah*, the vehicle came from the Maxim Motor Company. This familiar apparatus is still an active

piece of equipment, representing the department in parades and competitions around the state.

The Beckwith fire in the fall of 1938 resulted in the largest loss of life due to fire that this town has ever experienced. A father and five of his children perished in a blaze caused by the wood stove in the kitchen. The people of Deep River rallied around Mrs. Beckwith and her three remaining children and provided them with a new home within three months.

As the community grew, so did its firefighting needs. A second fire station was built in the Winthrop area in 1952, and a larger headquarters building was erected in 1961. A junior fire division comprised of boys aged 16 to 18, was organized, as well as a ladies auxiliary, for the support of the fire company. Attention to medical services was addressed in 1957 with the organization of the Deep River Ambulance Association, which was run as a separate organization in the firehouse and staffed by firemen. Later, the association obtained its own building and firemen continued to staff the crews, along with others.

The 1980s brought changes in the types of fires to which the department responded. The majority of emergency calls consisted of car fires and motor vehicle accidents rather than structure fires as in the past. Chemical spills and other hazardous materials were another part of the change in response, as well as marine emergencies. In the 1990s, women entered the company's ranks for the first time as firefighters and continue as active members of the department.

Today, the department operates with three fire engines, an emergency truck, an aerial platform, a pontoon boat for marine emergencies, and a brush truck specially equipped for brush and forest fires. The company roster includes 30 well-trained men and women ready to serve their community. The department purchased a 1976 Oshkosh Ariel truck with an 85-foot tower ladder from the Southbury Fire Department for $65,000. However, in the hearts of the firemen, it did not replace the original ladder truck built for the department in 1901 at a cost of $150. The old truck still maintains an active parade schedule.

—Rhonda and Richard Forristall

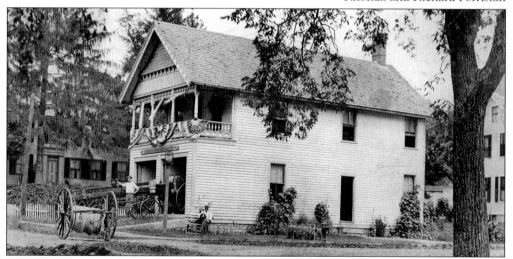

THE CHEMICAL ENGINE HOUSE, C. 1901. Robert Rankin, charter member of the company and chief officer in 1903 and 1908, is seated on the bench. The building was completed in February 1899 at a cost of $800. The firemen purchased the land from Adele Hodges for $100. Through socials and other entertainments, the men of the company raised money to furnish the building. The ladder wagon, with its complement of fire buckets, was built at Frank Howard's Carriage Shop, on Village Street, in 1901. Lane & Lane of Middletown donated the chemical engine (background) and the hose reel to the department. The building served as headquarters for the fire company until 1961, when the current building on the corner of Union and Elm Streets was completed. (Photograph courtesy of Deep River Fire Department.)

WINTHROP STATION. As the town of Deep River grew, so did its firefighting needs. Winthrop Station was built in 1952 at a cost of $9,000 on land donated to the town by John Heidtmann. From left to right are Ed Schweitzer, John Kurze, Art Pianta, Wally Schweitzer, Dick Schweitzer, Herb Haser (assistant chief), Harry Becker, Otto Schweitzer, Bill Tower, Irwin "Rupe" Wilcox, and Carl Ellefson. The trucks (right) are Beulah, the 1928 Maxim, and the department's newest arrival, a 1955 Maxim fire engine capable of pumping 750 gallons of water per minute.

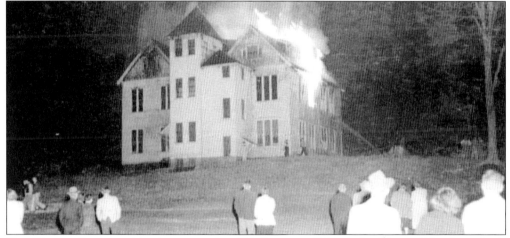

THE UNION SCHOOL. Also known as the Old Grammar School, the Union School was built in 1885 on High Street where the parking lot for the Deep River Elementary School is today. This three-story wooden structure consisted of 12 rooms and was used for both primary and high school grades until 1914. In 1954, the third floor and basement were used for storage by the Deep River Elementary School and the first and second floors were rented out to Ludwig Inc., a company that manufactured portable photograph-duplicating equipment. The fire alarm was turned in at 9:40 p.m. on November 15, 1954, by Charles Lyman who was out walking his dog and pulled the alarm box on the front of the firehouse on the corner of River and High Street. Principal James Frost, who was attending a meeting at the elementary school, rushed into the basement to remove the two lawn mowers. These were the only two items salvaged from the fire. Parents and neighbors came out to watch the spectacular night blaze. Men from Essex, Chester, and Westbrook arrived with more equipment to help contain the blaze. At 3:00 a.m., only embers remained but firemen kept their vigil throughout the night. (Photograph courtesy of Deep River Fire Department.)

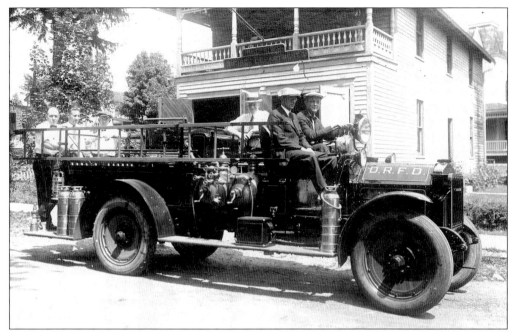

THE 1922 FEDERAL TRUCK. The contract for this fire truck was awarded to Behrens and Bushnell of Ivoryton. They furnished a red Federal chassis and mounted the chemical tanks, originally purchased in 1895, on the new truck. The body of the vehicle came from the James Puller Company of Hartford. All of the equipment for the truck was new with the exception of the chemical tanks. The vehicle carried 1,000 feet of rubber-lined hose, six hand extinguishers, 200 feet of chemical hose, one electric hand lantern, two oil lanterns, one 14-foot ladder, one 24-foot extension ladder, three extra nozzles, and several small hand tools. From left to right are Harry Marvin, Louis Ziegra, unidentified, Robert Rankin, Harold Jopson, and Harry Moore. (Photograph courtesy of Deep River Fire Department.)

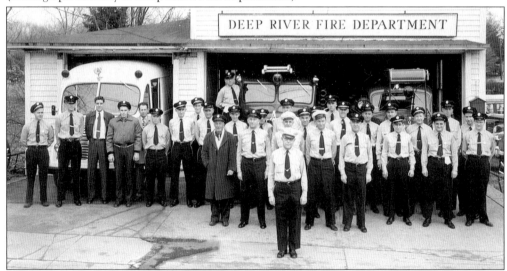

CHIEF DONALD R. MOORE AND COMPANY, C. THE 1950S. The chief and members of the fire company gather for a photograph c. the 1950s. (Photograph by Bob Turner, courtesy of Deep River Fire Department.)

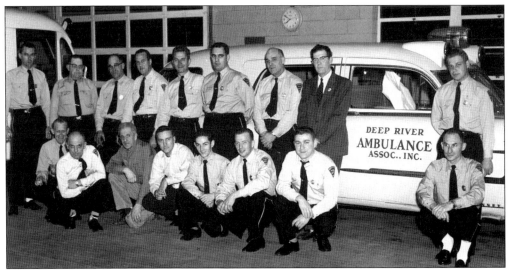

THE DEEP RIVER AMBULANCE ASSOCIATION. The Deep River Ambulance Association was established in 1957 to meet the growing needs of the town for prompt medical service manned by well-trained volunteers. Five Deep River firemen spearheaded this project: Dick Morrow, Arthur "Buzz" Turner, Dick Latham, Jack White Sr., and Ralph Ericson. Through meetings with the local physicians, representatives from all of the local civic organizations, and other interested citizens of the town, the Deep River Ambulance Association became a reality. From left to right are the following: (front row) Ralph Ericson, Otto Schweitzer, Larry Glover Sr., Sal Bartolotta, Al Camire, Dick Bogart, Dom Pulcini, and Harry Becker; (back row) "Buzz" Turner, Don Moore, Dick Schweitzer, John Kurze, Aldo Barocelli, Jim Beardsley, Ed Schweitzer, Ham Moore, and Roger Moore. With them is the newly acquired 1949 Packard-Henney ambulance, which had been painted white by the firemen, and a new rota-beam light, which was donated by the Whelen Engineering Company.

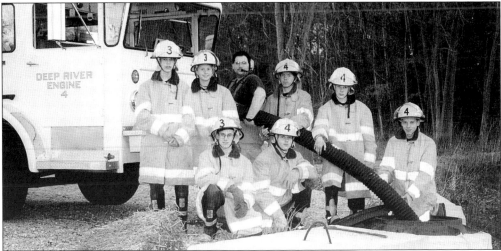

THE JUNIOR DIVISION, 1996. An active part of the department, the junior division holds weekly drills and training sessions. From left to right are the following: (front row) Eric Stanley and Edward Morrissey; (back row) Peter Czepiel, Ashley O'Rourke, Edward Pierpont, Shawn Kruszewski, Derek Zaremba, and Justin Gibbons.. (Photograph courtesy of Deep River Fire Department.)

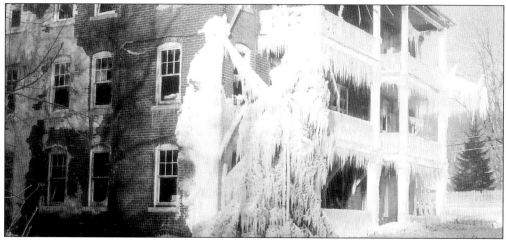

THE BROOKLAWN APARTMENTS. The Brooklawn Apartments consisted of a trio of three three-story brick buildings, located on North Main Street (now the parking lot of Riverwind Antiques and the Kirtland Commons Senior Housing Complex). On January 8, 1968, this early morning blaze had families fleeing in their nightclothes into subzero temperatures. A family of five was trapped on the third-floor balcony and, before the fire department had arrived, a 14-year-old boy climbed down the face of the building. Firemen quickly raised two 40-foot ladders and brought the others safely to the ground without a minute to spare as an explosion ripped through the structure. The fire had started in the boiler room of the first building on the corner of Main and Spring Street. Due to the subzero temperatures, pipes in the building overheated, setting the adjacent wood on fire. The boiler served all three buildings. Each of the buildings had to be evacuated, and 18 families including 22 children needed temporary shelter. Men from Chester, Essex, Westbrook, and Clinton came to assist Deep River through the mutual aid system. Men and equipment were soon covered in ice, hampering their efforts. (Photograph courtesy of Mr. and Mrs. Joseph Dorr of Deep River.)

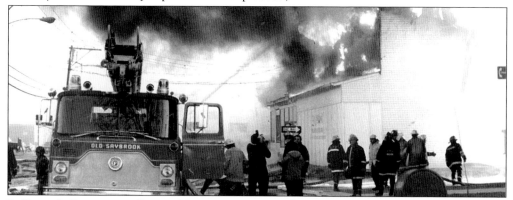

LAPLACE'S FURNITURE STORE, MARCH 14, 1981. The store was completely destroyed by fire in a spectacular blaze on March 14, 1981. The fire alarm box at the town hall was pulled at 3:15 p.m. as the family of William LaPlace was concluding funeral services for Jeanette LaPlace. The fire started in a warehouse section of the 20,000-square-foot wooden structure and was fed by the merchandise displayed on the three floors. This building had been partially rebuilt in 1946 after a fire had severely damaged it. Firemen were hampered by 45-mph winds, which fanned the fire and also brought tree limbs down, slowing response times. Chilling temperatures soon turned every surface to ice. Some 200 firemen from eight towns brought the five-alarm fire under control. To prevent further outbreaks of fire, Deep River firemen kept an all-night vigil.

Nine

THE FLOODGATES
OF HELL

The last 30 years of the 19th century brought the best of the Industrial Revolution to Ivoryton. A new, larger factory necessitated the growth of the village, as more workers needed more homes, entertainment, and recreation. To power this growth, Comstock, Cheney & Company built the Bushy Hill Dam on a feeder stream above the Falls River in 1872, creating a body of water known as Bushy Hill Pond. Perched 185 feet above the new factory, water flow could be regulated down a wooden flume into Clark's Pond, after which it flowed through the Clark's Pond Dam and eventually discharged into the Falls River behind the factory. To provide power to various factories and mills in the three villages, six more dams were in existence along the Falls River between the factory and the Connecticut River.

Some 100 years later, these dams were more decorative than functional, electricity having long replaced water as the power source of choice. The mile-long reservoir behind the Bushy Hill Dam had become a recreational lake used for boating and swimming and reaching depths of 30 feet. Comstock, Cheney & Company had merged with, and taken the name of Pratt, Read & Company Inc., although it remained a manufacturer of piano keys and actions. Located on factory grounds were upward of 1.5 million board feet of maple wood, used for the production of piano actions and keyboards. Sharing space in the Pratt Read buildings was Sounder Sports, manufacturer of high-end golf clubs. Ivoryton itself could no longer be considered a factory town, though Pratt Read still employed 160 mostly local residents.

On the evening of Friday, June 4, 1982, a few raindrops began to fall on the southern Connecticut River Valley. Forecasts for the weekend were for "rain, heavy at times," not an unusual occurrence for early June. Saturday morning, June 5, saw the beginning of the largest non-tropical rainfall in the recorded history of the area. Although it had rained off and on throughout the week, on Saturday a storm front stalled over the area, ultimately dropping up to 17 inches of rain in 72 hours. By dinnertime, the threat of flooding was apparent. By 8 p.m., water was seeping over pond and river banks, and by 10 p.m., water spilled over Clark's Pond dam, across Main Street from the Pratt Read factory, prompting volunteer firefighters monitoring the area to begin a widespread evacuation of Ivoryton, Centerbrook, and the River Road area of Essex. People who were outside just before midnight heard what sounded like a crack of thunder. But there was no thunder and lightning with this storm. What they heard, four miles away, was the Bushy Hill Dam giving way.

One side of the earthen dam had eroded, sending pond waters behind it roaring down the hill into Clark's Pond. The immense power generated by the 185-foot fall destroyed the Clark's Pond Dam, flooding the Pratt, Read & Company factory, carrying 1.5 million board feet of lumber into Falls River, breaking through the Comstock Dam across from the Ivoryton Inn. Behind the Ivoryton Library, lumber jammed a culvert and water flowed up and around it, flooding homes and buildings throughout the village of Ivoryton. Homes were washed off their foundations on and near Comstock Avenue as a six-foot wall of water rushed down to flow back into Falls River. The river washed out Main Street as it crossed to the north side, still carrying lumber, debris, and the odd golf club. Swollen to heights of seven feet, the river destroyed the dam built by the Bull family behind the Ivoryton Congregational Church. The dam built in

1700 behind the buildings currently owned by Centerbrook Architects held, but the water carved out new channels around it and continued to the 1823 Williams Dam at the intersection of Route 154 and Old Deep River Road, badly damaging it. The next dam farther east, along Denison Road, built in 1845 by the Denison family, was lower and therefore basically survived, as the river, still a raging six-foot wall of water, crashed through the last dam at the mouth of the Falls River, destroying the southern half of it, as it entered the Falls River Cove of the Connecticut River.

Good decisions, quick thinking, and a timely evacuation of residents prevented loss of life. Valiant efforts by police, volunteer firefighters, and private citizens rescued those unlucky enough to be caught in the greatest devastation in recent history. Essex could proudly and gratefully state that no lives were lost during those early hours of June 6, 1982. Nothing could save the buildings, however. More than 20 homes and buildings were lost or badly damaged. The Pratt Read factory suffered significant damage and loss of property. Sounder Sports, with many of its golf clubs washed down the river, set up temporary offices nearby and, later, relocated elsewhere. Most of Pratt, Read's 160 employees repaired and cleaned up the damage for six weeks. Production resumed, though jobs, shifts and methods were rearranged. The factory ultimately shut its doors in 1989. Ivoryton had completed its shift from factory town to residential community. The Pratt, Read complex was purchased by Frederick Hilles, president of Piano Factory Business Park LLC in Brooklyn, New York, at an open public auction for $750,000 in May, 2002.

In 1989, an archaeological dig led by Dr. John Pfeiffer of Wesleyan University near the mouth of Falls River, was searching for evidence of the Williams family shipyard and gristmill, and uncovered lumber from the Pratt Read factory five miles upstream. The flood of 1982, dubbed the 500-year flood, is firmly established as a significant event in the colorful history of Ivoryton, helping to end the ivory legacy of Samuel Merritt Comstock.

—Elizabeth Alvord

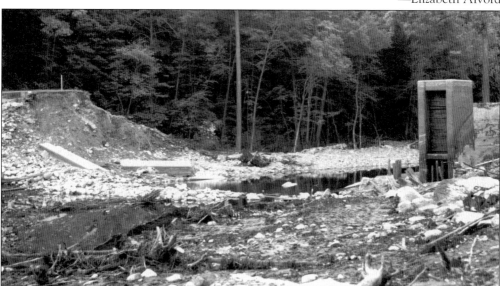

THE BUSHY HILL DAM. This view, looking south, was taken one week after the flood of June 6, 1982. The structure on the right is a water gate used to regulate water flow out of the Bushy Hill Pond to maintain the level of Clark's Pond below. The Bushy Hill Dam was built in 1872 and provided a power source for the upper factory for more than 40 years. This disastrous failure of the dam was a classic example of how the past can affect the present. After the flood, Pratt, Read gave the dam to the New York Diocese of the Episcopal Church. The church then rebuilt the dam. (Photograph courtesy of Tom Schroeder.)

106

BUSHY HILL POND. The pond is shown *c.* 1910 (above) and on June 12, 1982 (below). It was formed in 1872, when Samuel M. Comstock and George A. Cheney leased land from the Clark family for $10 per acre and built a dam across the Bushy Hill Brook. The pond formed by this dam was approximately 185 feet above the new Comstock, Cheney & Company upper shop and supplied an enormous amount of power when needed. Later, the factory raised the height of this dam to provide for the additions to the shop as more and more piano actions and keyboards were being produced. After the factory went to electrical power, Camp Incarnation and the Essex Fish and Game Club used Bushy Hill Pond primarily as a recreational area. (Photographs courtesy of Tom Schroeder.)

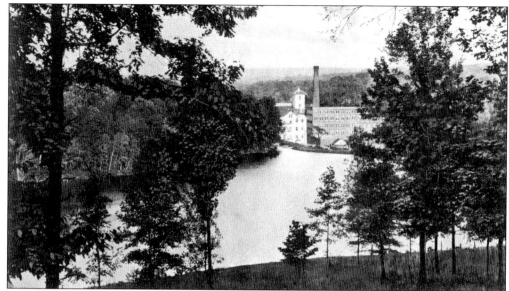

CLARK'S LAKE AND THE COMSTOCK, CHENEY & COMPANY, 1909. Formed by the Clark's Pond Dam (below), located across West Main Street from Cheney Street west of the factory, this pond was used extensively by residents for fishing and swimming. Comstock, Cheney & Company (later the Pratt, Read & Company Inc.) utilized pond water for non-potable uses such as processing and sanitation. Clark's Pond was named as such because the Clark family once owned the land here. The older house to the immediate west of this body of water was a Clark family home. The body of water was also known as Comstock Pond, since this was part of a series of ponds formed by Samuel M. Comstock to keep the factory running throughout the year. (From the Peter Comstock postcard collection, courtesy of Hanford Johnson.)

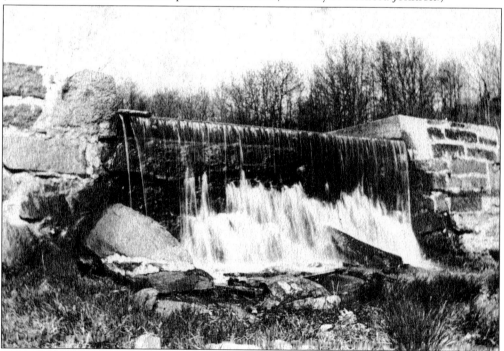

CLARK'S POND AFTER THE DESTRUCTION OF THE DAMS. After the Bushy Hill and Clark's Pond Dams collapsed, Cheney Street was literally wiped out and the factory took the brunt head-on, with the water rising to the second story of the brick section of the shop. Because the Clark's Pond Dam was not rebuilt, the pond today is a quarter of its original size. The pond is still used for recreational fishing, and there are picnic tables and a newly built (2002) dock available for public use. (Photograph courtesy of Leslie Barlow Photography.)

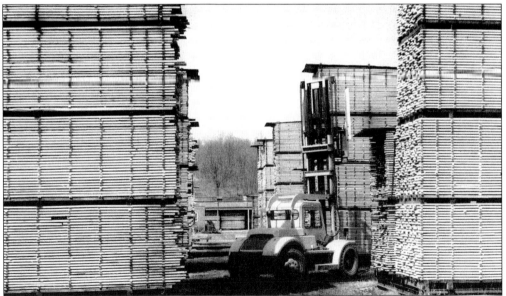

PRATT, READ & COMPANY LUMBERYARD, 1963. The maple wood is air drying in the lumberyard of Pratt, Read. Adjacent to this yard were the large kilns to which this wood was moved to be steam-heated and further dried. After this final drying, it was moved to dry storage (center). Up to 1.5 million board feet of lumber was stored at Pratt, Read & Company. During an archaeological dig in 1989, some lumber as well as golf equipment made at Sounder Sports was found at the mouth of the Falls River. (Photograph courtesy of Don Malcarne.)

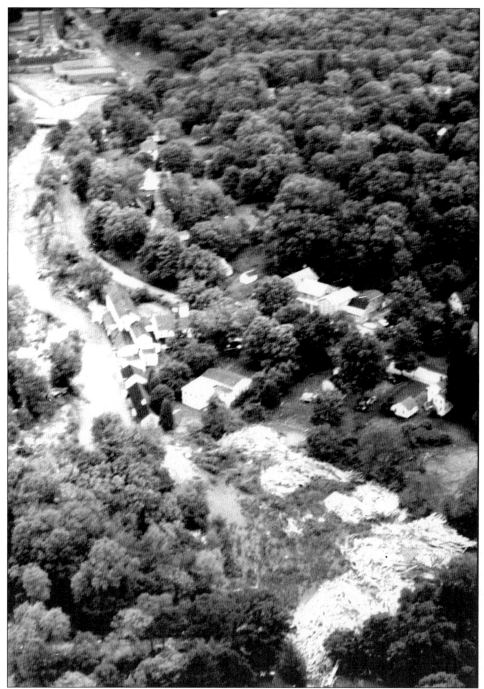

AN AERIAL VIEW OF IVORYTON. This aerial photograph shows Pratt, Read & Company (top) and the massive lumber jam at a small culvert (out of view at the bottom right) under Ivory Street. The water would have overflowed this small culvert in any case, but the lumber jam made it worse. Comstock, Cheney & Company had often flooded the area behind the library so that its employees could skate in the winter. It once was quite a swamp, which since 1890 has been deliberately filled in. (Photograph courtesy of the Mr. and Mrs. Robert English.)

THE MILL AT PRATT, READ & COMPANY, JUNE 1982. This photograph shows the damage at the Pratt, Read factory inside the mill, where the lumber was processed. Two roll-up doors at the far end allowed pallets of lumber—hardwood through one door, softwood through the other—to be rolled onto elevators that lowered it into the ground. Wood was taken off the top and the elevators were slowly raised until the pallets were empty. Having reached heights of six feet, the receding waters left massive amounts of mud throughout the grounds and caused severe damage to machinery. On Monday morning, employees arrived of their own accord, dressed in hip boots and carrying their own shovels, to begin cleanup. Incredibly, the water tower outside, a prominent structure in the Ivoryton landscape, stood through the flood. (Photograph courtesy of Tom Schroeder)

REPAIRING THE IVORYTON LIBRARY FLOOR, DECEMBER 1982. Water rose to the ceiling of the lower level of the Ivoryton Library, which, at the time was used for voting as well as other community purposes. The waters lifted a voting booth and left it perched on a door. More items were found in other rooms and up on the stairs. The wood paneling on the walls could be saved, but the concrete floor needed to be replaced. (Photograph courtesy of the Ivoryton Library.)

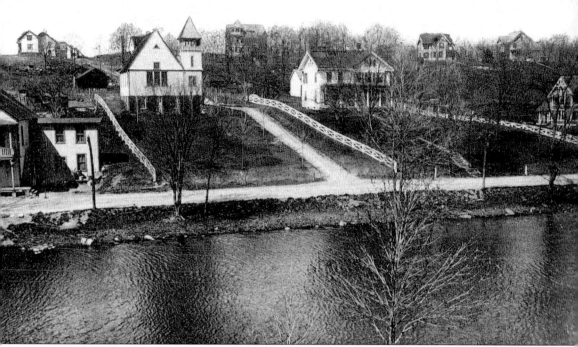

IVORY LAKE. Alternately known as Ivory Pond and Lily Pond, Ivory Lake (above, *c.* 1900) was formed between the keyboard factory and the ivory shop (now Moeller Instrument Company) by the construction of the Comstock Dam (lower left, *c.* 1910) in 1847. Power lines on the south side of the lake carried power generated at the keyboard factory to the ivory shop. The

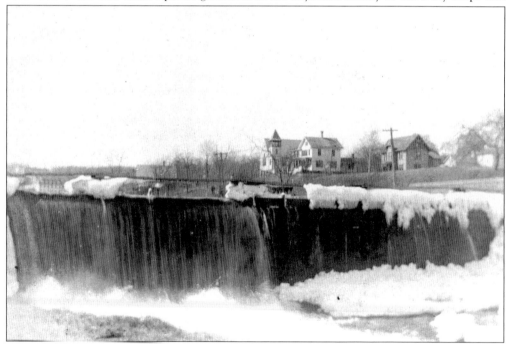

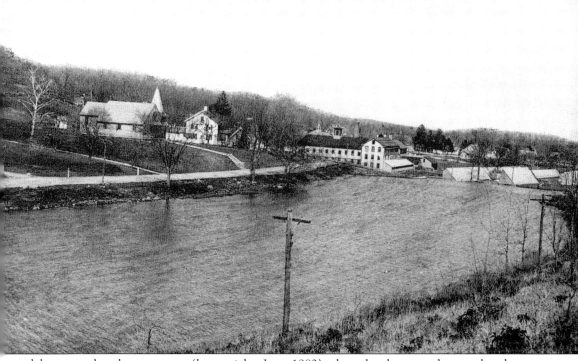

lake was reduced to a stream (lower right, June 1982) when the dam was destroyed and not rebuilt. The old dam foundations (behind the ivory shop) can still be found under the bushes on the north side of the Falls River. (Courtesy of Hanford Johnson, May Rutty, and Leslie Barlow Photography.)

A VIEW OF THE BRIDGE OVER THE FALLS RIVER. This c. 1900 postcard shows the view from bridge over the Falls River at Main Street in Ivoryton. (From the Peter Comstock postcard collection, courtesy of Hanford Johnson.)

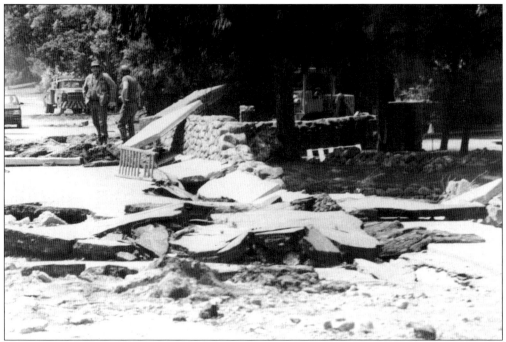

THE MAIN STREET BRIDGE. This photograph shows the damage to the bridge over the Falls River at Main Street. Direct access to Ivoryton was blocked for nearly a year until repairs could be completed. The Connecticut Water Company trunk line to Ivoryton went under this bridge and was broken. It was fixed within a few days, but a large area was affected and even the Essex Elementary School in Centerbrook was closed for a week due to this water supply problem. (Photograph courtesy of Leslie Barlow Photography.)

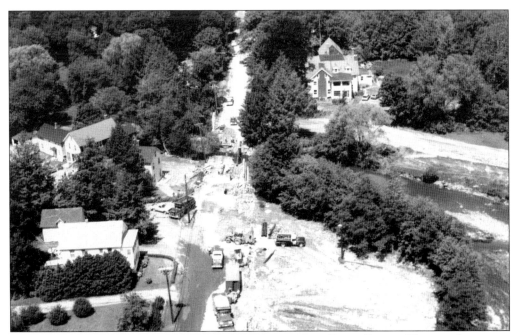

AN AERIAL VIEW OF THE MAIN STREET BRIDGE OVER THE FALLS RIVER. This aerial view was taken after the flood of June 1982. The Robert H. Comstock House is in the upper right corner. (Photograph courtesy of Janet Prann.)

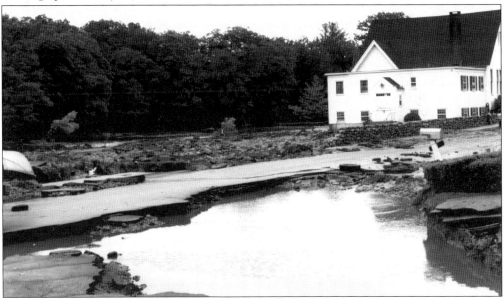

THE VIEW FROM COMSTOCK AVENUE. This June 1982 view was taken looking across Main Street toward the Ivoryton Congregational Church, with the Falls River behind. It shows the damage to the road and the church parking lot. The lot had been built on filled land and was, therefore, subject to erosion. The old Bull Dam, built 175 years prior to this flood, formed the nearby pond. This dam was destroyed but was rebuilt by people in the immediate area. It also had supplied power to Comstock & Griswold in 1834 and to the Comstock, Cheney & Company Bracket Shop, also lost in the flood. (Photograph courtesy of Tom Schroeder.)

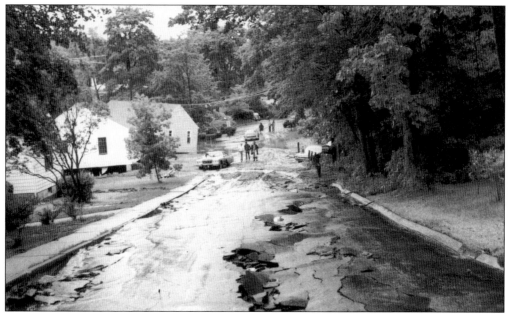

LOOKING DOWN COMSTOCK AVENUE. This June 1982 view looks down Comstock Avenue toward Ivory Street. It shows excessive damage to the road. On the left can be seen rental houses built by Jerome Wilcox, a one-time Pratt, Read employee. The Wilcox family had lived in Ivoryton since the advent of the factory. (Photograph courtesy of Tom Schroeder.)

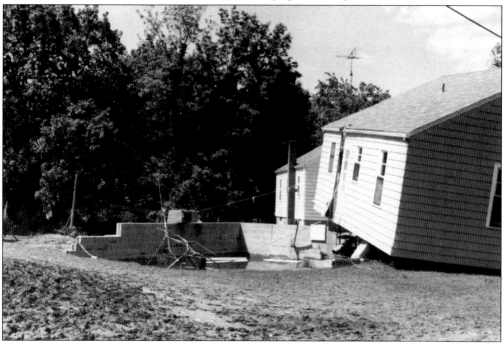

THE JEROME WILCOX HOUSES, JUNE 1982. Although these houses built by Jerome Wilcox at the intersection of Ivory Street and Comstock Avenue were washed entirely off their foundations, they were able to be lifted back on and repaired. (Photograph courtesy of Leslie Barlow Photography.)

Ten

LEGACIES OF WHITE GOLD

Many traditions and artifacts of the ivory years remain in Deep River and Ivoryton. In Deep River on South Main Street is the home of the Deep River Historical Society, the 1840 Stone House. Diagonally across the street, the 1833 Congregational church has expanded physically, as well as in the number of parishioners, and maintains a significant place in the culture of Deep River, as does the entirely rebuilt (in 1926) Baptist church on River Street. In the center of town, the triangular-shaped town hall, while appearing the same on the exterior as 100 ago, is undergoing many interior changes and renovations and is listed on the National Register of Historic Places.

One block north, at the corner of Main and Village Streets, the Victorian home of Richard Pratt Spencer, which became the Deep River Library in 1932, has recently been enlarged, and maintains a complete collection on microfilm of the *New Era*, a local newspaper published from 1874 to 1975. The Deep River Historical Society donated the microfilm viewer and reels in memory of Francis H. Adams and Andrew Horbal. The Pratt, Read complex is now Piano Works, a group of condominiums; and Kirtland Commons, new housing for senior citizens, has been built on the site of three six-family apartment buildings, originally constructed for employees of Pratt, Read & Company.

Perhaps the most noteworthy of Deep River traditions is the annual muster held on Main Street in July. Drum corps from many parts of the United States, and occasionally other countries, participate. This event has attracted crowds of more than 25,000.

Paul Hopkins, now 97 years old, remains one of the best-known residents of Deep River. A local boy, Hopkins graduated from Colgate University and was a first-rate baseball pitcher. He played in the major leagues for the Washington Senators and pitched Babe Ruth's 59th home run in 1927, the year that the Babe set his record of 60 homers, which lasted until 1961.

The Chase family of River Road carried on nautical traditions for years. Irwin Chase Sr. was active in the development of patrol torpedo boats prior to and during World War II, and his son Irwin Jr. was a career naval officer, reaching the rank of rear admiral. Recently, River Road has seen a significant break from tradition, as what was once a summer home and agricultural place has become residential and highly desirable. Another break in tradition was the establishment of a regional high school and junior high in Deep River in 1950, eliminating local high schools in Chester, Deep River, and Essex.

Ivoryton has many artifacts remaining from the Comstock, Cheney & Company years. The unique library, the Ivoryton Store, the ivory shop, Cheney Hall, and the Ivoryton Inn were all built either by the factory or because of it. The most famous of the remaining factory buildings is Comstock Cheney Hall, built in 1911 as a meeting place for employees. It has been maintained and renovated since 1938 as the Ivoryton Playhouse and was rented as a summer theatre from the company for eight years prior to then. Recently, the upper factory was auctioned, formalizing the end of an era that had started in 1834. Bushy Hill Pond, which was a major source of power for this plant, is now part of Camp Incarnation, an Episcopal Church establishment that runs nature camps, brings in youngsters for educational reasons, and operates Elderhostel classes.

People remain, however, and the significant Italian, Polish and Swedish neighborhoods that characterized Ivoryton at the beginning of the 20th century are somewhat intact. The factory houses are all there, although a person would be hard pressed to find one in its original shape. Ivoryton may no longer be a factory town, but residents and their offspring remain who remember the years of the shop. Ivoryton has a parade every May, and various neighborhoods are individually represented, continuing a tradition started years ago.

—Jeanne Field Spallone

VICTOR MALCARNE, 1914–1975. The Deep River Junior Ancient Fife and Drum Corps was established in 1955, about one year after Victor Malcarne asked young musicians to march with the Deep River Fife and Drum Corps at the annual muster. The juniors were invited to perform at the Lincoln Center in New York City in 2002. They performed at the Royal Albert Hall during the Millennium Celebration in London, England, Symphony Hall in Boston, Woolsey Hall at Yale University in New Haven, and Tanglewood in Massachusetts. Malcarne's son Terry, daughter-in-law Marilyn, and grandson Aaron continue to be active in the corps. In the 1975 *Deep River Town Report*, a poem commemorating him reads: His love for his country / was deep in his heart, / so, he joined the Drum Corps. / Vic Marched. / (Photograph courtesy of the Terry Malcarne family.)

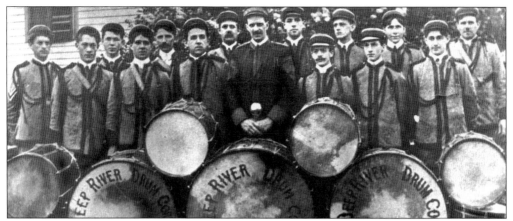

THE DEEP RIVER ANCIENT MUSTER. The Deep River Ancient Muster, started by the Deep River Drum Corps, is held annually on the third Saturday of July. It is approaching its 50th anniversary, with roots going back more than a century. Organized in 1888, the corps began having Field Days in 1949. The first Deep River Ancient Muster was held in 1953 at the suggestion of fifer Ed Olsen of Westbrook. Olsen is the present curator of the Museum of Fife and Drum in Ivoryton. The Company of Fifers & Drummers Inc. purchased the Polish Falcons Club in 1983 and opened the museum in 1985. The main floor, where programs and meetings are often held, exhibits uniforms, instruments, artwork, photographs, and flags. From left to right are Harry Pratt, Charles Buckingham, Edward Egan, Frank Joy, Nordahl Pratt, Charles Cavanaugh, Felix Starkey, Robert Rankin, Harold Sisson, Louis Pratt, Charles Glover, Edward Bentley, John Behan, Francis Hamilton, and Oscar Anderson. (Photograph courtesy of Deep River Historical Society.)

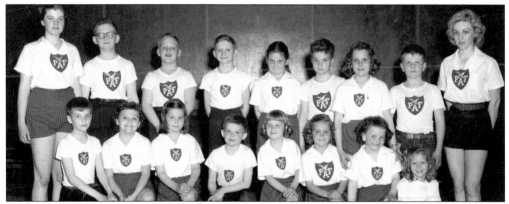

IVORYTON-BASED POLISH FALCONS CLUB NEST, FORMED IN 1886. The Polish Falcons Club offered gymnastics classes to children of Polish descent. The club started practicing at the Sobieski Club, using instructors from Bridgeport and New Britain. Property for a new hall was purchased from Alex Grabowski, and the building was erected in 1936. Besides gymnastics, the building was used for card parties, parties, weddings, and regular auctions. It was sold to the Company of Fifers and Drummers for $60,000, the proceeds distributed for scholarships to Falcon children and local students for many years. From left to right are the following: (front row) ? Koritokoski, Cathleen Hmielewski, Linda MacWhinney Saucier, Mickey Chmielewski, Nancy Marciniec Ebler, Helen Hmielewski, Marsha Borkowski, and ? Bump; (back row) Shelly MacWhinney Houghtaling, Robert Marciniec, Stanley Marciniec, Stanley Stopa, Sandra MacWhinney Huber, ? Koritkoski, Barbara Chmielewski, and Leonard Borkowski. (Photograph courtesy of Helen Zabielski MacWhinney.)

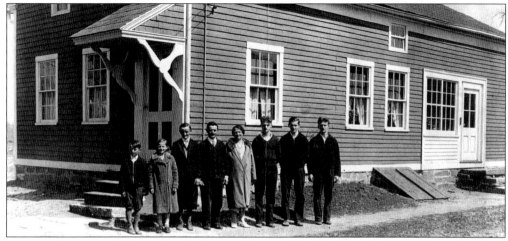

THE RELOCATION OF HOMES TO MAKE WAY FOR ROUTE 9. Before the construction of the new Route 9 was completed in 1967, weekend gridlock on Main Street in Deep River and other nearby towns, was a serious traffic problem. The old two-lane highway was crowded with weekenders headed to resorts or summer cottages along the shoreline. Sunday afternoons, when everyone returned at about the same time, were the worst. A new four-lane, limited-access highway was badly needed to solve the problem. A scenic highway, close to the Connecticut River, was considered in 1952 but was dismissed for several reasons, including the fact that several old cemeteries would have to be relocated. When the new Route 9 was finally built, it was not necessary to relocate cemeteries, but many homes were moved to make way for the new highway. In Deep River some homes were moved to a cul-de-sac named Fox Run Road, off West Bridge Street. In the 1933 photograph (above) are members of the Hazuka family, from left to right, Rudolph, Helen, Charles, George Sr., Anna, John, Joseph, and George Hazuka Jr., in front of their home, a Pratt, Read house at 100 West Bridge Street, still standing today near the entrance to Fox Run Road. Howard J. Duplessis, who was in charge of the moving, purchased Harry Lindner's house (below) and relocated it on a hill behind West Bridge Street. (Photographs courtesy of Helen Hazuka Pavelka and Mrs. Howard J. Duplessis.)

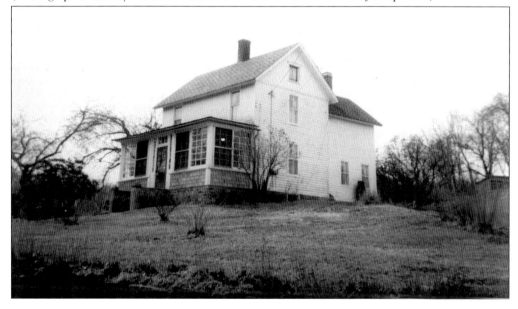

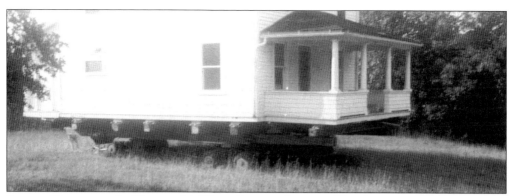

Sophie Kuzmierski's House, 94 West Bridge Street. This home was lost to Route 9 construction in 1967. It is shown in the process of being moved. (Photograph courtesy of Mrs. Howard J. Duplessis.)

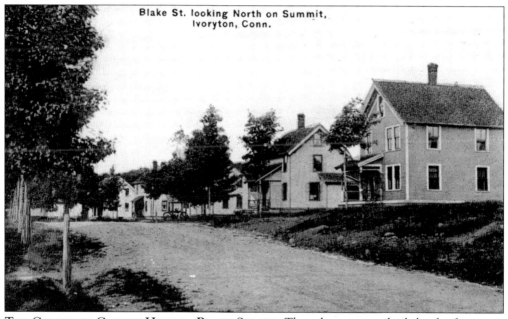

Blake St. looking North on Summit, Ivoryton, Conn.

The Comstock Cheney Houses, Blake Street. These homes were built by the factory to accommodate an increasingly large and mainly immigrant workforce. They were built in certain sections of Ivoryton, becoming, in effect, satellite communities. As time passed, these homes were often sold to employees, with the factory carrying mortgages. When Comstock, Cheney & Company combined with Pratt, Read & Company, in 1936, a separate corporation was formed to sell off all the remaining property of Comstock, Cheney & Company that had nothing to do directly with the factory. This new company, Ivoryton Realty Company, sold many company houses. At the time of construction, most of these homes cost the factory between $400 and $600 to build. Built well, they remain as private dwellings today, albeit there is only a handful in original condition. (Photograph courtesy of May Sterling Rutty.)

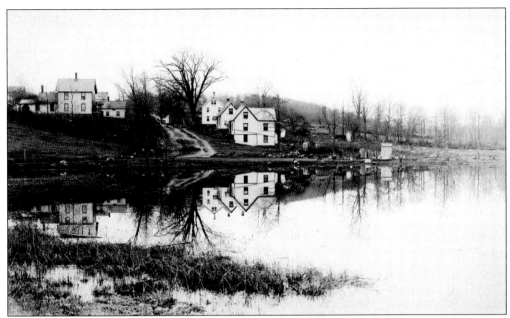

COMSTOCK CHENEY HOUSES, WALNUT STREET AND COMSTOCK AVENUE. This area was once called Ivoryton Heights. Samuel Comstock's village is different today. No longer are there dusty roads and wooden plank sidewalks, often made impassable by the spring mud. There remain distant memories of a first Columbia bicycle with hard rubber tires, narrow bicycle paths along the dirt roads, kerosene lamps, and a time when families had horses and surreys and the best leather harnesses. (Photograph courtesy of May Sterling Rutty.)

COMSTOCK, CHENEY & COMPANY SEMIPROFESSIONAL STATE CHAMPIONS, 1917. In the first part of the 20th century, factory baseball teams often achieved a high level of interest and success. Such was the situation with Comstock, Cheney and Company teams. Baseball was an important factor in Ivoryton, and the factory built a field off Walnut Street, behind the factory, which was eventually given to the town of Essex. It is said that over 3,000 people came to see the games. The Ivoryton Library plans to recreate this team's sense of spirit and community with an annual reenactment beginning in July 2003. Identified from left to right are Bradbury, Jones, Buerlein, Falsey, Sawyer, Pitts, Hale, Hilley, Shailer, Peterson, Westcott, Walsh, Nuhn, Keller, Cahill. (Photograph courtesy of Ivoryton Library.)

PAUL HOPKINS. Paul Hopkins, a native of the lower valley, went to Colgate University in upstate New York. He pitched for the Washington Senators in the American League. His name is in the Baseball Hall of Fame in Cooperstown, New York, for he was pitching when Babe Ruth hit his 59th home run in 1927, the year Ruth ended up with 60. His pitching career was ultimately sidelined by injuries. Hopkins remains one of the most notable athletes ever from this area. (Photograph courtesy of Deep River Historical Society.)

COOK BOOK

──OF THE──

IVORYTON LADIES' SOCIETY,

1898.

THE IVORYTON LADIES SOCIETY 1898. The largest donor for the building of the Ivoryton Library was the Ivoryton Ladies Society. A meeting was held in Comstock Hall on August 14, 1888, with G.B. French, H.S. Comstock, R.H. Comstock, J.E. Northrup, J.L. Clark, and H.P. Chapman. The group offered $1,960 to the library building committee. Today, the library hosts the Ivoryton Ladies Sewing Circle, a group which meets twice a month on Wednesday nights from 6:00 to 8:00 p.m. (Photograph courtesy of Ivoryton Library.)

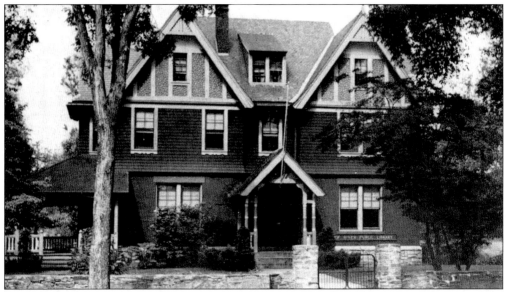

THE DEEP RIVER PUBLIC LIBRARY. In 1899, interest in establishing a library in Deep River was heightened when the Deep River *New Era* published an editorial discussing the need for a library in town. A committee was formed to plan the project and, on May 26, 1900, the Deep River Public Library was opened to the public; its shelves contained 675 volumes. The library was then housed in a designated office in the town hall. Later, the Spencer homestead, an 1881 residence at the corner of Main and Village Streets, was purchased to house the library. Supported by a village celebration, the library opened on May 10, 1933. A public whist tournament, sponsored by the local garden club, raised money to landscape the grounds, and 321 books were circulated in one day. Some notable events include donating 688 books to a Victory Drive in World War II to provide books for troops overseas. The library slogan, the result of a contest sponsored by the Friends in 1984, was won by Valley Regional High School student Laura Janoski, with her slogan "Hands Open Books, Books Open Minds." (Photograph courtesy of Deep River Historical Society.)

DEEP RIVER'S LIBERTY AND FREEDOM TREES. In 1976, a maple tree was planted on the green at the Winthrop Baptist Church and dedicated as a "freedom tree." That same year, in observance with the U.S. bicentennial, each Connecticut community was presented with a seedling whose ancestor was the famous Charter Oak. Deep River's oak was planted at the Winthrop church near the freedom tree. But it was not until May 2002 that the oak was dedicated as a "liberty tree." The engraved stone by the tree reads, "Liberty Tree: This tree, planted in 1976, is a descendant of Connecticut's original Charter Oak. Dedicated to the Rights of Man. May 26, 2002." The stone itself was quarried from the Fountain Hill Cemetery in Deep River. Liberty trees were the rallying spots for the pre-Revolutionary War patriots known as the Sons of Liberty. Pictured is Philip Shreffler, who conducted the dedication ceremony as a leader of the local Sons of Liberty. (Photograph courtesy of Deep River Historical Society.)

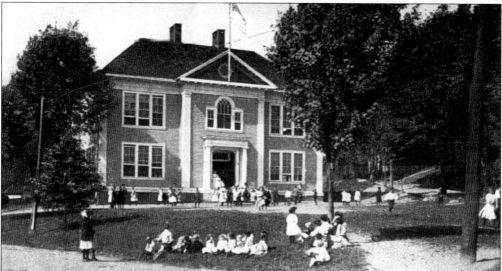

IVORYTON'S CHARTER OAK. In 1688, the Connecticut Constitution disappeared under mysterious circumstances and was supposedly hidden in the Charter Oak when Gov. Edmund Andros of New York was instructed to "take over the colony." In 1902, George H. Blake, a member of the state legislature and the Essex School Board, presented a seedling from the Charter Oak to the Ivoryton Grammar School. It was planted in an Arbor Day ceremony on the school grounds. The tree is no longer standing. (Photograph courtesy of Ivoryton Library.)

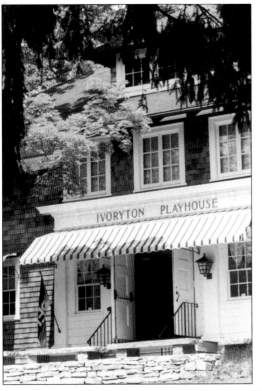

THE IVORYTON PLAYHOUSE FOUNDATION AND RIVER REP. River Rep is the summer stock theater group at the Ivoryton Playhouse. The playhouse dates back to 1911, when Comstock, Cheney & Company built it as an entertainment hall for the factory workers. Milton Stiefel brought Connecticut's first summer stock to the playhouse in 1930. Over the years Stiefel was able to draw a stream of stars including Helen Hayes, Ethel Waters, Groucho Marx, Tallulah Bankhead, Douglas Fairbanks, and Katharine Hepburn. Their photographs still line the theater walls. Residents in the three villages established the Ivoryton Playhouse Foundation in 1978, and Joan Shepard and her husband, Evan Thompson, established River Rep in 1987. From left to right are Evan Thompson, L. Michael Mundell, Joan Shepard, Joseph Culliton, Jenn Thompson, Chric Teegardin, Marion Markham, and Warren Kelly in *Lend Me a Tenor*, a 1993 production. (Photograph courtesy of Joan Shepard and Evan Thompson.)

THE IVORYTON VILLAGE PUMPKIN FESTIVAL AND IVORYTON DAYS PARADE. These two festivals return Ivoryton neighborhoods to a time of community spirit. The carved pumpkins at the Ivoryton Village Pumpkin Festival (above) rekindle the traditional All Hallows' Eve, with hundreds of carved pumpkins. Ivoryton Days (below) is celebrated every year on a Saturday in May with a parade and activities on the village green. Neighborhoods and organizations are encouraged to enter parade floats, which have grown larger and more elaborate in the lighthearted competition. (Photograph courtesy of Jane Fuller and Ivoryton Library.)

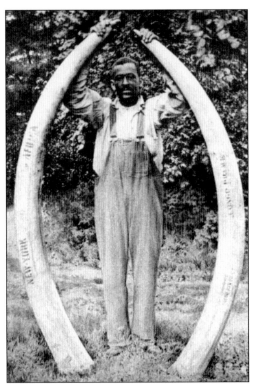

PLAQUE SHOWING STEVE BEALS. This plaque on the side of the Ivory Restaurant & Pub, located on the corner of Main and Kirtland Streets, reads as follows: "In 1809 George Read Began a Business Manufacturing Ivory Products at the Site Now occupied by the Piano Works. The Town grew up around this Industry. For Generations, the Children of Deep River Cut Their Teeth on Ivory Rings. Their Parents Became Skilled at Turning Ivory into Combs, Buttons and Especially Piano Keys. The Pratt, Read & Company Factory Became the Nation's Main Supplier of Piano Keyboards. During World War II, this Factory also produced more than 900 Waco CG4A Glider Aircraft to Carry Troops and Supplied into Combat. The Present Building Erected in 1881, is Listed on the National Register of Historic Places." (Photograph courtesy of Deep River Historical Society.)

THE PRATT READ & COMPANY MUSEUM, 1977. Machinery and material was gathered for years by George Cheney Seeley and Peter Harwood Comstock after World War II to create a museum in Ivoryton to perpetuate the history of both companies, Comstock, Cheney and Pratt, Read. Edith M. DeForest served as curator for six years after her retirement from Pratt, Read & Company Inc. The stained glass with the elephant shown in the museum was originally from the president's office that had been in a building located across from the factory. The small ivory-cutting machines can also be seen in the photo. The stools in which the ivory cutters sat are pictured. (Photograph courtesy of Edith M. DeForest.)